FORGING IDENTITY

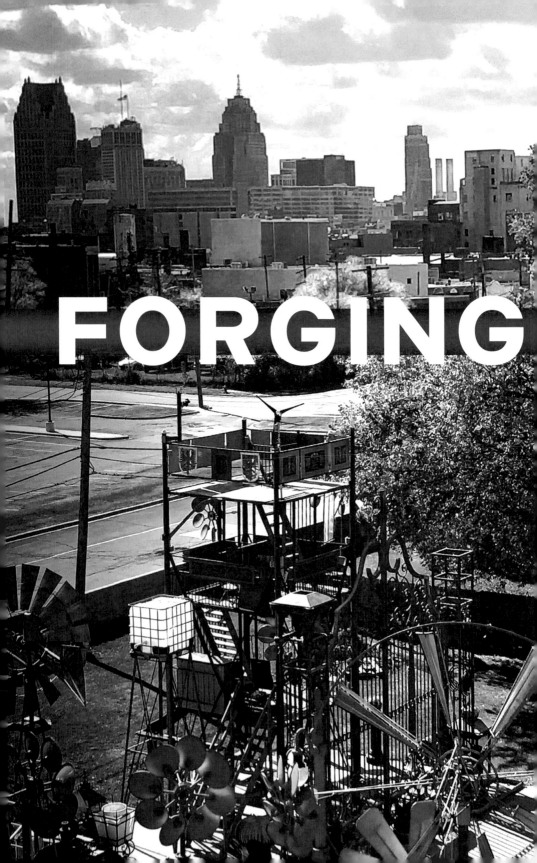

IDENTITY

The Story of Carlos Nielbock's Detroit

Paul J. Draus with Carlos A. Nielbock

MICHIGAN STATE UNIVERSITY PRESS | *East Lansing*

Copyright © 2025 by Paul J. Draus and Carlos A. Nielbock

Michigan State University Press
East Lansing, Michigan 48823-5245

Library of Congress Cataloging-in-Publication Data
Names: Draus, Paul Joseph, author. | Nielbock, Carlos.
Title: Forging identity : the story of Carlos Nielbock's Detroit / Paul J. Draus with Carlos A. Nielbock.
Description: East Lansing : Michigan State University Press, [2025] | Includes bibliographical references.
Identifiers: LCCN 2024028600 | ISBN 9781611865165 (hardcover) | I
SBN 9781611865141 (paperback) | ISBN 9781609177720 | ISBN 9781628955323
Subjects: LCSH: Nielbock, Carlos. | Metal-workers—United States—Biography. | Detroit (Mich.)—Biography. | Detroit (Mich.)—Social conditions—20th century. | Detroit (Mich.)—Social conditions—21st century.
Classification: LCC NA3512.N54 D73 2025 | DDC 709.2 [B]—dc23/eng/20240719
LC record available at https://lccn.loc.gov/2024028600

Book and cover design by Anastasia Wraight
Cover photograph is by Ika Danielson.

Visit Michigan State University Press at *www.msupress.org*

CONTENTS

Acknowledgments vii
A Note on Illustrations ix
Introduction xi

1	**Chapter One.** Curly Hair, Curly Mind
21	**Chapter Two.** Welcome to Detroit
43	**Chapter Three.** Craftsman and Contrarian
65	**Chapter Four.** Confronted with the Might
89	**Chapter Five.** Crazy as Hell
111	**Chapter Six.** Fighting (for) Detroit's Future

Conclusion 137
Afterword, *by Carlos Antonios Nielbock* 149
Epilogue, *by Marsha Music* 155
Farewell to Clarence 161
References 167

ACKNOWLEDGMENTS

This book started with a series of freewheeling conversations between Carlos Nielbock, myself, and many others, beginning shortly after our first meeting in 2012. Carlos is a character who is larger than life, but who also exists in real life, with people around him, including a close-knit family. While the narrative in the book largely comes from him and me, representing each of our standpoints to a greater or lesser degree, it also reflects many other conversations with a wide and diverse set of people over a span of more than ten years. Some of the people are mentioned in the book, but others are not. Nonetheless, they were a part of the story, and their perspectives also influenced me. I will try to name all of them here. I apologize in advance for any I may have missed.

First of all, profound thanks are due to Marsha Battle Philpot, a.k.a. Marsha Music, for her generous contribution of a beautifully rendered portrait of Carlos and the 1980s Detroit milieu. It was done so well it almost made writing the rest of the book seem unnecessary—except that we had already done it!

Very special thanks to Clarence Cheeks, Keenan Nielbock, Manuela and Frank Meierhoff, and Marianne Nielbock for their open and honest interviews, and to Axel Smith for translating during my visit to Celle. Thanks also to Tony Biundo, Karl Stocker, Eric Froh, and Walter Blevins for long conversations and letting us use their words in the text. Other folks who were involved in the story along the way include: Dan Carmody, Kim Sherobbi, James Godsil, Tanya Stephens, Beverly Nielbock, Fatima Sow, Myrtle Thompson Curtis, Richard Feldman, Lydia Levinson, Jason Lindy, Herman Jenkins, Kenneth Crutcher, Rukiya Colvin, Charles Ferrell, Naser Alijabbari, Horizon Gitano, Sigrid Bürstmayr, Shannon Haupt, Jūratė

Acknowledgments

Tutlyte, Khary Mason, Janai Gilmore, Chuck Rivers, Anne Peeples, Ellie Schneider, Dustin Zak, Tom Kim, Keegan Scannell, Joe Zakar, Arthur Bledsoe, Andrew Germann, Lorne Greenwood, Jim Gray, Jean Mallebay Vacqueur, Maggie Allan, Wencong Su, Christopher Pannier, David Liang, Priya Ganesh, Ajao Adetokunbo, Richard Bachman, and Pavel Cernoch. All of them have passed through the gates of C.A.N. Art Handworks or intersected the orbit of the Detroit Windmill and other projects over the years; some giving time, space, energy, and funding; and others giving much more.

Juliette Roddy, Belinda Nielbock, and Ika Danielson are not directly quoted in the book, but, without them, it would not have been possible. Julie made the first contact with Carlos and quickly befriended him and his family. Everything else followed from that. Belinda was always a calm counterpoint to Carlos's furious energy; she is a truly luminous soul, and it always makes me happy to see her smile. Ika, Carlos's administrative assistant, was an invaluable sounding board for both of us.

Thanks are also due to Caitlin Tyler-Richards, who believed in the book from the beginning, and the team at Michigan State University Press, including Liz Deegan and Elizabeth Demers. They have been flexible and responsive throughout the process.

My wife Carla Gonzalez and my children, Solomon and Serafine, have supported me (and sometimes accompanied me) through all the events, projects and conversations. My mother, Geraldine Draus, deserves my unending gratitude for always being there to listen.

Carlos and I both lost our fathers in the time it took to finish this book, so a special dedication goes to them: Walter Draus (1940–2020) and Clarence Cheeks (1930–2023). Clarence made his peaceful transition just after Thanksgiving in 2023, surrounded by family and friends. He is at the heart of this story. I am forever grateful for the time he spent sharing his memories with me.

A NOTE ON ILLUSTRATIONS

Carlos's medium is both tactile and visual, and it is hard to do justice to him or his work in written form. Even photography can fall short, unless it is of the highest quality. Over the years, I took many photographs of Carlos and his works, and sometimes I would stop to sketch them, either on site or more commonly from those reference photographs. These sketches were interspersed with my notes and are associated with memories. When it came time to assemble the book, I found that my photographs, many taken with my mobile phone camera, were not of sufficient quality to publish. I also saw that many great photographs and videos of Carlos already existed online and can be found with some simple internet searches of his name. The sketches, on the other hand, represented my own view of Carlos or, in some cases, his view of himself. I always had a fondness for books in which the narrative was accented by line drawings suggestive of the ideas or depicting simple scenes, but without too much detail, leaving the imagination of the reader to fill in the gaps. We decided to leave photographs out and instead to intersperse the book's narrative with a set of these sketches. Some generated at the time of the actions depicted; others produced later. As with the story, the sketches have a perspective that is limiting as well as revealing.

As much detail as we have tried to include, there were many things left out. In this sense, the book itself is a sketch, a rendition, a representation. Although the narrative is grounded in real experience, real people, and real places, it is not intended as an authoritative account, a history, or even a complete biography.

As the book neared completion, we also asked Carlos's long-time friend and illustrator, Detroit cartoonist Marco Evans, if he would be willing to contribute some of the many drawings that he has done over the years. Many thanks to Marco for saying yes to this request.

INTRODUCTION

I first met Carlos Nielbock the way many people do: by encountering his creations. They spin, they shine, they loom over the street where he resides like a sentinel presence. Towering iron gates and flashing windmill blades cut the sun into shards against the backdrop of hot pavement and green-cloaked stillness that was the Eastside of Detroit in the summer of 2012.

"Who made these?" That is the question that my colleague Juliette Roddy and I first asked when we spotted the rotating red windmills from our vantage point on the cracked sidewalk.

Carlos would later joke, "That is when everything started to change, when you and Julie came along with your clipboards."

We had been walking up and down Chene Street, formerly one of Detroit's densest and busiest commercial corridors, as it connected the historic residential enclaves of Poletown and Black Bottom. By the 2010s, the majority of the parcels were empty and many of the remaining structures were unoccupied by human beings. We were there because we were conducting interviews for a community-based research study, to understand more about where the neighborhood had been and where it was going. The area had been selected by a local nonprofit organization as the site of an aspirational project to utilize urban agriculture as a lever of sustainable redevelopment, and we were interested in what members of the community thought about these plans. Our goal was to walk every street in the area, and Chene was the main drag. That was the source of Carlos's comment about clipboards, although I can't remember if we were actually carrying them on the day we first spotted the windmills.

Popular images of Detroit from this era focused on the city as a ghost town, a tomb, or a blank canvas waiting to be remade. These tropes soon

became cliché, but they were nonetheless persistent, like the well-worn plots of horror movies (Draus and Roddy, 2016). We knew that this apparent emptiness was an illusion, informed by American frontier myths and settler-colonial fantasies. It concealed a complex, contested community that our interviews were designed to capture (Draus, Roddy, and McDuffie, 2013 and 2018). Nonetheless, at times, the street seemed so desolate that one would not have been surprised to see a tumbleweed roll by.

Along these walks, we encountered both transient and long-term residents. One man stopped for a few moments to talk, and we asked him what the neighborhood was like for him. He breathed in deeply and said, "Everyone around here is either hustling or got some kind of edge." We met a number of such people, who went by street handles like "Junebug," "Tino," "Popcorn," and "Shorty," some with no permanent addresses even though they had lived in the neighborhood all their lives. Sometimes we met them there on the street, spontaneously; sometimes we heard about them from others and managed to catch up to them later. The interviews we conducted are referenced in some of the articles we wrote (see Draus and Roddy 2022 and 2016; Draus, Roddy, and McDuffie, 2018 and 2013), but these were mostly passing associations. We were just academic drifters.

In the midst of this environment, so strongly associated with erosion and erasure, Carlos's space stood out as an attempt at some kind of permanence. It lay at the southern end of this stretch of Chene Street, where it ran into the diagonal spoke of Gratiot Avenue. Tucked in between the post office, the pawnshop, the restaurant supply store, and the bank, it was marked by his works of metal art and bounded with gates and fences that declared it a distinct territory, almost a kingdom apart. If you stopped to peer through the medieval, metal gate, you would see this simple sign, in Old English script:

<p style="text-align:center">C.A.N. Art Handworks

Architectural/Ornamental Metal Work

European Master Craftsman

Carl A. Nielbock</p>

At the time, the city of Detroit was mired in the muck that the Great Recession had deposited in its wake. The area had not mysteriously emptied; rather it had been assaulted by decades of economic and social abuse (Draus,

Introduction

The chiaroscuro impression of light cut by ornate metal gates and spinning windmills at Carlos Nielbock's workshop, a sight that catches the eye of passersby and makes them wonder what happens inside.
Drawing by Paul Draus.

2009). Chene Street and the rest of the Eastside were particularly hard hit by the foreclosure crisis, a wave of bank-generated abandonment that tore through a community already devastated by decades of disinvestment, drug wars, structural decline, and arson.

Detroit's historic bankruptcy was still a few years away, and nothing seemed certain in the city or the neighborhood. Visionary plans emerged alongside pronouncements of doom, many of them originating outside of the city. The urban agriculture initiative that Julie and I intended to study, for example, proposed to convert the abundance of vacant space around Chene Street into productive landscapes full of art installations, bicycle trails, and urban farms. We wanted to understand the impact the project might have, if it succeeded, and whether it would, as promised, benefit the surrounding communities, or what remained of them. The response we often got, when interviewing residents, was that they hadn't seen such plans,

that they didn't think whatever was happening was going to benefit them, that the community was no longer viable, and in any case, the fix was in. In other words, the city and nonprofit leaders were also hustling and angling for some kind of edge.

In a conversation we recorded several years later, Carlos put it this way, using his own unique brand of adopted English: "It got as bad as it can get, so bad that the water was running down the street and the houses burning, the demand of all the outstanding debts at once. It makes it real easy to get out of here, there can be no lower condition of the land than what it was. It became a liability. You got to pay somebody to take it."

Unlike many others who headed for the exits during those difficult years, Carlos took that bottoming-out moment as an inspiration and worked on his own solution to the crisis, rather than (as he said) "sitting here and waiting to die." As an artist, Carlos saw the emerging environment as a kind of paradise, while it lasted, with the open space to walk his dog and the freedom that was provided by the lack of regulation. Like others in the neighborhood, he had spent years during the Great Recession struggling just to keep the lights on, stay out of bankruptcy, preserve his business, and maintain his home. In the early days of the first Barack Obama administration, green energy was seen as one of the focus areas for government investment, a way to build a new, more sustainable economy. For his part, Carlos saw more potential in this strategy than the dreams of urban agriculture. This was how he began to develop his Detroit Windmill design. If he could not continue to make a reliable living from his ornate metalwork, perhaps he could mine the wind.

When the Detroit Future City strategic plan was released in 2012, a year before the city declared bankruptcy, Carlos saw the area where he lived colored turquoise-green on the map and labeled as a potential "Innovation Ecological" and "Live/Work" zone. He read this as a sign that a big change was coming. The document had been developed after a full year of listening sessions by a team of urban planners and designers, and it offered a menu of possibilities and priorities for the city as it moved into the twenty-first century. It was seen by many long-term Detroiters as a harbinger of what was to come, for better or for worse, as the city sought to strategically shrink or "right-size." These tea leaves were read differently depending on one's own position. Newman and Safransky, in a 2014 article titled "Remapping the Motor City and the Politics of Austerity," offer a trenchant critique of

the Detroit Future City project, observing that: "This depopulated—though very much inhabited—built environment has given rise to exploitive representations showcasing emptiness in the form of crumbling buildings and neighborhoods transformed into vast 'urban prairies'" (20).

Carlos had his own suspicions. After all, his workshop looked out onto one of these spaces, now largely cleared of residents, that was seen as a site for the potential "reimagining" of Detroit. Nonetheless, he chose to believe the promise. "I made up my mind, I want to be a part of Detroit Future City," he said. "Sign me up." He made a similar commitment to Detroit's application to become a UNESCO City of Design in 2015, lending his workshop to the campaign displaying Detroit as an active scene of creative industry. Fulbright scholar Irfan Hošić, in his unpublished essay "Detroit: The City of Design and Its Ideological Backgrounds," writes: "After being continuously deconstructed throughout the second half of the 20th century, losing more than 50% of its inhabitants and struggling with basic needs of the civilized world, such as electricity, water supply and other urban services, Detroit became [an] interesting lab for diverse social actions." Hošić offers examples of grassroots design projects that sought to intervene in the cycles of abuse and abandonment, including the Brightmoor Maker Space and D-Town Farms, which persist to this day. Images of urban prairies notwithstanding, this local ferment was the reality that the myths of an urban frontier often missed. At the same time, Hošić raised the possibility that private capital, as in the case of Detroit-based luxury brand Shinola, would position itself as the city's rescuer, offering another version of employment as corporate servitude.

It was hard to be a long-term Detroiter, abandoned and stigmatized by the racist policies of the late twentieth century, and not harbor some suspicion about the Detroit Future City vision or the City of Design application. Though not a native of the city, Carlos had been there long enough to see multiple promises made and betrayed, and he also perceived a threat in the advancing wave of interest and investment in Detroit. This tide swelled following the 2013 election of Mike Duggan, the first White mayor since the 1970s, and the settlement of the city's bankruptcy in 2014. By this time Julie and I had developed a relationship with Carlos and his family that went beyond research interviews. We began working on grant proposals with him and looking for potential partners for some of his projects. He

felt that his castle of imagination and determination was no longer a secure fortress in the face of the "New Detroit." While better positioned than many of those around him, he also had more potentially to lose. His optimism for the future often alternated with moods of dark foreboding.

"I feel under the gun like a motherfucker," he said in one of his frequent diatribes. At this point, almost a decade after our first meeting, I had had the opportunity to listen in on many of Carlos's conversations and impromptu lectures, some directed at me, some to others. Carlos's front door was usually closed to the street, but his magnificent works of metal drew both tourists and visitors throughout the year. In his presence, I was exposed to a parade of people and perspectives, from Detroit's abundant community of artists and craftspeople, to contractors and architects, historians and historical re-enactors, professors and reporters, business owners and church pastors, extended family members and long-time neighbors, and just curious passersby.

As a sociologist, I found this gathering of people irresistible, but on another level, it could be overwhelming. Carlos's life and story encompassed almost everything I had come to know and love about Detroit, and much that I had yet to learn and appreciate. It was a Detroit story, and an American story, full of confidence, conflict, and contradiction. It was a drama of creativity and frustration, of triumph and loss, of busted-down, rock-bottom failure, as well as recovery and reinvention.

Over the years, we had developed a working relationship, where I brought my modest set of academic tools to bear on some of his visionary projects, and tried to help him bring them to life. At times, this was a rocky road, and more than once I had to walk away for a few days or weeks, to separate from Carlos's intense furnace of drama. In the summer of 2018, I assisted him in the process of building and installing two of his original windmills in the Eastern Market District of Detroit. This took us from the city's scrapyards and power plants to community meetings run by planners and designers, from locksmith shops to greasy spoons, from cocktail parties to university halls, and many places in between. Mostly we hung out on the Eastside, at Carlos's workshop or on top of his custom-built Sky Garden, where he could study the wind, watch the lights come on over the city, and contemplate his place within it. For a period of time, at least, I was seemingly enmeshed in every part of Carlos's world, often talking on the

phone with him several times a day, and handling matters financial, personal, and professional on his behalf.

Somewhere along the way, we started talking about writing a book on his life and work. For me, this was an opportunity to explore the themes of his unfolding story more deeply. For him, it was the chance to get his ideas more fully into the world and, of course, to try to make some money. I tried to tell him that the kind of books that professors write do not normally make for bestsellers, but as usual he was not deterred. The highlights of Carlos's story were by this time well known, at least to those in his circle of association around Detroit. Marsha Music, in her eloquent epilogue for this book, touches on many of them:

The son of an African American soldier and a German barmaid, Carlos Antonios Nielbock was raised in the small town of Celle in Lower Saxony in the 1960s and 1970s. He found his calling in his early twenties, when he was trained as a master metalworker by Catholic monks at the reformatory of Johannesberg. He arrived in Detroit in the early 1980s, looking for his father, and he found not only a family but a home. He established himself in the United States through pure determination, undeniable skill, and persuasive charisma, and forged a metal restoration and fabrication trade in Detroit in spite of having no money and speaking little to no English. An immigrant in America, he identified with the spirit of striving embodied by other immigrants but was not connected to a broader immigrant community. He embraced Blackness, in all its pride and beauty, as fully as any native-born Black Detroiter, but wrestled with the street culture of the neighborhoods where he made his home. He was both Black and White, while at the same time being fully or completely neither, an embodiment of Du Boisian doubleness, born on the other side of the Atlantic. A true American individualist, he also maintained a very German regard for order. He was a temperamental artist as well as a calculating businessman; a rule-breaker, outsider, and survivor, who longed for mainstream acceptance and success. A perpetual boundary-crosser, he felt most comfortable in his own workshop, alone with his restless mind.

In sum, Carlos was in the great American tradition of clashing contradictions. The chapters that follow explore some of these aspects of Carlos's story in more depth and detail, supplementing his own narrative with other sources, including interviews with his family and associates, and historical

references. Carlos is a larger than life character who also has some jagged edges. This makes him compelling but complicated. I incorporate my own perspective as a White male college professor, of similar age to Carlos, fully acknowledging that there are aspects of his experience that exceed my ability to properly convey.

At the same time, I propose that the themes in Carlos's story connect to many others. After all, who does not identify with a longing for a true home, on the one hand, and the resistance to restriction, on the other—conflicting but connected impulses that animate everything from ancient legends to American road movies and rock-and-roll music? Like a folkloric trickster, Carlos is forever seeking to turn the tables on "the Man," even while knowing, as all gamblers do, that "the house always wins." The continual tension between individual and community, capitalism and creativity, humility and hubris, all of these elements are present in Carlos's story.

As I listened to Carlos recount episodes from his life, I envisioned a kind of adventure narrative spanning two continents, somewhat in the spirit of *Don Quixote*, a tale that Carlos adored. I have drawn on cultural myths and stories as well as history and biography, incorporating insights from social science as well as arts and humanities. While the range of influences is broad, this is not intended as an exhaustive scholarly book, nor does it have a clear, singular thesis. Rather it is meant to capture something of the energy and turmoil of a creative mind, as well as the excitement and conflict of a city in the midst of transition.

The book's conclusion surveys the landscape of contemporary Detroit, assessing the odds of Carlos's achieving success and making the pitch for a twenty-first-century Afro-futurist craft economy that brings his ideas together with grassroots politics and institutional reforms that could enhance equity and sustainability while fostering creativity and innovation. Carlos's struggle for success, recognition, and redemption speaks to larger issues in cities like Detroit, especially in relation to racism and the forces of gentrification. The stakes are at once personal and social: survival, success, the vindication of an artist's vision, and the full inclusion of a marginalized but resilient community in the economy of urban redevelopment.

So here we go: The story begins in a small town in the north of Germany and ends with the ongoing battle for the soul of a great American city.

Chapter 1

CURLY HAIR, CURLY MIND

By the time I met Carlos Nielbock, he was already well practiced at telling his life story, and he was certainly aware of the fascination it provoked. In 2016 he stood before an appreciative audience at the Charles S. Wright Museum of African American History in Detroit, as part of the Secret Society of Twisted Storytellers series hosted by Satori Shakoor, to speak on the theme of "Fathers and Figures." He began by describing his own father, Clarence Cheeks, as he was in the 1950s, and proceeded to explain his own origin in terms of the stark realities of racist segregation:

> He was a Black GI, real good-looking, full of energy, and he just wanted to prove himself, and he found himself with all those limitations that pre-emancipation bear with him, there was Black bathrooms and White bathrooms, and all those different things that different races have to do, and he met my mother, which was a White woman, and they fell in love, and out came me, and the Army didn't really like that so much, so they sent him back to United States, and I stayed behind, with my mother, in Germany.

This account summarized a heartbreaking history into a concise origin story: a family separated by racist state practices, a young man left to grow up without a father. This separation was the central theme of Carlos's early life. Along with the fact of his blended identity, it drove his quest to find (or make) his place in the world. But as is typical in autobiographical narratives,

Chapter One

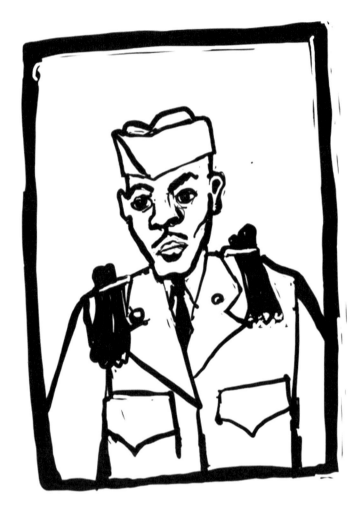

Clarence Cheeks, Carlos's father, cut a dashing figure in his military uniform.
Drawing by Paul Draus, from a family photo.

there was a lot that he left out, or glossed over. It explained where he came from but not who he *was*.

How much of any person is inherited, how much is produced by their environment, and how much is simply a lightning stroke of luck, igniting otherwise latent qualities? Where does our character originate—in our minds, our blood, our genetic code, or in the air we breathe? These are perennial nature-nurture, chicken-and-egg questions that animate human

history, inspire inquiries into the lives of heroes and villains, and lurk within innumerable family sagas. So it was with Carlos, whose powerful personality and unique vision invited an investigation of his origins while, at the same time, they eluded any easy explanation.

In getting to know Carlos, and grappling with his story, I also had to face the limits of my own perspective. First and foremost, I could not understand the experience of living in a body defined as Black, with all that entailed. I had to trust what he and others told me, because this was a side of the world that I was unable to see. To borrow the words of W. E. B. Du Bois (1903), it lay on the other side of the veil. Throughout my own life, I have learned to appreciate the things I don't understand about racism and its effects. The best advice that I have received, when it comes to White people understanding others' perspectives, is that sometimes you simply need to shut up and listen. My parents, to their credit as working-class children of the World War II era, were committed non-racists, but their primary solution to the problem was simply not to talk about it.

My blindness to the experience of Blackness wasn't my only shortcoming in approaching this story. While his hybrid heritage as an African German American was at times a source of alienation, it was also key to his identity. As I got to know Carlos better, and we began developing the idea of a book about his life, I saw that the German side of his experience was also central to his identity. Although I am technically both a German American and a Polish American, I don't speak those languages and have never lived anywhere but the United States. In fact, historians have argued that the process of "becoming White" in America involved a surrender or erasure of any such cultural heritage, in exchange for the benefits provided by Whiteness (Roediger, 2005). All that cultural variation was effectively abandoned by my own forebears in order to join the great White middle class. As a result, like most White Americans I don't know much about Europe, even though I may think I do.

I grew up in a White-dominant context, and even though I had been educated through years of experience, observation, and instruction, to evade the traps of racist thinking, I still found myself constantly employing these cognitive cages. As a result, I was also culturally programmed to read people as binaries, especially when it came to the fictional but powerful category of race. If that is your engrained lens, someone like Carlos scrambles the codes.

The first question that unconsciously came to me as soon as I saw his name posted outside his workshop was: "What ethnicity is he?" In the dominant Black/White schema, European heritage is often coded as a component of Whiteness, and categorically antithetical to Blackness. The conceptual confusion that people often experienced with Carlos had less to do with him than the expectations that other people carried around in their heads.

Carlos was difficult to categorize using the binary system: was he Black or White, an immigrant or an American, a craftsman or an artist, a worker or a capitalist? Because the answer to all these questions was "yes," one quickly finds their a priori categories and associated assumptions deficient. Perhaps more than any facts of his background, the thing I came to appreciate about Carlos was that he wouldn't let anyone else define, delimit, or confine him. These poles each had a powerful pull, and he refused to give up any claim on any part of his cultural heritage or his ancestry. He was all these things, yet he could not be reduced to any one of them, or even the sum of them. He overflowed them.

Ika Hügel-Marshall, an Afro-German author and activist, described her own experience growing up as an "occupation baby" in early 1950s Germany as one of constant shame and internal conflict. Her father was an African American soldier, named Eddie Marshall, but he left Germany due to an illness while her mother was still pregnant. After she was born, her German mother married an ethnic German man, but he never embraced her as his own child; her mother was effectively coerced into surrendering her to the God's Little Acre Children's Home. There she found that her behavior was often attributed to her otherness, to the "Negro in her." The nuns who worked there once took her for an exorcism, to drive the devil out of her. As a result of this experience, she said, "Everywhere I imagine little black devils: behind the cellar door, in the basement, under my bed" (2008, 43). Another child would steal her pencils and force her to say, "I'm a little niglet, a chocolate covered piglet," before he would return them (49).

The daily assaults took an inevitable toll. "It is universally accepted that blacks are stupid and so on and so forth, and nothing in my daily experience suggests otherwise," Hügel-Marshall wrote in her autobiography. "It's no wonder I try as hard as I can to ignore my blackness, no wonder that my desire not to stand out from the crowd grows even stronger" (50). As a

young woman she would grow angry at the sight of other Black people due to this internalized shame. "I didn't want anything to do with them," she said in a BBC interview conducted in 2020, "because for me being Black meant being sidelined and inferior." The 2017 documentary *Afro. Germany* by journalist Jana Pareigis provides numerous examples of individuals who endured similar comments as children of color in Germany, often focused on their hair or skin, which placed them permanently outside the social norm. As one man, who lived through the Nazi regime said, "We didn't need a yellow star."

Carlos was born in 1959, more than a decade later than Hügel-Marshall, in the town of Celle, in the state of Lower Saxony, south of Hamburg, near the city of Hannover. Celle is defined today by its historic Old Town composed of traditional, half-timbered houses as well as its baroque castle. His father, Clarence Cheeks, was stationed there as a soldier in the US military, but he was transferred out of Germany when Carlos was about three years old. Like Hügel-Marshall, Carlos was raised, along with his younger sister, Manuela, in the household of his maternal grandparents until his mother met and married another man, named Heinz Nielbock. According to Carlos, "He adopted me, and married my mother, and adopted my sister, so we had German names, German everything. There was no distinction on paper, between us as interracial kids, or [anything] like that. Also he was like an up-fluent businessman, who really observed some power in the city. He had status, so he acted like a blanket of protection." However, despite the claim to authentic German-ness that their surname implied, the biological parentage of Carlos and his younger sister were evident in the appearance of their hair and skin.

Carlos's experience paralleled Hügel-Marshall's in that his German mother also married an ethnic German. However, Carlos's mother never surrendered him, and he had a younger sister who shared his African American heritage, so he did not experience the total isolation described by Hügel-Marshall. Carlos's first vivid memory was not one of shame but of triumph: the fins of a Cadillac, sweeping through the streets of Celle, like a flying ship. Detroit, the Arsenal of Democracy, had directly contributed to the conquest of Hitler's Reich, and the Black soldiers in the newly desegregated American military ironically found more welcome in the cities

and villages of Europe than they did in their home country. The children born of relationships between these soldiers and ethnic Germans, on the other hand, had to navigate a very different landscape.

One day Carlos shared an old German expression with me that he often heard when growing up: "*Krause Haare, krauser Sinn, mitten steckt der Teufel drin.*" It literally translates as, "Curly hair, curly mind, the devil is in the middle of it." It was meant to account for his difference, his inability to fit in. Though it could be read as a harmless statement about the mischievous personalities of curly-haired people in general, it took on a very different connotation when applied to a boy of African ancestry, living in a small town where there were very few people of color. Used in this context, it connects to the elemental myth of race itself, the idea that there is an essential nature attached to a specific heritage, that curly hair cannot be straightened, and dark skin cannot be washed off, and that these characteristics will always define you, no matter what you do. The reference to the devil implies the idea of a bad seed, reducing the individual to only one dimension, and a stigmatized one at that.

As Carlos explained, "It's the association with curly hair to another race, that race-mixing, it doesn't matter how curly, it starts with curly: *Krause Haare. Krause,* it's not straight. Anything but not straight, so you can already know a bad apple, a non-Aryan person, a person that is already fucked-up based on their genetic composition. *Krause Haare, krauser Sinn,* it reinforces stereotypes that whatever fucking curly hair you had, you are part of the underclass, the *untermenschen*: a sub-human. And the tell-tale sign is the *Krause Haare,* and they have *unt krauser Sinn,* even the brain is not like your brain, it's twisted and winded in mysterious ways, that only *scheisse* [German for *shit*] can come out."

"*Krause Haare, krauser Sinn,*" revealed the undercurrent of othering that attached itself to him. According to Carlos, "That was used by people, they couldn't really get to me, people in the city. As a kid, growing up, I was almost, like, untouchable. There was fast punishment in the form of *ohrfeige,* that's when you get struck with the flat hand over your ear, it's a demeaning, painful, and lasting type of thing. Or a kick in the ass, literally, like full speed, like you kick a football. Nobody could do that shit to me. Heinz Nielbock was right there. So they start saying crazy shit, like *Krause Haare, krauser*

The old German expression *krause Haare, krauser Sinn*, or "curly hair, curly mind," was used by older people in the Celle community to link Carlos's physical features to his attitudes and behavior, and this only solidified his defiance.
Illustration by Marco Evans, used with permission.

Sinn, 'look, here he come, look what he do.' So I was observed all the time, so, of course, I give them what they wanted to see."

In the sociology of deviance we often refer to the idea of the self-fulfilling prophecy, the way a stigmatizing label shapes behavior by convincing someone that other people expect it from them—as Carlos said, "I give them what they wanted to see." Likewise, the field of psychology has developed

the concept of stereotype threat, which produces a similar result, foreclosing other possibilities by convincing someone that "their kind" isn't capable of succeeding in certain areas (Steele and Aronson, 1995). For example, the idea that Asian students are good at math but bad at sports may foster a willingness to invest significant time in STEM classes and neglect athletics, thereby reinforcing the original stereotype.

Pierre Bourdieu, the twentieth century sociologist, explored the question of how the social world gets into the bones and brains of individuals and affects both their identities and behaviors throughout their lives. In a massive multi-year study, Bourdieu and a team of researchers chronicled the perspectives of individuals living what would normally be considered unremarkable lives: social workers, factory workers, teachers, students, housing project residents, and those stranded by deindustrialization in communities that stubbornly persist after their economic means of support are removed. As Bourdieu writes, "the family is necessarily a matrix of the contradictions and double binds that arise from the disjunction between the dispositions of the inheritor and the destiny contained within the inheritance itself" (1999, 507–508).

Carlos's life, I saw, was just such a matrix of contradictions, although perhaps more confounding than most. His world was split from the beginning by macrosocial factors outside of his control: history, culture, and racism. This fracturing was only compounded by his own dispositions—the destiny of inheritance that eventually drove him beyond the bounds of Celle, the small town in Lower Saxony that both nurtured and constrained him.

Carlos once told me that one of his greatest inspirations was Gunther, his "U-boat grandfather," who had worked as a repairman on a German submarine during World War II. "He's the one, if you had a leak, he's got to fix it, or everybody will drown like a rat." He then turned and fixed me with his icy eye: "So who do you want to take with you on the U-boat?" This question was offered to me in an offhand way, while we were in the shop one day, and he was running down the latest developments on his many projects. It conveyed something about his ethics as well. He admired those who dove into a problem and got their hands dirty; one of his most cherished insults was to call someone an "innocent bystander." When we were pulling light poles off a scrap pile, for example, and he needed assistance, and you were slow to respond, he would say, "Hey, don't be an innocent bystander."

It was one of many references to his German upbringing that emerged in Carlos's daily discourse. One day, he told me about Till Eulenspiegel, a German trickster character, possibly based on a real person but later immortalized in works of music, literature, drama, and film. Till is a fool who turns the tables on the social elite, showing their true faces in the process. Carlos talked about the poor kid, who is paid to take the rich kid's beatings, because of course you were not allowed to physically discipline someone of noble birth. I asked him if this was reflective of his own experience growing up, he replied: "When you go there, to Germany, you can ask them."

To understand Carlos's character and perspective, I decided it was necessary to go back to his beginnings—to his parents, Clarence and Marianne, and to Detroit and Germany in the post–World War II period—to understand the worlds they came from, as well the social and personal forces that brought them together. Initially, I relied solely on Carlos's account of his life in Germany, but he told me I should go to the source and meet with his sister and his mother in Germany, so in October of 2018 I arranged to meet with

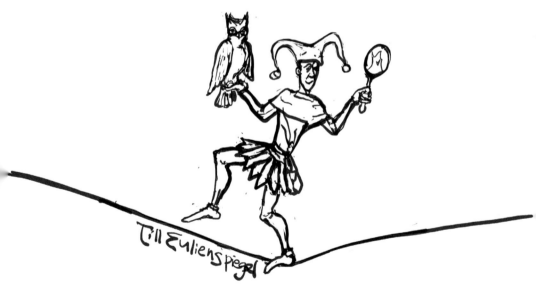

Till Eulenspiegel, a German folk character, known for pulling practical jokes and engaging in roguish adventures in defiance of authority, here keeping balance while holding the mirror and owl that are his namesake—representing wisdom on the one hand and the reflection of society's true face on the other.
Drawing by Paul Draus.

Carlos's younger sister, Manuela, as well as her husband Frank, while visiting Frankfurt with my own father and brother. By this point, Carlos and I had decided to develop his story into a book, and I wanted to learn more about the mix of circumstances, the context and texture of his experience as a child and young adult. His upbringing in Germany clearly informed everything Carlos did, but he had also evidently fled the place as though his life depended on it. Manuela, on the other hand, had never left Germany, except as a tourist. She saw herself as a German through and through. Carlos described her in the same way: "My sister is very proper," he said.

Manuela agreed to meet me at the Café Hauptwache, a former jail converted into a restaurant, located in the center of Frankfurt, Germany, where they serve eggs topped with *Grüne Soße*, the distinctive green sauce of the region. It was a rendezvous point that Manuela had selected, and she spotted me first as I entered from the plaza outside. When she approached I immediately saw the family resemblance: the lean build, the animating energy, the piercing gray-green eyes, and the curly, light-brown hair. They shared the same heritage, the same mother, and the same biological father as well as the same adopted father. Yet you could not have found two people more different than Carlos and Manuela. While Carlos eventually followed his father's trail all the way to Detroit, Manuela stayed rooted and content in German culture, although she saw it through a shaded lens. She said, "We grow up like this, we don't know where we belong, but I see this as a chance, and I give this to my daughter. I tell her she can sit at the table with the Black people, or you can sit at the table with the White people. We are mixed." Manuela's comfort with her heritage was balanced by an awareness of her difference: "I never really belonged here, or belonged there. I am always on my own because there was no one I can trust, and this is the same with Carl. He don't trust no one."

Manuela and Frank's accounts of Carlos's early life supported both his stories and my own impressions of his mercurial character. Celle was a small town, and Carlos and the children who grew up together all knew each other; they would meet up on their bikes and go on adventures. Often Manuela found herself in the role of lookout, while Carlos got into trouble or played tricks, in the spirit of Till Eulenspiegel or Max and Moritz, the characters created by Wilhelm Busch, who embodied many of Till's characteristics and replicated some of his pranks.

They both grew up in Heinz's family business, which Manuela described simply as "a bar where men could come to meet women." Carlos called it a cabaret, catering to the tastes of the occupying British and American forces. Carlos's mother, Marianne, worked in the bar. This is where she met Clarence, but after the military shipped him out, she developed a relationship with Heinz, who inherited the business from his father. In an earlier conversation, Carlos had told me how living in the business, following Marianne's marriage to Heinz, shaped both his perspective and his social position in Celle.

"My bedroom was directly over the cabaret," he said, "right on top of it, so when I looked out the window, I see all the action, and my whole room was like BOOM-BOOM, from the bass, and especially when the show act came, the special drum roll announcement and all that stuff, so that was rather interesting, rather exciting all the time. And then when I grow older, then I was helping the artists move in and out; they all changed every month, so we had new dancers, or artists, or illusionists, or burlesque dancers, or complete nude dancing, and so I helped them to move in and stuff. So I was, like, I got always the preferen[tial] treatment, so it was, like, great. I was the popular boy in all school, because my school friends all wanted to hang out with me."

When I asked him the name of the place, he laughed and refused to answer at first, but then told me, "It was called the Devil's Bar." He elaborated, giving the name in German: Zum Teufel, which literally means "To the Devil." Idiomatically, it meant something more like "in hell." According to Carlos, "It would be like, 'go to hell.' That would be the proper translation. Because it was, like, you know, it opened up real late at night, you had to have a tie on, to get in it, and it catered to the officers of the occupied forces, that was occupying Germany, and, of course, after their service, they wanted to party, like a *Moulin Rouge* type of atmosphere, with new acts every month. It was something, boy." He laughed at the recollection. Images of billowing smoke and red lights, of black ties and bare flesh, of crashing drums, sinuous dances, and double entendres filled my mind.

Everybody in the family worked at the bar, and they all lived upstairs. Heinz was the chef, while Mariana was the hostess, and the grandparents worked in the coatroom. The only online reference I could find for the Zum Teufel, or The Devil's Bar, was listed on an Army Rumour Service website,

where one blogger described as the "most disgusting bar you've ever been to" and went on to describe a bawdy performance that concluded with chairs and stools flying. The period described was the 1970s, when Carl was a young man growing up there. I read this entry to Carlos, and he laughed out loud, though he disputed this depiction of the bar as a nasty, low-class establishment.

Frank, Manuela's husband, was a childhood friend from Celle, who accompanied Carlos on many of his adventures, even into young adulthood, when they would dress up and go to the discos in Hannover and Hamburg. He saw Carlos's ethnic difference as something that set him apart, but not necessarily in a negative way. It made him interesting, and he had the charisma to capitalize on that, to win people over. He was attractive, and women liked him; they would even light his cigarettes for him. As Carlos grew older, he gravitated towards Black people wherever he could find them. He hung around the Jamaican soldiers serving in the British Royal Air Force, also stationed in Celle. He was enthralled by the reggae music that they listened to, and he began attending Caribbean music festivals across Germany.

Carlos grew into adulthood in the 1970s, while Germany went through its own transitions. As he explained, "In Germany before 1968 or 1969, there was no talk about the past. That's when the students started to figure out that the Nazis were back in the government. That's when the big shift took place, the severing, the *historische aufarbeitung*, or historical reappraisal. All of a sudden young people became disrespectful towards their elders. Before that, this was unthinkable. And then there was Heinz, and for him there was only one solution for the hippies and their uncut hair: the work camp or *arbeitslager*. They used to say, 'Forced labor gets you fresh. From morning until night, until the water boils in your ass.' There are very cruel things they say in German. The only thing they don't do, like in America, is put shackles on you."

Scars of the war were still fairly fresh when Carlos was growing up. Celle is located less than a hundred kilometers from the East German border, which had been closed in 1952. Communities were separated, houses destroyed, the ground plowed up, and a restricted zone five kilometers wide was established along a meandering path that divided one side of the country from the other. In the 1960s Germany was still actively occupied and World

War II was a recent memory for adults. Carlos recalled seeing the restricted zone between East and West when he was a boy, climbing the guard towers and looking across at people standing on the other side.

When I visited Celle more than sixty years later, I walked through the rainy streets lined with iconic timber houses dating back centuries, and I could imagine how Carlos's eye was trained by that environment to appreciate the presence of both history and artistry. The French Garden, or *Französischer Garten*, was his playground as a young man, occupying an area adjacent to the Old Town, which is popular with tourists from Germany and abroad. The *schloss*, or castle, overlooks everything. For me, it was like entering a medieval stage set. It was April 2019, and I was able to take a couple of days following a work trip to Berlin to go see the town of Carlos' birth. I met Carlos's mother, Marianne, in the restaurant at my hotel the morning after my arrival. She was accompanied by Axel Smith, a young Afro-German metalworker who was also engaged to Carlos's daughter Belinda. Axel's father was a former British soldier, and he spoke perfect English as well as fluent German, having been raised in both cultures. He translated while she spoke, and it was like a bottle of sparkling water being uncorked and poured.

Like Carlos, Marianne remembered that the American soldiers drove big cars, and her fondness for Americans was rooted in her childhood experience. When her family was fleeing their home in Koenigsberg in 1944, ahead of the invading Russian army, they were picked up and given a ride by an American truck caravan. The soldiers gave her dark chocolate in a can; she remembered the name *Scho-Ka-Kola* and how it made her feel. This was also known as aviator's chocolate, and it contained a high percentage of caffeine. The memory of this substance, consumed at a moment of vulnerability and need, influenced her view of Americans from that moment on. Neither racism nor the language barrier prevented her and Clarence from connecting, but the uniform may very well have had an influence.

She remembered one Christmas Eve when Carlos was about five or six years old. He had received a kit car at a family gathering, which was very exciting for him. The adults continued with the party, and shortly later they realized that Carlos was gone. They set out to look for him in a panic. The Schlossberg castle was located at the center of town on the top of a steep hill, only a few blocks from where the family lived. At the bottom of the

hill, there was a decorative pond, and that was where the family eventually found Carlos and his kit car. He had immediately taken the car to the biggest hill he could find and rode down to the bottom. "Das ist Carlos," was how Marianne described this and many other episodes: "That's Carlos." He saw no reason why he shouldn't go straight to the castle.

I was reminded of what Manuela had told me about Carlos's and his preternatural confidence. "He was always like this," she had said. "When they would ask us, in school, what we wanted to be when we grew up, with Carlos there was no hesitation. 'I am going to be king,' he would say, or 'I am going to be chancellor.' And nobody would laugh at this—they knew he was serious. He always had a way of talking, of getting other people to go along with him."

When I met her, Marianne was focused and energetic, a quality I saw echoing through all of the family members I had met. Though Manuela was more restrained, she also had this kind of electric aura about her and a gaze that can seem to look right through you. Marianne would grab my arm when there was something she wanted me to see, and, at the end of the day, she said there was a chemistry there; she had a good feeling about me, or else she would not have been so open. Though I certainly understood the power of romantic love's attraction, I still wondered how it was possible that she and Clarence communicated, when neither spoke the other's language. However, on this bright spring morning, I saw how this could happen. Though I didn't understand most of her words, I could grasp much of what she meant to say, the similarities between English and German coming just often enough to spark recognition.

When I asked Carlos, in late 2023, about the reasons why he left Germany, he paused, took a breath, and said: "I have probably made a few bad decisions." I had to laugh, and so did he, because this was an unusual admission. He went on, "But I'm also most eager to redeem myself. Repent and redeem myself. I didn't know what that word was back then, but I know that's how you describe it. Quickly I found out that, in Germany, there is no redeeming. You can repent all you want but there ain't no redeeming. There's no coming back from nothing in Germany; you only getting in deeper."

"What did you need to come back from?" I asked.

"Like I say, bad decisions, that led you into being perceived as not being part of this society, when I really did want to be a part of the society. And

my perspective was influenced, [by] how we was living there at Teufel Bar in Germany—that was not like [how] the regular society lived. There was hypocrisy there too, because everybody looked down on an establishment like that, but everybody showed up there, and showed out too. And the next day, back to normal." Heinz Nielbock, he explained, "had big influence, because he knew the dirt on everybody."

For Carlos, the way out of Celle came unexpectedly through the working of metal, which he learned from Otto Zutkamp, the old master at the Jugendhilfe Johannesberg, a Catholic monastery and boarding school.

Carlos's first complete metal work, the result of a practical examination requiring all the skills he had learned at Johannesberg.
Drawing by Paul Draus.

The school had been closed during the war, and when it reopened in 1946, it took in many of the children who had been orphaned, as well as those who presented problems in their homes and schools—what today we might call at-risk youth. "There was way more horror in there, in my peers that was there, than there was in my life," said Carlos. "If you in with the tough and rough, then you gotta be tough and rough too, or you gonna go down, baby." He had to adjust to the environment, but, according to him, the experience changed his life. He saw how the old master would have apprentices rushing to light his cigarettes and carry his tools, and, when he swung the hammer, he found a connection with his medium and became committed to his craft. Later he would just say, "I learned from the old guys, in the old days, with the old ways."

In the late 1960s Carlos saw the American film *Cool Hand Luke*, starring Paul Newman. The movie was about an all-white Florida prison work gang and the recalcitrant rebel who defied every rule, earning the respect of his fellow inmates and the enmity of the camp bosses, who eventually shot him dead. "That whole movie is like me," said Carlos, "That's how it went in Germany with me."

He quoted one of the film's most famous scenes. Luke is crouched behind a bush, supposedly relieving himself while shaking a branch to show that he hasn't tried to run away. A guard on a horse with mirrored sunglasses and a ready rifle watches through his scope from the road. "Still shaking, boss!" Luke yells, as the guard fires a few scare shots nearby. The branch keeps shaking, and Luke keeps yelling, until he doesn't. More shots are fired, the branch keeps shaking, but there's no sign of Luke. Realizing that Luke has duped them again, the guards run to the bush, only to find a string tied to a branch, still being pulled from afar by Luke, who by this time has taken a good head start in his break for freedom. In the film, Luke suffers for his independent streak. He takes several beatings, he spends a lot of time locked up in The Box, and he ends up being shot dead in a church following his last fateful run.

Some of the parallels to Carlos were more than metaphorical. At the Johannesberg monastery and youth home, he would work on metal behind the backs of the masters, when he was supposed to be cleaning up around the shop and getting beer. "But I then emulated what I saw them do. I could see what the guy was doing, and I could understand how he'd do it, how

he'd strike, the heat, all of that, I had an instant understanding of it, and then against all the rules and the regulations, start making stuff, and then that was discovered and I got *orfeige* and ass-kicks because I went against the rules, not cleaning up like I was told, fucking around with the fire, this sort of stuff. And I kept doing it, and by the time I made this rose for my grandfather, and they cut it in three pieces and throw it in the trash, and I picked it up and put it back together. And he saw it again, and he took it and ran to the headmaster and said look, 'This is the second time I caught him!'"

The headmaster looked at the rose, and he said, "Nielbock did this?" Noting the craftsmanship demonstrated by the rebellious apprentice, the headmaster nodded his head. "And since that day, they give me the fancy job. So to say, any job with any ornamentation in there, they give it to Nielbock."

After leaving Johannesberg, he entered the German military. "When I got there, they didn't even want to let me on the train for the recruits, because of my curly hair. I had an Afro then, a nice Afro, and they had already identified me as an *ausländer* [an alien, a foreigner]. But I had my recruitment papers, showing I had been drafted. I was the special candidate from the day I got on the train." Eventually, after a few incidents, "I was escorted to the barber, to see that I get my hair cut. I don't know if I can talk through those experiences unless you experience that shit yourself. So I just try to fit in, but I was deemed renitent [stubborn] because of what I did. I was not promotable: against the rules, spoiling the barrel, being the rotten apple, troublemaker, stirring up problems." The desire to be included was opposed, at times, by a suspicion of other peoples' motives: "I have an inquiring mind. I always want to know stuff, and, if I don't get the straight answers, then I'm suspecting something else behind it."

On another occasion, he summed it up this way: "If they impose that much shit on you, the system will try to break you like that, and you got to maintain your integrity."

When he returned to Celle, following his time in the military, he brought with him this new skill and purpose related to metalworking, but he didn't want to work for anyone but himself. According to Marianne, he was always trying to do his work at home, which involved working with hot metal, and naturally there would be fires. Neighbors would look in and say "you can't do this there." He tried running a small business doing his metalwork back in Celle, making custom bird cages and selling them in

Chapter One

Young Carlos displaying his hand-fashioned bird cages in Celle, early 1980s. He was quickly able to make money with his newly acquired skills, but soon found the German craft system too constrictive.
Drawing by Paul Draus, from a family photo.

the local market. "I made money from day one with my metalwork." But it didn't work out because there were too many rules. "There was no getting my shit together in Germany, because of the unforgivable system that only rewards continuous application and continuous refinement of an academic path. You ain't shit in Germany without your papers, man. You going to be at the *Hauptbahnhof* [train station], asking for money."

Carlos and Marianne differed in their interpretation of his treatment in those days. Carlos asserted that the traditional Germans, the leftover Nazis

and Brownshirts, who had gone back into government and civil society, sought to exclude him due to his ancestry; she felt that he exaggerated this, and that his ethnic background never truly impeded him. Marianne said that she knew that Carlos had this feeling, but that he really liked to put it out there, a lot more than it actually was. "*Schauspieler!*," Marianne exclaimed, and then again, banging her hand on the table: "*Schauspieler!*" The literal translation was simply: "Actor!," someone who revels in drama. Another expression Marianne used to describe Carlos and his relation to the world was "*Der Kreis schließt sich*"—"The circle closes." Marianne thought Carlos exaggerated the challenges he had faced in his youth. He was loved everywhere and by everybody in Celle, she said. When Marianne watched the video from Carlos's Twisted Storytellers event, where he emphasized his estrangement from Germany and his connection to his Black father in America, she was disappointed. "He talked as though he didn't have a family." In her view, the situation of isolation that he portrayed was one that he himself created: a drama that centered on him, which he himself directed.

As I thought about these characterizations of Carlos, I was reminded of Don Quixote and the many debates concerning that story's main character: was he an idealistic dreamer or just a selfish old man? ("Crude and cruel" was how Vladimir Nabokov described Quixote in an essay from the early 1950s.) Like the man from La Mancha, Carlos was intent upon a quest that was often clear only to him and from which he was not easily deterred. Carlos certainly had a flair for the dramatic, a tendency toward conflict, and an inclination to see himself as the center of events, whether as a creative force or as a target for resentful others. According to Lithuanian philosopher Leonidas Donskis, "Don Quixote is closely related to the great paradoxes in life. How to sustain our moral code in a world where morality is vanishing? How to sustain noble-mindedness and noble behavior in a world that mocks and despises an individual who tries to sustain such behavior?" (2008, 44). Carlos likewise seemed a character from the wrong time, fighting for a worldview that was either alien or antiquated, often unsuccessfully, but unwilling to ever give in. There also were things he experienced, things he saw, that others around him (including his mother) did not, or could not, perceive.

These specific elements of his background likely contributed to his character and his perspective. First and foremost his ethnic identity placed

him outside of German-ness even as he adopted German ways to the utmost degree: marching with the town militia, called the *fanfare*, learning to play the traditional songs, and being celebrated for his shooting ability. Second was the experience growing up above the Zum Teufel cabaret and seeing the society's hypocrisy on daily display. Third was the monastery where he learned metalwork but also came face to face with the fact that he would probably never be able to work on the big projects, the churches and monuments, until he was old and gray, because of the long, involved process imposed by the guilds: six years as a journeyman, just to work on one's own, and then years of striving within a system controlled by old white men. Finally, there was his experience in the German military, where he felt he was treated like a foreigner with his Afro hairstyle and his attitude.

Perhaps more important than any of these external influences was something deep down in his being that bucked against all forms of constraint. Manuela said that her father Heinz had many ways of describing Carlos, but his favorite was this: "Carl is like an elephant, he picks up the big thing, he is strong in the front, and then he tears it down with his ass." Marianne affirmed this, saying that Heinz often called him "*Elefant im Porzellanladen*," or an "elephant in a porcelain shop." This tendency to sometimes get in his own way, to snatch defeat from the jaws of victory, was something I also witnessed. As his mother would say, "*Das ist Carlos*."

Carlos and Marianne agreed on one thing: that his prospects in Germany were limited, given the mismatch between the structure of society and his stubborn and rebellious independence. No matter what the specific cause, eventually he came to this realization about himself: that Celle couldn't contain him. Everything about the town that had nurtured him was now too restrictive. One night, Marianne received a call from the police, telling her that Carlos was lying on the ground in front of the Zum Teufel bar following a fistfight with a local man. In her mind, this incident cemented his desire to leave the town behind. In the early 1980s, after the death of his adopted father, Heinz Nielbock, Carlos left Germany and set off across the ocean, like the immigrants of past generations. He wanted to go to Jamaica. He got his papers, and he set off on his journey to find the land of Bob Marley. Instead, he found his peculiar destiny in the city of Detroit—along with a host of new and distinctly American challenges.

Chapter 2

WELCOME TO DETROIT

When I visited Celle in 2019, the Zum Teufel bar was long gone. After our initial interview at the hotel, Carlos's mother Marianne showed me the building the bar once occupied. We then drove to her house so she could show me some photos and documents as well as the devil mask made of painted plaster that once hung in the bar, which she kept wrapped in brown paper and plastic bubble sheets on top of her wardrobe. It was a deep red with gold highlights, and there were three naked, dancing women adorning the devil's face. Carlos had wanted to bring it to Detroit years ago, but he was afraid that it would offend some of his churchgoing friends. First among these was Marth Jean "the Queen" Steinberg, an iconic local figure, who would have a profound influence on his life in his adopted country and help him navigate the terrain of both Blackness and American racism.

As W. E. B. Du Bois, the sociological giant of the nineteenth and twentieth centuries, famously wrote in *The Souls of Black Folk*: "One ever feels his twoness, an American, a Negro; two souls, two thoughts, two unreconciled strivings; two warring ideals in one dark body, whose dogged strength alone keeps it from being torn asunder" (3). This "double consciousness" has been noted as a signal characteristic of the Black American experience. It was not produced by any genetic ancestry, but by the lived reality of racism, the conflict between the inner life of people and the demands and expectations of a majority White culture that severely restricted every form of right and opportunity.

In Carlos's case, this inherited doubleness related to racism was compounded by his European upbringing and his adopted American identity, being at once White and Black, German and American. This four-fold Du Boisian split was at the core of who he was and naturally informed how he

Chapter Two

The devil mask that once hung on the wall of the Zum Teufel. Carlos's mother, Marianne, kept the mask wrapped up in her small house in Celle. Drawing by Paul Draus.

saw Detroit, with its own conflicted history and divided allegiances. Though he clearly experienced racism while growing up in Germany, it was wholly different from what he later saw and experienced in the United States. In this sense, he was also reflecting Du Bois's legacy. Du Bois, in fact, had traveled to Germany in the late nineteenth century in order to learn more about his own country. Concerning his own experience as a young student in Berlin, Du Bois (1990) once wrote, "if I had not gone immediately to Europe, I was about to encase myself in a completely colored world, self-sufficient

and provincial, and ignoring just as far as possible the white world which conditioned it" (34).

Carlos's story followed a parallel trajectory—it was an escape from one society's provincial constraints into a new world of choices and challenges. Unlike Du Bois, however, Carlos did not return to reside in his homeland following his foray abroad. Instead, he essentially reconfigured his identity as a Black Detroiter—the son of the father whose absence had defined his early life.

Carlos Antonios Nielbock arrived in New York City in 1984 with stars in his eyes, his hair styled in an Afro, his neck adorned with multiple gold chains. He soon set off on a Greyhound bus to Detroit in search of his long-lost father, Clarence Cheeks. All he had was a letter with an address on Helen Street, located about four miles east of downtown Detroit. He got off the bus at the old Greyhound station on East Congress Street and started wandering around downtown, in the cold of a Detroit winter. Someone took pity and asked him where he wanted to go. He showed them the address, and they drove him to Helen Street, where he arrived at his father's doorstep, unannounced.

According to Carlos, Clarence first greeted him and welcomed him to his home. Then he asked, "When you going back?"

Clarence's version of the story was a little different. When Carlos arrived in Detroit, he said, "I was glad to see him. He had a long, black leather coat on, and he had hair like he has now, kind of wild, bushy. I probably asked him when he was going back, but I didn't mean anything about it."

Though he did not know his son, Clarence could identify with the journey that Carlos was on. He had his own bitter struggles before he ever went abroad. He came to Detroit from rural West Virginia in the middle of the twentieth century, when the city was still booming, arriving like so many others at the iconic Michigan Central Station, then only four decades old. He recounted that moment, and what he carried, when I sat down and talked to him over a corned beef sandwich on Super Bowl Sunday in February of 2019. "I came up here on the train, at the train station here," he recalled. "They had packed my lunch, fried chicken in a shoe box. It was '48, when I graduated, so right around '50-something. I never will forget that. I come in there, with my lunch in a shoe box, fried chicken, jelly sandwiches, and stuff." He didn't talk about the legacy of

the shoe-box lunch, but it was a way for Black travelers to avoid dealing with the discrimination of purchasing meals during the Jim Crow era, to both save money and dine with dignity.

He moved to the Eastside to stay with his brother, in the old Black Bottom neighborhood of Detroit. This was the era of segregation, so even world-famous Black celebrities, such as Joe Louis, the boxer, who knocked out Nazi champion Max Schmeling in 1938, lived in the ghetto. Clarence remembered seeing Joe Louis and other local luminaries in the neighborhood. Clarence worked at a place called Lakeview Barbecue, and sometimes he used to walk up Hastings Street, where he remembered getting pulled over by the Big Four, a notorious unit of White police officers, big as football linebackers, who were given free rein to terrorize Black communities. Clarence would always tell them he was on his way to church.

"Black people used to not be able to go over to the other side of Belle Isle," he said, unless they had a job or some other "legitimate" reason to be there. He remembered picking up Pfeiffer G-I-Q (General Imperial Quart) beer bottles and returning them for a nickel apiece. Pfeiffer was a brewery located at Beaufait and Sylvester, one of the three leading sellers of beer in the post-Prohibition period, behind Stroh's and Schmidt's. Later he worked at Falcon Show Lounge on Gratiot and 7 Mile, and then at Plymouth Motor, located where the Parade Company is now.

Though discrimination was a daily fact of life in Detroit, when Clarence went abroad as a soldier, he carried the promise of America with him and generally experienced better treatment from White people abroad than he did at home. Famous Black American artists like Josephine Baker and James Baldwin continued to reside in Europe throughout the postwar period because the pressure of daily racism was so much less severe than it was in the States. All four branches of the US military were fully integrated by 1954, meaning they no longer officially practiced racist segregation. According to the Library of Congress, "The fight against fascism during World War II brought to the forefront the contradictions between America's ideals of democracy and equality and its treatment of racial minorities" (2014).

As a military police officer stationed at an airbase, Clarence had access to decent income and a car, and he was able to buy gifts for young Marianne and take her out on the town. He was a good dancer, and he used to regularly go to Celle, along with a Puerto Rican soldier named Tony Torres, who also

Clarence as a young man in Celle, playing bongos at his cot. He worked as a military policeman but in his off time enjoyed dancing and nightlife. Drawing by Paul Draus, from a family photo.

liked to dance. They were regulars, a big hit among the locals, with their sharp uniforms and their polite ways. When I met Marianne, Carlos's mother, in April of 2019, I asked about Clarence's dancing, and she said, "Yes, he was fabulous." Then she laughed, and said fondly, "Love Me Tender," thinking of the association with Elvis Presley and all things American. Clarence, like other American GIs, frequented the Zum Teufel, and that's how he and

Marianne met. He was known there by an affectionate nickname: "Chanel #5." Clarence told me that they would go to a place that he called "Silver Sea" (*Silbersee* in German), a lake located in Lower Saxony. He said that he would talk "off-beat German and she would talk off-beat English, that's how we communicated."

When I met Carlos's sister, Manuela in Frankfurt in 2018, her account of the relationship between Clarence and Marianne was even simpler and more direct: "He didn't speak any German, and she didn't speak any English. But you don't need to speak to make love."

Though romance between young people is one of the oldest human stories, their relationship had added significance due to the social and historical context. According to historian Timothy Schroer, "The presence of African Americans in the force occupying the defeated Third Reich represented a further object lesson in establishing that blacks were not racially inferior to Aryans or other whites" (2007, 133). For their part, African American soldiers found in occupied Germany a place refreshingly devoid of the kind of everyday racism that they experienced back home in the United States. Schroer notes, "the presence of black soldiers and their pursuit of sexual relations with German women stood as a singular occurrence in the struggle for racial equality" (132). When Richard Loving (a White man) married Mildred Jeter (a Black woman) in Virginia in 1958, they were prosecuted for violating the US color line and sentenced to a year in jail. Though the case went all the way to the Supreme Court, anti-miscegenation laws were not ruled unconstitutional until 1967.

The relationship between Clarence and Marianne was no secret in Celle in the late 1950s. In fact, Clarence was well liked by people in town and by Marianne's parents. They had two children together before the US military caught on and relocated Clarence, forcibly separating the young family. Carlos was the oldest child and was named after one of Clarence's friends in the military. Manuela was named after a song that Clarence and Marianne used to dance to, a popular Italian ballad recorded by Rocco Granata in 1959. They wanted to be married, but she was too young and her parents would not give necessary permission. According to Marianne, her parents said that, if the love was that great, Clarence would come back to Germany. For Clarence's part, he stated that the military intervened whenever he tried to do so. "They shit-canned all my requests."

Welcome to Detroit

The young family in Celle, Germany: Clarence and Marianne's relationship was no secret, and Carlos was a happy child. Drawing by Paul Draus, from a family photo.

Clarence and I were sitting on the first floor of Carlos's home and workshop in Detroit, talking about events from the middle of the past century, and I asked him how he felt about the young family he had left behind in Germany when the Army relocated him. Clarence paused thoughtfully and said, "Manuela thinks I don't love her, but I do. I used to send money. We used to correspond. I used to write to Marianne, and she would write me back." After he tried and failed to marry her, he was transferred back to Wurtsmith Air Force Base, in Oscoda, in northern Michigan. He reminisced about that as well, "There were only three blacks there. I used to run with all them Indians. I liked it up there."

Clarence returned to Detroit after leaving the military, and his life went on. Though he wrote letters to Germany, he was not able to return.

He went to work for the City of Detroit and settled back on the Eastside on a block of Helen Street where many of his extended family members also lived, but he never married. When Carlos arrived, as a young man in his twenties, he was swimming against the tide. According to common cultural (meaning White) perception, people weren't moving to Detroit in 1984. On the contrary, they were leaving in droves. According to Barry Petchesky, writing about the riots that followed the Detroit Tigers World Series victory that year, "Detroit was a strained and dying city in 1984." In remembering this era, Carlos repeated a common line, "It was like, 'last one out, turn out the lights.'"

To be fair, the 1980s was a bad decade for American cities in general. Gerald Ford had famously told New York City to "drop dead" just a few years earlier. With Ronald Reagan's election in 1980, the hammer came down even harder. Block grants and welfare benefits were massively cut, further entrenching urban populations in poverty, driven by the rationale that such withdrawals of assistance were actually helping them by forcing them to become more self-reliant.

Meanwhile, depictions of urban life grew even more negative. In 1981 the film *Escape from New York*, starring Kurt Russell as the violent antihero Snake Plisskin, portrayed the nation's largest city as a giant prison colony, and in 1982 Ridley Scott's *Blade Runner* envisioned twenty-first century Los Angeles as a neon-lit, rain-drenched cesspool defined by inequality and corporate corruption. No city figured more strongly in narratives of urban decline than Detroit, which had its dystopian moment in 1987, when Paul Verhoeven's *Robocop* depicted a future Detroit abandoned by all but the most violent and criminal elements.

Racism was a big part of this picture, both in terms of the reality and the perception. Though often left unstated in accounts of "urban decline," you couldn't escape the simple fact that most White people didn't want to live around Black people, and they voted with their feet, as the economists say. Even worse, they couldn't seem to stand the fact that Black people were claiming power for themselves.

When *Robocop* came out, I was a young man living in Chicago. Harold Washington, Chicago's first Black mayor, had just been reelected after spending four years fighting an intransigent city council (Thomas, 2017). This era was comically memorialized by the comedian Aaron Freeman in

his *Council Wars* satire, in which the dashing Harold Skytalker took on the nefarious Darth Vrdolyak, named after the old-school alderman, who actually represented my grandmother's neighborhood on the South Side. Harold, an eloquent former prizefighter, eventually prevailed over Vrdolyak and his minions on the council, but he tragically died of a heart attack, in his office, that November.

Coleman Young, Detroit's first Black mayor, was elected in 1974, narrowly defeating the White police commissioner, John Nichols, in a contest largely defined by issues of White police violence. He consolidated his power over time, but he did so against tremendous resistance. Known for his colorful quotes, Young once offered a diagnosis of the real problem afflicting the city, stating: "Racism is something like high blood pressure—the person who has it doesn't know he has it until he drops over with a goddamned stroke" (McGraw, 2005). By the time Carlos arrived, Young had been in office for ten years, and Detroit had become a Black majority city, not because the Black population grew significantly but because more and more White people left. Former Detroiter George Clinton and his legendary funk band Parliament released their classic anthem "Chocolate City" in 1975, proclaiming, "We didn't get our forty acres and a mule, but we did get you." The song was mostly about Washington, DC, but it had clear relevance for Detroit, which was the biggest "Chocolate City" in the country.

Opposite this image of Black political power and cultural pride emerged an implicitly racist narrative of urban decline. Ze'ev Chafets's 1990 book *Devil's Night and Other True Tales of Detroit* told a story that had already been solidified in the public imagination through a decade of disinvestment and negative media coverage. A representative passage from Chafets set the tone for many years of negative coverage to follow: "Detroit today is a genuinely fearsome-looking place. Most of the neighborhoods appear to be the victims of bombardment—houses burned and vacant, buildings crumbling, whole city blocks overrun with weeds and the carcasses of discarded automobiles" (164). This image of a nightmarish urban landscape was red meat for White fears, justifying the abandonment by effectively blaming the remaining mostly Black residents. According to Thompson (1999): "As the city grew poorer, its social deterioration escalated, setting in motion a vicious cycle of greater white antipathy toward the inner city and, in turn, greater social malaise" (164) More than two decades after Chafets,

journalist Charlie LeDuff (2014) echoed these sentiments, writing: "And when normal things become the news, the abnormal becomes the norm. And when that happens, you might as well put a fork in it" (129).

Tragically for Black Detroiters, the expanding vista of the 1960s and 1970s soon collapsed into a diminishing window, as jobs and opportunities fled to the suburbs and abandoned buildings burned. Arson was fueled by White flight, as now-absent owners also relocated to the suburbs and sought to recoup their investments through insurance claims. The drug trade moved into many neighborhoods and cycled through abandoned structures with a destructive ferocity. Peter Adler's *Land of Opportunity*, published in 1995, chronicled the rise and fall of the Chambers Brothers, the legendary Eastside family, who brought corporate sensibilities to the street drug trade, turning apartment buildings into crack cocaine factories and purveying the resultant rocks in small, cheap, and convenient packages designed to let poor people enjoy a quick, intense high and keep them hustling for more. Devil's Night thrill-seekers, many of them White suburbanites, only compounded the problem, granting sensationalist headlines to news outlets eager to feast on the spectacle of a city's slow, painful, and greatly exaggerated death.

How strange must Carlos have appeared in this context, arriving on a bus with his green eyes, his minimal English accented with German, his disco clothes, and his baroquely antiquated skill set of traditional metalwork? For Carlos, Detroit was a revelation. "I had never seen so many Black people before," he said. It was a place full of cultural pride and a sense of possibility. He entered a scene of tumult and excitement, defined by strong communities fighting to hold it together. This was the flip side of the story, visible only from the perspective of Black people, who finally had the boot of the notoriously abusive "Big Four" police unit removed from their collective neck. Like the Chambers Brothers, who had arrived on the Eastside in the 1980s and pursued their own dream of success by building a crack cocaine empire, Carlos envisioned opportunities where others saw only a scene of disaster. "I first came here on a tourist visa, to look for my dad, and I stayed for a full length of three months. The minute I saw everything here, from downtown to everything, I just loved it, and I know I got to try myself here."

At the same time, there was a lot for him to figure out. America was not all that it seemed to be from Cold War Germany. "I was so impressed by the

United States, and it was so different than I stereotypically experienced it, you know, from what I saw in Germany, from TV, about America. I had no concept about social economic turmoil. I didn't have that. The only thing I know from America was Westerns, *Streets of San Francisco*, and *Dallas*, with J. R. Ewing. So that was a tough thing to understand. But I also know that my vehicle is the work that I am performing, the metalwork, that was true in Germany, that would be true here too." The America of *Dallas*, populated by wealthy White people wearing ten-gallon hats and trying to succeed at all costs, was a far cry from Detroit. With his artisan's eye Carlos could see the glory of the art deco and industrial age masterpieces that adorned the city, but in the fight for survival, such objects were nothing but niceties. When he met his cousins and told them about the work he did, the fine metal gates and elaborate ornamental ironwork, they quickly told him, "Nobody has any money for that here. You've got to go to Hollywood."

"I was hanging around right here," he recalled, "Trying to get some orientation, and every person that I showed my little portfolio to, and was able to explain what I do, especially the ones of my family, told me that there are no rich people here, and I need rich people to buy my stuff, and for me to find rich people I got to drive to Hollywood, to go to California." So off he went: "Of course, the first thing I got is a car and drove to Hollywood. It took four days, and I was there." An immigrant of color, a stranger in a strange land, he joined the other immigrants standing in line in Los Angeles and made his way alongside them as he always did, working with his hands. Because he had a German mechanic's license, he was able to work on luxury vehicles, of which there were many in Los Angeles. "Back then," he explained, "if you had a foreign car, import car, you couldn't bring it to a regular car dealer, you had to go to a special car shop. I looked at all the German import car people, Volkswagen, Mercedes, Porsche, all this stuff, and I introduced myself, say you have a job? I did that part-time, so I had some more time to hang around."

Carlos's hustler instinct kicked in while living on the fringes of LA, and he identified another need: providing automotive first aid on the city's chaotic freeways. "I had a whole trunk full of jumper cables, oil, so whenever I saw somebody break down, I stopped and helped them, and people was all happy for me to come and stuff, and I made a lot of friends. People showed me LA and showed me what they do, and it was a real great thing." A

constant learner, Carlos absorbed information about the furniture makers and the wrought-iron business that existed in LA, which was completely dominated by Mexican artisans.

After a year, he had reached his limit in LA and thought he was burned out on America. "It was a tough thing altogether," he said. "I was so through, oh my God, I was done. I called the embassy and told them I'm here on a tourist visa. I want to get home. I'm through. I want to go home to Celle town." But the plane ticket sent by the German Embassy was from Metro airport in Detroit, not from Los Angeles. "I had to ride back on Greyhound, broke as hell, no money. By the time I came to Detroit, it was the middle of the night. I was trying to just do a few hours and then go home." The only place he knew was the old house on Helen Street, where Clarence stayed, and there he was able to sleep. Then, from the pit of his broken-down, depths-of-night despair, he woke up to bright sunshine, and his father's city somehow spoke to him. "He had a rose garden in the back, with his plants, his little gnome sitting there and stuff, and it looked so beautiful, and full of tranquility, and it was cool, and I changed my mind again, like that."

Instead of getting on a plane and going back to Germany, he remained there on Helen Street in Detroit and began looking for jobs the very same day. By then, he knew the terms to search for in the Yellow Pages: *ornamental iron, wrought iron, welding*. He found a job working for a metal supplier with a whole warehouse of work to be done, with ample tools and equipment just lying around dormant. The guy didn't know what to make of Carlos and his German accent, but he said, "Go ahead, show me what you can do, find the equipment." So that's what Carlos did. "All the equipment was there—old anvil, old fireplace, all this stuff, but now it was not really being used anymore, because they [were] using punches and electric welders and modern stuff, so the old equipment was like laying around, you know. So I put a little blacksmith shop together, with the forge and a worktable and this and that, and started making wine racks, and little gates, and sculptures, a seagull and all kinds of real good stuff."

Impressed with his work, the supplier took some of Carlos's pieces and started selling them. "I was working for four dollars and fifty cents an hour then. And since the guy was the general supplier for all the other welding shops, a lot of fabricators came there and bought their stuff, and he would

say, 'Look what this Nielbock guy can do.'" The supplier took Carlos's work to the National Ornamental Metal Association (NOMA) and showed it at the annual convention, where it won a Gold Medal. As a result, Carlos was given a raise of fifty cents, bringing his wage to a whopping five dollars an hour, placing him on near-equal footing with his White coworkers. "I was able to maintain myself amongst all them trailer park hilly-billies—oh my God, the worst kind—because of the work that I was doing."

Along with a hustler's edge, Carlos also had a nose for a raw deal. "I was expecting more than fifty cents, for sure," he said. As in Germany, his inquiring mind began asking questions. He really got upset when he heard what some of his coworkers were saying. The boss, they shared, was going around telling people "that he got a dumb German working in his shop that do a bunch of good metalwork for him, for pennies." Carlos approached the boss and asked, "Is that right?" He began to learn the ins and outs of how the business worked. He found out that contractors could make a lot of their money on what they called "fancy work." These were often ornamental metal railings and other architectural accoutrements, installed in historic districts of affluent suburban communities like Grosse Pointe and Bloomfield Hills. These kinds of jobs required skills that went beyond the scope of most metal suppliers—skills that Carlos possessed. Soon he learned how to make his own deals with these contractors to come in and do this work for them at a higher rate of pay.

"I did this a few times, until I got this job. It was a whole big railing job. It had fell over; it was buried for many years in the mud, and it was thin and corroded, and so I fixed the whole thing, made it all nice and good again, and I got $14 an hour to do the job, and it took about a month or so to do it. Come to find out that the guy got $35,000 for the restoration job, and it was the railing that prevented people from falling into the Rouge River, beyond the waterfall." Without knowing it, Carlos had been working on the Ford Fairlane Estate, the former home of Henry Ford and his wife Clara, located in Dearborn, Michigan—one of the premier historical sites in the area. Though he was now making considerably more than $5 an hour, it was still pennies compared to the overall price charged for the job. This was another lesson for him.

"I couldn't do anything about it, but I made that as my reference point," he said. The $14 per hour arrangement was better than the deal he had before,

but he now knew he had to learn how to be in business for himself, to not be taken advantage of anymore. "I went to a number of so-called consultants and crazy stuff, just to understand that there are a lot of people talking a lot of crap out here who really don't know. So that's where the Small Business Administration came in, and I understood the order and the rhyme and the reason, the understanding about where I'm located, where I'm situated, what's going on, the Empowerment Zone, all this whole stuff going on with Coleman Young, and Ronald Reagan, and the whole shit right there, and all I want to do is work for the White House and do some crazy metalwork so I can get paid good, you know? So that was the eighties." It wasn't quite the world of *Dallas*, but Carlos was learning how to succeed in the trenches of American capitalism.

Back on Helen Street, he moved into an abandoned house owned by his father and began fixing it up. He carried buckets of water from another neighbor's house and lived without heat for a year. He set up his anvil in the kitchen, and the neighbors would see the fire dancing through the windows at night and think the devil was hard at work. His first project was repairing a railing in the Palmer Park mansion of Levi Stubbs, the legendary lead singer of the Four Tops, one of Motown's most famous musical acts. Stubbs's baritone voice was immortalized in hits such as "Baby, I Need Your Loving" and "Reach Out (I'll Be There)," which he performed on the *Ed Sullivan Show* in 1966. Later he provided the voice for the monstrous carnivorous plant in the 1986 film version of the off-Broadway musical *Little Shop of Horrors*.

Stubbs had lived his whole life in Detroit, and he represented a kind of local royalty—exactly the kind of client Carlos was looking for. The job had been started by Carlos's previous employer, the metal supplier, but he hadn't finished it because he didn't have anyone with the skills to do so. As Carlos recalled, "I got a call out of the blue, asking if I could fix a railing that somebody started. And, so I took a look at it and told him I could fix it no problem. He was driving around in his Rolls Royce there, Levi Stubbs, and it was a different atmosphere back then, and I was able to hire my first guy, my first cousin, and I did this job, and it got me a couple of thousand dollars, in one hand, boom-bam!"

From there, word started to spread around town about the talented German metalworker living in the dilapidated old house on the Eastside. His second big job was working for a Presbyterian church on East Jefferson

Avenue. They rang his doorbell, saying they needed a cross. "They give me the job, so I made this cross, forged it, and I bought all the equipment from the flea market: the welder, the vise, bought some other stuff from the pawn shop. I was able to buy all this stuff cheap. And I did the job in the backyard, over by Clarence. It was hot as hell, and I put a blue tarp up, so I had protection from the sun and rain." The cross is still there, standing in front of the church on Jefferson Avenue, in the Indian Village section of Detroit, an area formerly populated by auto barons and other members of the city's early twentieth century elite.

It was around this time that Carlos received his most momentous visitor, the person who changed his fortunes and his life. "I got a call, and some guy came to the building, and it was Martha Jean's chauffeur, and he told she wanted to talk to me." The name was pronounced with an expectation of recognition. At that moment, Carlos didn't really know who Martha Jean was, but he had noticed that everybody in the community listened to the same radio show, at the same time, every single day. He described the scene: "Everybody listened to Martha Jean radio, on 1400 AM. At 6 o'clock, there came blues; Jay Butler played blues until late, late night, and Clarence and all his buddies, after work, they partied, went to the store to get a little drink on, and congregate there, on the riverfront or they had different places where they congregated, but they all listen to this one radio station. It became like a thing that you listen in on, so I knew the voice, she had this particular voice."

Originally from Memphis, Tennessee, Martha Jean Steinberg moved to Michigan in 1963, after establishing herself there as "the Queen." According to her daughter, Diane Steinberg Lewis, "We had nothing, but what we had of ourselves, was to name ourselves, so we became Count Basie, and Duke Ellington, and the Queen of Soul, Aretha Franklin . . . they gave themselves royal names, and when you speak that name and you claim it, you become that in your spirit, so it's very important what you name your kids, what you call yourself, or what you let other people call you. So that's my mom, Martha Jean the Queen—the Queen of Detroit, who was on radio from 1953 until 2000" (Bjärgvide, 2021). She worked for a radio station in nearby Inkster before relocating to the city of Detroit in 1966. She was the first African American woman in the nation to own her own AM stand-alone radio station. While she began her radio career as an R&B disc jockey,

Chapter Two

her real devotion was to gospel music, and in Detroit she soon became a revered institution.

In 1967, during the urban disturbance that reduced parts of Detroit to ruins and resulted in the activation of the National Guard, Martha Jean famously remained on the air for forty-eight straight hours, calling for peace in the streets. She later became an ordained minister, and by the late 1980s she was nothing short of a saint in the eyes (and ears) of many Detroiters, even conducting large group baptisms in the Detroit River. This context helps one to appreciate the significance of her visit to the humble unlit house on Helen Street. Carlos described her arrival like that of an angel alighting from on high.

"I was working out of the house, like *Sanford and Son*; I had my welder that I bought, and I worked at nighttime, 2 o'clock in the morning, all kinds

Martha Jean performing a baptism in the Detroit River. Drawing by Paul Draus, based on a photograph by Tony Spina, Walter Reuther Library

of blue light came out of my house, you know, and crazy noises, like the anvil, BING! So people thought, like, I'm nuts in there. When they passed down the street, they crossed the street, going to the other side of the sidewalk. It became a curiosity, and it got around to Martha Jean. And she wanted to talk to me, so she came to the house on Helen Street, and all the neighbors almost fell off their porches." As a celebrity of local radio, Martha Jean was familiar to all, yet distant. She wasn't someone that people expected to see on the street. "All of a sudden she poppin' up in the neighborhood, with a limousine, and a driver and all of that shit. She came to the house, looked through my little makeshift operation right there, and she had a handkerchief in front of her mouth like that, because I had kerosene heaters in the joint, it wasn't no heat there, no water, or anything."

Word had reached the Queen about the mysterious blacksmith, a Black man from Germany, and she wanted his advice in designing a Christian theme park featuring sculptures of figures from the Bible, to eventually be built in Las Vegas. She had heard about a German woodcarver in the town of Frankenmuth, located near Flint, Michigan, and wondered if Carlos would go with her to see him. Frankenmuth had utilized its German immigrant heritage to become a statewide tourist attraction. (It also briefly appeared as a proposed solution to the deindustrialization and economic collapse of Flint in Michael Moore's 1989 film *Roger & Me*.) Since he was a genuine German craftsman, she thought that Carlos might be able to fabricate similar work. He agreed to go, and Martha Jean and her chauffeur picked him up on Helen Street. They rode out to Frankenmuth, where he saw the prefabricated products of the tourist woodcarver. Needless to say, Michigan's ersatz Bavaria didn't impress the native of Lower Saxony, but he accommodated her interest, and the encounter led to a long-term relationship and a lasting regard for the Queen. Martha Jean understood some of the technical aspects of sculpture and figure-making, and she took his advice about avoiding the woodcarver.

To return the favor, she asked Carlos, "What can I do for you?" He replied, "All I want is work." He then made several tables for her, with Detroit's distinctive Pewabic tile, to hold her sculptures and her angels and things, and she introduced him to her daughters, who ran the Home of Love Ministry on Grand River Avenue. "They wanted me to stay there with them, more protected and not living without water or whatever," he

said, "but I couldn't leave my tools, because they would all be gone the next day." But they began to look out for him, checked up on him regularly, and gave him some work. He went to their church, and he started listening to Martha Jean all the time, just like everybody else in the neighborhood.

Beyond the economic and social support she provided, Martha Jean offered Carlos a fresh perspective on the majesty and tragedy of the Black experience in America. "It really helped me to understand the cultural relevance, the cultural ground that I'm on. It gave examples of stories, when people called in, to talk about their struggles that they going through and this gospel, the Black church's power to overcome all of those obstacles, and it revealed something, and that's how I had a real great understanding of how this Blackness works here in Detroit, and I identified with that to a great extent, you know." Here he paused, considering the complexity of the situation, and his own installation within the greater matrix that was America. "But I cannot surrender to those circumstances. I tried to master the circumstances; I tried to work with them into my reality."

For Carlos, Detroit was a history book full of lessons. From the perspective of the Black community, these lessons were not necessarily hopeful. Black people, in his view, had been ground down by stony, outward circumstances, shaped by openly malicious racist intent, for the entirety of their residence in the country—which is to say, from its very beginnings. They didn't expect the system to give them much more than possibly the means to survive, and this resulted in a kind of fatalism. While he embraced the Black community and fully identified with their struggle, he flat-out rejected the idea that there was no way to overcome one's circumstances. Perhaps it took a man accustomed to working with metal to believe that the unyielding realities of life in 1980s Detroit could also be bent to one's benefit.

Although Carlos had experienced racism growing up in Germany, Detroit was very different. In both places, he knew that he didn't quite fit into the pre-existing order, and often he had to figure it out the hard way. As he said, "All those people that look like me, mixed-up people, try to insert themselves in the White society, had a harder time than me trying to be Black in a Black community." Martha Jean, who was herself of mixed parentage, became a kind of Northern Star. In fact, when I asked him about his relationship to the story of *Don Quixote*, he directly referenced Martha Jean. "*Don Quixote* is the saga fairy tale that everyone in Germany knows.

I even got my Dulcinea, that's Martha Jean, the virtuous woman." As a woman who had made a transition from entertainment to religion, becoming a moral and political figure in her adopted city of Detroit, she presented a template for Carlos to follow. "It's the biggest story of redemption that I heard," he said. "I was fucked up when I came. I was ready for redemption."

In a few years, the Helen Street house was restored, with help from Clarence's cousins and the neighbors, whom Carlos employed with his own earnings from his biggest job to date: the restoration of the majestic Fox Theatre. A glamorous movie palace originally built in the 1920s, the Fox had fallen into disrepair by the late twentieth century, as had many other buildings of its type and vintage in American cities. Little Caesar's Pizza magnates Mike and Marion Illitch purchased the building in 1987, and its restoration began shortly thereafter. An unknown immigrant with no connections would seem to have little chance at winning such a contract, but Carlos took the coaching he had recently received from the Small Business Association and his newly printed business cards, embossed with the name C.A.N. Art Handworks, a rough English translation of *Kunsthandwerkstatt Nielbock* (the name of the company he started in Germany), and he made his pitch.

"I got proper, you know, I had a suit and a tie, and a business suitcase, and I came correct, and I walked there and I told them, 'I'm Carl Nielbock, and I'm here to do the metalwork.'" Rather than throwing him out, they pointed to the original big blueprint drawings of the Fox Theatre and asked if he could make any sense of them. Carlos knew what to do. He had learned this from his training in Germany. "I had to take one look at the drawings, and it all like fall right in place. It all make sense to me, this bas relief, this repetitive pattern, it's beautiful, it's like somebody play an instrument, and all of a sudden you see the right notes to the instrument, you know what I'm saying?" He marveled at how things had been made in America, how it was even possible to do something that was so small and filigreed and beautiful and produce it in a scale so that it could cover a whole skyscraper. "By the time I got a couple of pieces and produced a sample, I was 100 percent confident that I can do the whole Fox Theatre, no problem." Carlos and his confidence won the job, and it helped to put him on the map in his adopted home city.

Eventually Carlos moved out of the house on Helen Street and bought a three-story brick building on Wilkins Street, just outside the Eastern

Chapter Two

Carlos working on the metal work restoration of the historic Fox Theatre, circa 1992.
Drawing by Paul Draus, from a newspaper photo.

Market, where he now resides. Sitting with me on the first floor, Clarence and Carlos talked about the condition of the building, a former paint warehouse, when they got possession of it. He described it as "burned out on one side, a rope hanging out so people could climb in and out, alcoholics and heroin users and prostitutes hanging out in the alley 24/7, every type of degrading human behavior taking place, hundreds of whiskey bottles scattered through the grass." One day Carlos had his truck parked outside, and someone set it on fire as part of the then-infamous annual ritual of Devil's Night. But by the time he and his crew of family and friends finished working on the building, it was a three-story working and living

space, inhabited by Carlos's multitude of expanding projects and interests. Eric Froh, a young man who moved to Detroit with a fine art degree from Western Michigan University, began working with Carlos in the early 2000s. Once he saw what Carlos and his crew had created on the Eastside, he set his sights on the same: "I saw what Carlos had built, and I wanted that shit for myself."

The challenging circumstances of the city bore down on Carlos and simultaneously buoyed him. He had fought against barriers of prejudice, language, and poverty and had personally prevailed, but his larger struggle was against the circumstances themselves. That fight, to bend reality to match his own vision, to make things that would last against the forces bearing down, was the one that drove him. When I met Carlos, around 2010, these early glories were long in the past. A series of other struggles and triumphs were to follow, both for the city of Detroit and for its passionate adopted son. By the late 2010s the house on Helen Street that Carlos had restored while doing his first big jobs at the Fox Theatre was abandoned again, lost to foreclosure when the employee he gifted it to couldn't keep up with payments.

In 2019 we toured the remains of the workshop in the backyard together. A steel bench and vise still stood there, rusting. A forest of tangled growth had invaded the small space and was pushing in through the gaps in the walls. "I made a million dollars in this house," he said, as the summer sun streamed in through the corrugated plastic that covered the still-solid wooden frame of the work area. "That isn't coming down," he said, as I pushed against one of the beams. "My uncle and I built that. It will last a hundred years."

Chapter 3

CRAFTSMAN AND CONTRARIAN

We were sitting on the raised platform that occupies the center of Carlos's Detroit domicile, an inner sanctum three stories above the street, populated by an army of African bronzes in the shapes of kings, queens, clerics, and warriors. He was sinking into his favorite sofa, facing an oversized flat screen TV in an ornate wooden cabinet, playing a constantly rotating series of seventies soul, reggae, rap, and history videos in English, German, and various other languages. Carlos was in one of his "deep couch" moods, loaded up to pontificate, and the TV provided an animated backdrop to his thought process. His English was imperfect from a textbook standpoint, but it was nonetheless precise and personalized. He molded the words to fit his meaning, forming his own phrasings, a distinctive vocabulary that he effectively mobilized.

"Germany is an old society, a community of thinkers and inventors. That's what they pride themselves in, and even on a lower scale—economic and social—people are thinking comprehensively," Carlos said. Then he contrasted this image of German culture with his view of mainstream American life: "Over here you're just a consumer, like a cow. Eat, shit, drink, sleep, and the next day, over and over again."

His statements effectively captured the contrast between Carlos's ideas about Germany and the United States, while also illuminating a conflict within his own character. In each culture, there were things he admired and things he disdained. The German mode of thinking, of approaching the world in a *comprehensive and thoughtful way*, as he called it, was clearly something he valued, in contrast to bovine American consumerism. On the other hand, the constraints of German rules and traditions chafed at him, to the point where knew he needed to leave.

Chapter Three

Deep couch surfing: Carlos, with bronze busts behind him, holds forth from his favorite sofa. Drawing by Paul Draus.

In a short online video, produced for a crowdfunding campaign to support one of his many projects, Carlos had described his younger self this way: "I was a very charged young man, and when I was introduced to the skilled trades by me observing an old guy putting iron in the fire and beat[ing] it into a shape that end[s] up to be a beautiful scroll, I was so fascinated, and that's kind of what I inspire to." These unintentional malapropisms—*inspire* instead of *aspire*—somehow amplified his meaning. Inspiration was what he had received from his exposure to the metal arts, and he aspired to share this spark with others.

But the spark of his creative imagination was often produced by striking out against the stone of the ordinary and orderly. Because he was raised in a small German town, by German parents, he grew up with all the local traditions. Despite the African American heritage that marked him, always, as an outsider, he carried those old-world sensibilities, instilled through years of socialization and experience. "I was in the town militia, the *fanfarenkorps*, and I was pulled into the demonstration, blowing my horn. I didn't know what the fuck was going on, but I was always surrounded by people asking questions, thinking critically."

The skilled trades, specifically metalworking, had saved his life, and he wanted to offer that option to others, especially to those who were not (in his words) academically inclined, but who could work wonders with their hands if given the chance. American society had no place for manual arts as Carlos conceived of them—its conceptual categories were too limited, too binary. Matthew Crawford, in his book *Shop Class as Soulcraft*, criticizes the false opposition of mental and manual work, arguing for a reunification of "thinking and doing." The over-intellectualization of education, Crawford maintains, has led to a deficit of practical problem-solvers. He writes, "The repairman has to begin each job by getting outside his own head and noticing things: he has to look carefully and listen to the ailing machine" (2009, 17). Later in the book, Crawford states, "I believe the mechanical arts have a special significance for our time because they cultivate not creativity, but the less glamorous virtue of *attentiveness*" (82). This also means having an awareness of the hard edge of the world, and the limits it imposes. Richard Sennett makes a similar observation in *The Craftsman* (2009): "That you might have a neurotic relationship with your father won't excuse the fact that your mortise and tenon joint is loose" (27).

The attentiveness needed to join two pieces of metal, such a simple task in the hands of a master, was painfully apparent to me as I knelt and dropped the hood of the welding mask. I touched the rod to the steel until the arc sparked like a miniature star and the molten lines began to spatter and pool. Depending on your degree of coordination and control, this might result in a neat, zipper-like seam that could easily be smoothed with a grinder, or a bunch of ugly warts that need to be ground off before the final product looks presentable. After letting me struggle for a few minutes, Carlos kneeled and effortlessly placed the neat tacks, dime-sized drops linking two formerly

separate pieces of metal that he needed to hold the structure of the sculpture together—zip, zip, zip. He wasn't wearing a hood. I asked him why not.

"I'm not looking at it," he snapped. "What do you think I am, a moron, eh? That shit will burn the back of your retina." To another young man, who was in the shop grinding metal without safety glasses, he offered similar harsh but mindful advice, "You get one of them metal pieces in your eye, it'll never come out, it'll cool down and sit in there like a fishhook." As Crawford writes, in a section on "Agency Versus Autonomy": "In any hard discipline, whether it be gardening, structural engineering, or Russian, one submits to things that have their own intractable ways" (65). Metal as a material was malleable but deadly, and Carlos would always remind me of this, saying simply: "This shit can kill you."

Arc welders work by channeling a high-voltage current of electricity across a gap with such intense heat that the metal on both sides melts and pools together, becoming one. To do this, you must respect the elemental powers that you are unleashing. The welding rod burns down quickly, as the arc consumes the coating and metal becomes liquid. In that diminishing gap of space and time is where art occurs. It is a little like holding lightning in your hand, with the power to bind elements, turning solid to liquid and back again, making something new in a process that is barely under your control. It was no accident that blacksmiths were envisioned as gods in several mythologies, from the Greek deity Hephaestus to the Yoruba spirit, or Orisha, known as Ogun. Wole Soyinka described Ogun as "the master craftsman and artist, farmer, warrior, essence of destruction and creativity, a recluse and a gregarious imbiber, a reluctant leader of men and deities" (1976, 27). Mythologically, Ogun was a mediating figure, connecting the world of gods and humans, an "explorer through primordial chaos, which he conquered, then bridged, with the aid of the artifacts of his science" (30).

Carlos had been the first one to tell me about Ogun, and he seemed to display some similar characteristics, most notably the dynamic merging of creative and destructive tendencies associated with the mercurial deity. In Soyinka's interpretation of Ogun, this derived from his origins as a being torn asunder and lost in the void, who then reassembled himself through force of will and creativity, manifested in his technical skill, his craft. Perhaps Carlos's character had also been forged out of his early experience—most notably the trauma of separation from his father.

Craftsman and Contrarian

In the Yoruba mythos, Ogun was both artist and warrior, a mediator between primordial chaos and the practice of craft discipline. Drawing by Paul Draus.

Whatever its sources, he was a contrarian to the bone, and this made his own quest for legitimacy and acceptance more difficult. Not satisfied with the metal repair jobs that could pay the bills but would always beat him down, as he said, to "the lowest common denominator," he aimed for loftier targets. It wasn't enough to design and repair elaborate gates for wealthy patrons in the suburbs; he wanted to bring the rewards back to Detroit and spread them around the community that had nurtured him since his arrival in the 1980s.

Despite his criticisms of American consumerism, Carlos was no anti-capitalist. This sometimes placed him at odds with others in his social circle, which included associates of the late activist-philosophers James and Grace Lee Boggs. A Chinese American woman born in Rhode Island, Grace Lee earned her doctorate in philosophy at Bryn Mawr and then became involved in radical politics in 1940s Chicago, where she met the Marxist cultural critic C. L. R. James. After moving to New York, she met her husband, the radical union organizer James Boggs, and they settled in Detroit in the 1950s. At the time, Detroit was the center of American industry and a hotbed of militant unionism. James Boggs died in 1993 at the age of seventy-four, but Grace Lee lived until the age of one hundred, becoming a revered figure who mentored generations of grassroots revolutionaries. Thomas Sugrue, in his *New York Times* obituary (October 8, 2015) for her, wrote: "She hoped to turn Detroit's forty or so square miles of empty land into an archipelago of small, collective farms, a model, she believed, for a sustainable future." This effectively summarizes the kind of visionary organizing that Grace Lee inspired, and why Detroit was so central to her, both as a real place of resilience and as a symbol of what was possible. In a 2012 conversation with Angela Davis, later published online with the title "Reimagine Everything," Grace Lee explained her hopeful vision for the city she called home:

> We have been lucky in Detroit. Out of the devastation of deindustrialization, we have recognized the need to create a post-modern, post-industrial society. I urge you to come to Detroit and get the idea and share the experience of the American revolution we are creating and to begin your own visionary organizing back in your own community.

By the time I met Carlos, his workshop had become a regular stop on tours led by the James and Grace Lee Boggs Center to Nurture Community Leadership, because he seemed to exemplify the spirit of "making a way out of no way" that defined their brand of community-based innovation. In terms of gender, age, and ethnic background, Grace Lee and Carlos could not have been more different, but they shared some significant characteristics: an outsider identity, a passion for ideas, and a love for their adopted home of Detroit. Carlos recalled an intense, sit-down conversation that he had

with Grace Lee at her home, among her books, where she often welcomed prominent visitors. He had done work for the Boggs Center over the years, including repairs on an aging metal gate outside their building, and he welcomed the attention brought by the tours, which sometimes included students from places like Stanford University and MIT as well as a range of activists visiting Detroit from all over the world.

However, Carlos was also openly critical of some Boggs Center efforts, especially the community gardens and makerspaces, which he saw as inadequate solutions to the dearth of opportunities facing Detroit neighborhoods and the need (as he put it) "to make your own economy." The late Frithjof Bergmann, retired professor of philosophy at the University of Michigan, Ann Arbor, and author of *New Work, New Culture* (2019), was closely associated with the Boggs Center, but he also represented the antithesis of everything Carlos stood for. As Carlos put it, "They want to minimize everything." As an adopted American, whose first memory was seeing the fins of a Cadillac as it cruised past him in postwar Germany, Carlos bristled at the idea of reducing one's ambition: "It struck me that people want to curb the demand to take full advantage of everything America ha[s] to offer; have a big car, a big TV, a big house. They want you to live like in Saigon. I need a big truck; we don't want no little putt-putt car, like in Saigon."

He also disagreed with their embrace of a barter economy based on shared communal values rather than markets and cash: "They told me there is not going to be no money no more," he declared. According to him, this idea "made us look stupid, like crazy, man." The Boggs's circle tended to view the city's abandonment by government and industry as inadvertently producing the crucible in which new possibilities were born, advocating local, handmade solutions to the city's large-scale structural problems. They saw in Carlos a vivid representative of that spirit of creative resilience—which he no doubt was, but in fact he saw things quite differently. As he put it, "I believe we should be making more money, and they think we should get rid of it."

This was somewhat of an oversimplification of Bergmann's view. In a 1994 interview conducted by Sarah Van Gelder, Bergmann stated: "The idea of high-tech self-providing grew out of my own experience growing all of my own food and living virtually without cash." Like Grace Lee, Bergmann saw the survival expertise of people in Detroit as a kind of manual for a postcapitalist future:

There are quite a good number of projects that I am associated with, particularly in Detroit, in which welfare mothers, inner-city African-Americans, and any number of people contribute their labor to upgrading and maintaining the apartment houses in which they live. There are different arrangements, but the upshot is that people put a certain amount of sweat equity into the houses and in return they get part ownership.

In some ways, Carlos's own experience was not so different from what Bergmann (himself a German immigrant) describes. Carlos had also benefited from the sharing economy through his integration in Clarence's family and neighborhood, borrowing water, sharing food, and so on. But Carlos seemed to see the small-scale sustainable future espoused by Grace Lee and Bergmann as a surrender, almost a capitulation to poverty and second-class status. "You got to have an economy," he would repeatedly say, and in his view a real economy didn't come from "potatoes and tomatoes," his shorthand for the "farms, greenhouses, and neighborhood watches" that many others were espousing. It was a distinction that opened up a rift of difference in terms of future strategies.

In a sense, Detroit was not just a city in transition but an epic battleground of ideas over what the future of cities should be. Juliette Roddy, Anthony McDuffie, and I published an article in 2018 that drew on interviews we conducted in the Chene Street area, considered in relation to both apocalyptic and utopian visions of the city that were then evident in scholarly, mass-media, and popular-culture narratives. In our interviews, some people saw Detroit as a leading indicator in the downgrading of working-class fortunes more generally—a warning sign, or a worst-case scenario—while others viewed it as an inspiring incubator for future social formations. The vistas of waving fields of grass engulfing the remnants of burnt-out houses had become postindustrial clichés thanks to social media, but for residents of many neighborhoods these were not tantalizing images but facts of daily life.

In an interview included in that article, Carlos elaborated on the process of economic disinvestment and its effect on the local environment and residents, providing an account that was both descriptive and analytical:

All the houses right here . . . they got foreclosed. They got a letter in the mail that the house is foreclosed—move out. And when they didn't move

out, they called the Sheriff. And the Sheriff put 'em out with their clothes on the curbside. And leaving the houses unoccupied. So within a few years, within two or three years, there was a huge percentage—amount of houses unoccupied and subject to vandalism. All the people out of work and can't get no jobs. The only way they result into not being criminal, to get any money, is scrapping. Scrapping is taking resources and returning them into the recycle and re-manufacturing cycle, reclaiming. So there are thousands—tens of thousands of people—still today involved in recycling, and destroying things, and bringing 'em to the recycling center. All to the point that you only have one house on one block left in some neighborhoods.

Carlos and Grace Lee lived about a mile and half apart and had witnessed the same withdrawal of resources and precipitous decline in population on the city's Eastside, accelerated by addiction and subsistence activities, such as scrapping. They were both responding to the same thing, but they drew somewhat different conclusions. Grace Lee saw a revolution brewing among the ruins of a dehumanizing and unsustainable system (Bailey 2013), but Carlos did not see the same potential in capitalism collapsing. For him, the debate was not only intellectual but also a personal matter that had practical consequences for his business and neighborhood. "Potatoes and tomatoes" were not going to be enough. People needed to be able to make money in order to share it. He referred to this as a "value-creating proposition." Rather than constructing a new economy that was somehow outside of capitalism, they needed to be able to plug into the capitalist machinery, to siphon off some of its power, and use it to build their own.

The debate between Grace Lee and Carlos echoed other long-standing debates concerning the nature of contemporary capitalism and its relationship to community, on the one hand, and craft practices, on the other. While the Boggs's circle saw no redeeming value in the capitalist-industrial system, Carlos had a more pragmatic view. This paralleled the historic divide between W.E.B. DuBois and Booker T. Washington, described so clearly and succinctly by Detroit poet Dudley Randall (1969). But Carlos's perspective also reminded me of the iconoclastic economist, Thorstein Veblen. Veblen was a child of Norwegian immigrants who grew up on a farm in northern Minnesota and ended up in the halls of academia. Though

not an immigrant himself, he always carried an outsider's identity with him, from Cornell University to the University of Chicago and finally Stanford, where he retreated into relative obscurity. Upon his death, he requested that all his papers be burned. According to P. A. Saram (1998), Veblen was caricatured as a "misfit, a cynic and an amoral, all-around troublemaker; an interesting legend, in the tradition of Loki of the sagas" (582).

While today he is best known for his concept of "conspicuous consumption," the idea that people will pay much more for extravagant objects and services than they are worth, simply to demonstrate how much time and money they have to waste (1899), Veblen actually had a lot more to say about the tension between capitalist imperatives and the craft-oriented goals of engineers and designers. For Veblen, disinterested engineers were the heroes of history, but they were fighting an uphill battle. Capitalism, for Veblen, was defined by its embrace of what he called the *pecuniary instinct*, which was the lust for money as an end in itself. This was essentially different from the *instinct of workmanship*, which was motivated by the intrinsic value of solving problems and creating elegant, efficient, and beautiful designs. This quality of *craftsmanship* is described by Sennett (2008) as "a basic, enduring human impulse, the desire to do a job well, for its own sake" (9).

According to Veblen, capitalism exists in a parasitic relationship with this commitment to craft. The pecuniary classes, as he called them, are always at work, trying to monetize their inventions and optimize financial gains from them. Henry Ford, the industrialist whose name came to stand for a whole integrated system of production and consumption, was born out of the class of engineers and skilled trades but also helped to defang them, breaking their complex skills into component parts and spreading them across his assembly line. By 1932, when his security guards shot down unarmed, unemployed workers in the cold of March, Ford was no longer a symbol of the engineer hero; rather, he was thoroughly identified as a capitalist crank. As described by the muckraking novelist Upton Sinclair in his 1908 book *The Flivver King*, "Henry was more than any feudal lord had been, because he had not merely the power of the purse, but those of the press and the radio; he could make himself omnipresent to his vassals, he was master not merely of their bread and butter but of their thoughts and ideals" (147).

In *The Vested Interests and the Common Man* (originally published in 1919) Veblen wrote, "The workman has become subsidiary to the mechanical equipment, and productive industry has become subservient to business" (1969, 39). Veblen defined a "vested interest" simply as "a marketable right to get something for nothing." For Veblen, the cost of this vested interest came out of society's pocket, as it amounted to a pot of accumulation that was diverted from production and subtracted from the store of natural resources that might otherwise belong to the community as a whole. The vehicle for this diversion amounted to "devices of salesmanship," which he distinguished from those of "workmanship" and described as "ways and means of driving a bargain, not ways and means of producing goods or services" (100). Much of this historical struggle would occur in Detroit, where the modern assembly line first emerged. This revolutionized production once again, lowering the intrinsic value of labor even as Henry Ford increased his wages to offset the anger of the skilled workers his innovation displaced. As Kat Eschner noted in *Smithsonian Magazine* (2016), "the assembly line was met with hatred and suspicion by many of his workers."

Detroit was also at the center of the twentieth century Arts and Crafts Movement, which directly opposed the homogenizing effects of industrialization, particularly in relation to traditional handicrafts. The legacy of this movement was visible all over the city, right alongside that of the industrial revolution itself—in the renowned Pewabic Pottery, in the Albert Kahn buildings and the architectural ornamentation of Corrado Parducci; in the campus and curriculum of the Cranbrook Academy of Arts and the College for Creative Studies. Through his traditional training in Germany, Carlos was well versed in these principles before he ever arrived in Detroit and discovered its neglected treasures. In Germany, the contemporary form of the craft guilds still wielded power. As Carlos explained to me, there were bodies known as *Handwerkskammer*, which roughly translates as "chamber of crafts." They set the standards and guidelines that must be followed in carrying out certain kinds of work, especially on historical buildings or anything defined as *heritage*.

According to historian Hal Hansen, the strong German tradition of craft education and regulation emerged in the context of the nineteenth century, especially in the southwestern states of Baden and Württemberg,

where "the diffusion of ideas, market information, technology, production skills and design, business methods, and so on that underlay industrialization was slowed or blocked by the [area's] remoteness from large urban centers; its dispersed settlement patterns; its profusion of small, craft-oriented producers with limited financial resources; and its dependence on diffuse, renewable energy and material resources that reinforced geographic dispersion" (2009, 35). This last part seemed like it might describe contemporary Detroit—the limited financial resources part, at least—and it certainly called to mind the type of localized, craft-oriented economy that some in the city had been proclaiming.

For his part, Carlos lamented the absence of such standards and governing bodies in the United States, and one of his more ambitious dreams was to establish a *Handwerkskammer*, or craft chamber, for Detroit, with himself in a prominent position. He was a vocal and persuasive advocate for the preservation of those "skilled trades that built Detroit into the Paris of North America," as he was fond of saying. He wanted to work with the universities in the United States and Europe to train those who were motivated, to think about their role in identifying people who were physically and technically inclined, for whom manual arts were "conducive to their style of learning." The mismatch between the education system and the learning styles of young people was something that he had experienced personally, and he saw evidence of this all around him in Detroit as well.

But that wasn't the only mismatch he confronted. For a truly dedicated craftsman working in a capitalist context, there is an unending conflict between the *demands of the market* and the *demands of the work*. The buyer is fixated on price and doesn't want to pay any more than an agreed-upon amount; the contractor needs to compete on the basis of price, but the craftsman is also compelled by the demands of quality. What if you agree to a certain job, and get halfway in, only to realize that doing the job right will require more time, better materials, and hence more cost? Do you eat that cost, do you cut corners, or do you go back to the customer? In the end, whoever cuts the check has the control, at least in America, a fact which Carlos constantly bemoaned.

Ironically, Carlos had fled Germany because he didn't want to conform to the arcane rules that would make him old and gray before he got to work on the kinds of projects he loved. In America, he had the freedom to make

Carlos explaining the concept of the *Handwerkskammer* in his workshop. Drawing by Paul Draus.

his own way, to earn jobs through his talent for metal and salesmanship, and to build a business based on his creativity—but his *craft* was not respected. His Quixotic dedication to his own craft, his business, and his vision was so singular that it was isolating, and he had difficulty delegating tasks or trusting others to get it right.

Before working with Carlos, I was woefully ignorant about the difference between AC and DC, voltage and current, resistors and transformers, rectifiers and inverters. As a sociologist, I was continually shocked (pun

intended), but not necessarily surprised, by how little we knew about the systems that sustained our consumption-driven existence. I also became interested in another tension, that between Nikola Tesla and Thomas Edison. Tesla was eccentric and brilliant, with ideas for inventions fully formed in his head; Edison was hard-nosed and diligent, a work-shopper as much as a wunderkind, who surrounded himself with an efficient organization and mastered the rules of business as well as science. Aside from stylistic and temperamental differences, they had a basic disagreement about the purpose of their work: where Tesla felt that knowledge should be freely shared, Edison was stubbornly proprietary. Tesla ended his life with fewer than three hundred patents, while Edison had more than a thousand.

For his part, Carlos oscillated between Teslaesque and Edisonian tendencies. Personality-wise, he was more like Tesla, a compelling, dynamic character with wild hair and blazing eyes, surrounded by whirling devices, a mind full of visions that can't be contained, seeking the means of their expression, which must always come from others, from outside, from those who never moved as fast as he might like. On the other hand, he longed for Edison's organized shop, the team in white coats, the file full of patents, the efficient production line, and the flow of capital, not gifted or granted but earned through ingenuity. Here is another way that Carlos set himself apart from others, adhering to an older ethic: "I don't have no yacht, no summer house, no fancy car; I don't take no vacation. I only want to work and put others to work." It was the joy of being the creator that he craved, as well as the recognition of his work. For that he was truly greedy. The art, the work itself, was the crucial component, and not work that was fashionable, but solid, beautiful, and functional.

Carlos believed as strongly as any American-raised, business-class blueblood in the basics of free enterprise. In fact, he epitomized these ideals, coming to the States with nothing but skills and ideas, clawing his way into the tough market of depressed Detroit with only his wits and talent to back him up, building himself into a recognized player in the local development and restoration scene, such as it was. But he kept his business small and personal, centered, like the Zum Teufel had been, around the family. He was thus caught between these opposing pincers: on the one side, the unending personal and community obligations, putting food on the table, and keeping

the lights on, and on the other, the demands of a competitive economy, with its equally ceaseless drive toward the bottom line.

Craftspeople need customers, and often it is the well-off who are most willing to pay for their highly refined services. One day, as we were driving through Grosse Pointe to visit the sites of some of his previous creations, Carlos pointed out a man tuckpointing a low stone wall, and said: "See, these houses are employing probably hundreds of people, making good money doing this work. Why can't it be guys from the 'hood out here making money in Grosse Pointe?" Another day I went to see him at an estate in Bloomfield Hills where he had designed, fabricated, and installed myriad intricate metal ornaments over the years: filigreed cupolas, fences, gates, arches. These people are wealthier than the lords who financed European castles, he would say. Why shouldn't they be supporting the highest level of craft here in the United States and employing people with high wages every step of the way?

Carlos made a good living doing jobs in the wealthy suburbs over the years, but he had his share of bad experiences too. In the summer of 2017 an unscrupulous contractor screwed him out of $50,000, letting Carlos do more and more extra work, and in the end paying for none of it. Once, at a meeting that included another friend who had witnessed the situation, Carlos stood up from his chair, leaned forward dramatically and said, "What about *Grosse Pointe*? You watched them bend me over and give it to me!" You could feel the pain in the contorted movement he made for emphasis, and in the growl-like rolling of the *r* that he applied to *Grosse*. This was a battle that Carlos had fought and lost, and it ate at him.

Tony Biundo, one of Carlos's long-term collaborators, had a degree in chemical engineering but made his living as a brick mason and concrete contractor. He was with Carlos on the Grosse Pointe job, and he recounted how this unscrupulous contractor set out to shortchange Carlos. In one meeting, he told me, Carlos explained that he wanted the restoration to last one hundred years. The contractor responded, "I don't give a shit. It only needs to last one year," because that was the length of time on the warranty for the work. The client had wanted to hire Carlos directly, but he was not able to pull a big enough insurance bond to cover the job, which put him at the contractor's mercy. As a result, the contractor made Carlos eat the cost

of lead remediation services that turned out to be necessary. Tony said, "I tried to protect him, but he kept saying, 'I can handle this.'" He concluded the story by simply saying: "Carl is stubborn."

In Carlos's view, his level of craft justified a higher price for his services, but others could then swoop in and copy his technique at a fraction of the cost, presenting themselves as the lowest bidders. He was therefore engaged in a constant hunt for jobs that could keep him afloat and clients who were willing to pay a premium price and put up with his level of artistic obsession. In the end, his real product was himself, and it came with an added cost—you had to deal with Nielbock, and though he could bend any metal, he would not bend his knee to anyone. As I began to work with Carlos, not just as a writer and researcher but as a project partner, I saw his sharp edges emerge. Some of these encounters threw off sparks.

In thinking of Carlos's encounters with *Grrrosse Pointe*, I was reminded of the Norse myth concerning the construction of the great wall of Asgard, which offers an unintended insight into the workings of capitalism. I say *unintended* because the story's origins clearly predate anything like contemporary capitalism, but the spirit embodied in those myths harmonizes nicely with Thorstein Veblen's mock-anthropological perspective on economic history. In the myth, the gods of Asgard need a wall to keep the ravenous frost giants out of their beautiful city, but they either can't build it themselves or don't want to do so. Along comes a craftsman who promises to build it for them in only three seasons, but he asks a steep price: the hand of Freya, goddess of beauty, in marriage, as well as the sun and the moon. The gods think this is an outlandish request, of course, but their clever comrade Loki, god of mischief, convinces them that they should still hire the guy, on the condition that he finish the wall in one season, not three, and that he have no help, except from his horse.

Loki's logic is this: the conditions are impossible, and the man won't be able to finish the job, so they can then refuse to pay him anything. Whatever work he has done they will get for free. After that, they can send him on his way, possibly beating him first for his impudence. Then they can just finish the wall themselves. The builder takes the deal, and he surprises all the gods, including Loki. His horse is a marvel, hauling twenty huge stones at a time and throwing up the massive wall at a furious pace. Worried that he will meet the terms of the agreement, and thus claim his prize, depriving Asgard of

The builder and his horse were constructing the wall of Asgard far faster than the gods anticipated.
Drawing by Paul Draus.

both beauty and light, the gods furiously demand that Loki do something. Loki has the power to take other forms—he is a trans-species-trans-sexual god—and he first turns himself into a gorgeous mare, and then prances before the builder's horse until it chases after him, leaving the builder high and dry. As a result, the builder does not complete the wall on time. Thor, the god of thunder, who had been away from Asgard for the season, returns to town and deals the builder (who, it turns out, is a frost giant in disguise) a deadly blow with his mighty hammer.

When I heard this story, lovingly retold by British fantasist Neil Gaiman (2017), I immediately thought about Carlos and the Grosse Pointe job: how they hired him because of the work he could do, added more and more conditions, and then stuck him with added cost, with the result that he labored for an entire summer and lost $50,000. The craftsman, in this case,

was aligned against the capitalist gods, who never want to pay any more than they have to. The wealthier they are, the more demands they make and the less willing they are to foot the bill. Every contractor has stories like these, it seems. Once in a while you may get ahead when dealing with the gods. But most of the time, they win.

That's one way to read the story: as a cautionary, instructive tale, warning those with ambition what happens when they try to get one over on the gods. But what if Carlos saw himself not as the hardworking but hapless builder, but as Loki, the mischievous shapeshifter, half-Asgardian, half-Jotun? In this story, Loki's interests happened to align with the Asgardians, but in other tales, he steals from under their noses. Loki is often among the gods, but he is not *of* them. In his own recollection of growing up in Germany, Carlos had identified with the trickster figure of Till Eulenspiegel, who was celebrated for playing scatological jokes on those in positions of authority. Carlos had gotten a glimpse of how the capitalist game works when he saw the contractor paying him to do all the skilled work but then claim the lion's share of payment for the job for himself. Since that moment, he was determined to be on the other side of it, to be the capitalist as well as the craftsman—to have the best of both worlds. For him, this was what *inclusion* often meant—being cut in on the deal rather than cut out of it. "If you are not at the table, you are on the table," as community organizers often say.

Carlos often said that he wished to avoid *polarizing* approaches that pitted the interests of wealthy (often White) people against those of working-class people of color. Skilled trades, in his view, presented one way of leveling the field. "How can you start speaking about the great American iconic art?" he would ask, "How can it be presented so it's not polarizing?" He pointed to the metalwork that adorned art-deco architecture jewels like Detroit's Fisher Building, saying: "The complexity embedded right here; this is perfection right here." He saw the intricacy of craft objects and other functional adornments and the skills required to produce them as a potential bridge between those who had the resources to pay and those who had the skills to produce them. In his view, you need aristocrats, billionaires, and, in today's world, corporations to pay for the high-level skills of true artisans like himself. Otherwise, they would simply be replaced by machines or, in today's world, by 3D printers and overseas sweatshops, by Amazon and Ali Baba. This idea placed him at odds with the view of Grace Lee and others

who envisioned a world where available technologies, in the hands of local communities, would enable the emergence of circular economies and cut aristocrats, billionaires, and corporations out of the loop.

In *The Craftsman* Sennett uses the Greek mythical figures of Pandora and Hephaestus to dramatize the problem of technology for contemporary society. Pandora opening the casket gifted to her by the gods is an explanation for the origins of evil in society: "in opening the lid, she transformed the sweet perfumes into poisonous vapors, the gold swords cut their hands, and the soft cloths suffocated those who held them" (2009, 293). In contrast to the seductive but threatening beauty of Pandora, Sennett offers the figure of Hephaestus, the Greek god of fire, blacksmiths, and metalworkers. Hephaestus built the homes of all the gods, but he was also looked down upon by them as ugly, with a lame foot, and a body bent by hard labor. Sennett writes that "the clubfoot symbolizes the craftsman's social value. Hephaestus makes jewelry from copper, an ordinary material; his chariots are fashioned from the bones of dead birds" (2009, 292). In his dealings with the moneyed classes, Carlos played the Hephaestus role well, but he was never satisfied with that position. Like Loki, he was not above doing a bit of gouging himself.

In "The Alchemy of Craft," D. M. Dooling writes of the connection between the transformation of metals and the transformation of the self:

> Left to themselves, in the course of thousands of years, ores would grow into metals, and metals into gold; but with fire the metalworker could accomplish in hours what would take nature so many centuries; he could "transform" ores by smelting and change the character of metals. And by so doing, he himself was changed and took on the character of one set apart: a magician, a wielder of power, a collaborator with the Creator. (1985, 93)

I had seen Carlos in action enough times, a volatile mediating element, making connections where you might not think it likely or even possible. What if, like the molten metal linking separate sections of steel, Carlos might succeed through transformation, altering himself in the process, but also modifying the substrate, tying his molecules to its structure? Was intensity and brilliance alone enough? Or would Carlos, like Tesla, release most of his energy into the sky, while the bulldozers of business, as usual,

leveled Detroit's creative field? By bridging polarities between past and future, Black and White, downtown vested interests and neighborhood residents, especially those disconnected young men that he saw all around him on the Eastside, Carlos saw a way to bring some of the rewards back to the community.

According to Sennett,

> We share in common and in roughly equal measure the raw abilities that allow us to become good craftsmen; it is the motivation and aspiration for quality that takes people along different paths in their lives. Social conditions shape these motivations. (2009, 241)

If inspiration could be ignited in others as it had been for him as a young man in Johannesberg, Carlos believed, a workforce of skilled artisans could emerge from the distressed social conditions of Detroit's neighborhoods. For Carlos, the magic number was *one out of three*, and he described a kind of triage that was required: "One out of three people in this city, you can't do anything—just connect them with social services, keep them off the street, and out of crime. One out of three might be academically inclined, so they can go to college and get a professional job. One out of three may be technically inclined, but we need to have the programs for them."

These inspired young people would need projects to work on, with resources to hire them, and pay an appropriate price for their skills. The most obvious source for such projects, from Carlos's perspective, was the wealthy and corporate class itself. Rather than opposing corporate-led revitalization projects or capitalism, per se, Carlos insisted that he, his neighbors, and family needed to be included in any new development taking place in their communities. A field of hand-built, high performing windmills, rising from the weeds of Detroit's neglected Eastside neighborhoods could be the new local industry that would engage that population, bringing both green energy and economic power to the people.

Carlos's distinctively designed windmills were picturesque; they captured peoples' imaginations, and it was possible to paint them in almost legendary terms: a device linking earth and sky, built by the hand of a craftsman, the descendant of Ogun transplanted to Detroit, using captive lightning and shards of the city's industrial past, it pulled energy from the air that circulates

all around us, and it could transform the urban landscape from a desolate field of weeds to a green and flourishing village. It was a fitting symbol of Carlos's ambition, to bridge the gap between unequal worlds, to achieve true inclusion through sharing the spoils of productive capitalism. But first he needed to make it work in the eyes of the city and the world.

Chapter 4

CONFRONTED WITH THE MIGHT

"That's like Yankee engineering. That's like homeboy engineering in Detroit!" Carlos declared, while showing me around his workshop sometime in early 2017. It was one of his colorful, on-the-fly characterizations, in this case summarizing his own version of Edisonian innovation. Pieces of his latest project were scattered across tables in the work area in varying stages of assembly. He had just been awarded a Knight Arts Challenge Grant for $100,000 to install two of his hand-built windmills in the Eastern Market District, a few blocks west of the workshop. The goal of the project was a prominent public display of locally designed, upcycled green energy, installed in the popular open-air market for all to see and, what's more, to charge cell phones and other electronic devices. It would demonstrate to a generation of post-millennials, in the most direct way possible, that wind could produce useful power in the busy midst of a city.

Carlos's windmill concept was both the realization of a personal vision and a response to a societal challenge. It had emerged out of the wreckage of the Great Recession, and the systematic dismantling of the city that he saw taking place all around him. Like Ben Franklin's bolt of lightning, the idea came to him while he was trying to install a pirate satellite dish on the roof of his property. A gust of wind whipped up and caught the dish like a sail, nearly carrying him with it into the sky. After climbing down, he wondered, could that power be harnessed?

Following the near-collapse of the world economy and the election of President Barack Obama in 2008, a lot of investment and attention was directed at the potential of wind turbines to provide clean, green energy for the nation (Environment America, 2017). However, when Carlos scanned the

Detroit horizon from his workshop, all he saw was one lone, three-bladed wind turbine, erected to service a charter school down the street, and the thing never seemed to turn. If the wind wasn't strong enough, or it was blowing in the wrong direction, the blades didn't budge.

So Carlos built a device of his own, drawing on the public-domain concepts of historic European and American windmills, using more and longer blades, a pivoting axis, and a fan tail that would detect the wind and turn the propeller to face it directly, feeding off the inconsistent ground-level eddies characteristic of urban landscapes. He saw this as both a response to the crisis of the moment and as a path for Detroit's future, which drew on the city's storied past.

"When the economy went down," he said, "the last thing that anybody wanted, or had an interest in, in those hard times, was ornamental metal. There was nothing going, and nothing going in the foreseeable future, either. But I see my skills are so needed for when this stuff is getting better." He saw a parallel between the rebuilding of Germany that took place after World War II and what was needed in Detroit. As a child of both Germany and Detroit, with his rare skill set, he felt he had a unique perspective and something substantial to offer his adopted city. "Germany was complete rubble after the war; that's how Detroit was looking. Everything was burned down. Everything had collapsed, and the skilled trades that you need to build this back up, those essential things, have historical relevance; they have spiritual, community relevance. They are the trademark of Detroit."

The Detroit Windmill Project, as it came to be called, provided a potential model of a local, sustainable industry that could power Detroit's grassroots economy. The windmill was a concrete demonstration of those skills and aptitudes, the combination of technical ingenuity and gritty determination that had made Detroit great in the first place, applied toward the present circumstance. "You design a better mousetrap, and that's the great American experience, right there. I studied the American windmill. I calculated what was needed, and I said, 'What about green energy?' Low-level wind, that is the way to go. That's when Charlie Annenberg came along. He saw the whole reportage of what I was doing, and he gave me the money to build one windmill, and I actually made two."

Charles Annenberg Weingarten, a philanthropist from California, passed through Detroit in 2012 with his dog, Lucky, to tour the wreckage of

the recession, as so many others were doing at the time. He met with some prominent neighborhood spokespeople, such as revolutionary scholar-activist Yusef Shakur, Pastor Barry Randolph of the Church of the Messiah, and the artist Tyree Guyton, known for his world-famous Heidelberg Project. Weingarten made a twenty-minute documentary film, where he peered into abandoned buildings, walked between columns of steam emanating from the downtown sewer grates, and pondered the meaning of Detroit's decline. After Guyton guided him to the roof of the old Brewster Housing Projects, which he envisioned becoming an immense participatory art project, Weingarten looked out over the expanse of freeways and apparent emptiness, and cried, "Calling the next Thomas Edison! Calling the next Henry Ford! Calling the next Rosa Parks! *We need you!*"

Weingarten's closing statement of the film, directed at the camera from a park bench next to the frozen Detroit River, might have been directed specifically at Carlos, so closely did it mirror some of his own claims about the city:

> The last 150 years was marked by the industrial revolution; you got to wonder what would be the next revolution. Detroit is going to return to glory through simple things, like farms, greenhouses, neighborhood watches. Artists—they're paving the way and writing the language again. It's a place like no other. If you got the spirit, the tenacity, the determination to make things happen, this might be the place for you. (Weingarten, 2012)

Somewhere along his wandering path through Detroit, Weingarten had met Carlos, who is briefly shown in the film, hammering hot metal on an anvil, and his misspelled name appears in the credits. Though not given a speaking part, he clearly made an impression, and Weingarten even provided some startup money to move the first windmills from backyard concept to public display. Out of the fields of tall grass left behind by the waves of abandonment, arson and demolitions, Carlos's windmills began to rise (Spröer, 2016).

The first model was inspired by the classic American windmill, as well as those Carlos had seen plying the skies of Germany in his youth. As Ryan Schnurr (2018) has stated: "These windmills have a quaint, decorative sort of feel, like something you would find at an antique mall. But they are in

fact technically profound pieces of equipment with a history of powering American expansion." Robust windmills, built of wood and canvas, had been used to turn millstones and pump water to supply farmers' fields for generations before the dawn of electric power and the dominance of fossil fuels. Carlos had grown up watching the frontier-fantasy dramas based on the work of Karl May (Spröer 2016). May had never visited the United States, but he had immortalized it in romantic Western myths, later turned into films that were consumed by Germans en masse, so Carlos was familiar with this iconography. He wondered why they could not instead be fashioned from contemporary, cast-off materials—like that sail-like satellite dish—and be re-engineered to meet the needs of his neighbors, not only for home-grown power but for locally based jobs and skills-based education.

Throughout the 2000s, people regularly came to Detroit to gaze at so-called ruin porn. But some, like Weingarten, also came to look for sources of hope and inspiration. In Carlos's view, this often led to projects that were more symbolic than substantial. One of his regular grievances was the way in which foundations and nonprofits appeased the community with cultural displays, funding feel-good activities—"face painting and bouncy huts," as he called them—that left nothing solid in their wake. In the meantime, the real money was being made by corporations picking up big-city contracts or cutting deals to avoid being taxed on their profits. Carlos believed that real inclusion occurred not when your art was featured in a festival or on the cover of a nonprofit report but when you got bids to actually rebuild the city.

As it happened, Carlos's own work was regularly featured on cultural tours—sometimes with his permission, sometimes not. His iconic "DETROIT" sign, consisting of five-foot-tall letters fashioned using a variety of metalworking techniques and materials, was a common target for tourists and photographers and was featured on the cover of Detroit Future City's *139 Square Miles* report (2017), the website of the Detroit Justice Center, and who knows how many Instagram and Facebook posts. One day I was at his studio, and we looked out the window to see a bus stopped on the street. It was a local tour company, and they were pausing to have a look at the sign and presumably to take photographs. "They come by here all the time," he said. "Wedding parties too."

The windmills, over time, achieved a similar profile. With Weingarten's support, the first major windmill prototype was publicly displayed at the 2011 Detroit Maker Faire, where it was named one of the "5 coolest DIY Projects" by *Popular Mechanics* magazine (Wojdyla, 2011). It also caught the eye of David Scheltema (2013), a reporter from *Make* magazine who attended the Faire in 2013. He described it as "a large windmill made from discarded items including a collection of repurposed satellite dishes, a truck axle with a bright glinting rim, salvaged bicycle gearings, a supportive metal assembly to give height and framing for the blades of the fan, and two car batteries to store the clips and eddies of wind's energy in a chemical medium—they all had function and utility, but also beauty." Scheltema's story contained all the elements of Carlos's "vision for a new Detroit," which, he wrote, "rests in the ideals of a distant time, one which he hopes he can remake here by reformulating the city which intemperately clings to its automotive history into a place where teams of craftsmen thrive."

This account of Carlos was in a recurring register, with a set of notes that would become very familiar to me, not only through our own conversations but also through those he carried on with others who crossed his path. Carlos's vision was consistent, but it also sprouted new branches as it grew and evolved. Some of these I overheard directly, while others found their way into more magazine articles, online videos, and narrative accounts. The windmills outside his workshop proliferated along with the stories, and by the mid-2000s Carlos became something of a local legend. He entranced visitors to Detroit with the power of his presence and his wondrous field of whirling blades. Over the years, many stories were produced for different media about the Metal Man from Germany and his quest to recover and transform Detroit.

The windmill was the project that drew me to Carlos, and the one most strongly associated with him in the public imagination. The complicated historical reality behind the self-made myth he so often presented was fascinating. But no less interesting to me was the gritty process of creation that went into those marvelous metal displays, and moving a project from idle imaginings into workable plans. After more than five years of conversations and several attempts to secure funding on his behalf, I finally succeeded in landing a small grant for the purpose of testing the windmill's

full potential. In 2018, supported by a Knight Arts Challenge Grant, we aimed to install two of the devices in nearby Eastern Market. We planned to use the installation as a platform for generating some baseline data.

For Carlos, it was important for people to understand that the Detroit Windmill, as it came to be called, was more than just a recycled wind turbine or a mobile sculpture. Rather, it represented a form of industrial ingenuity that would allow people to make the best of a bad situation, to take the cast-off waste of consumer society and convert it into free green energy, literally harvested from the air around you. The windmill was a potent symbol of old-fashioned backyard innovation and industriousness—"Yankee engineering," or "homeboy engineering," as Carlos had called it—so it was fitting for the upcycled devices to sprout amid the de-industrialized terrain of Detroit's near Eastside.

Because the windmill's component materials were salvaged and scavenged from the urban detritus, the windmill also epitomized the process that has come to be known as upcycling: converting castoffs into products that enhanced their use value. Ironically, Carlos didn't realize he was upcycling until some Austrians who were visiting Detroit to evaluate its potential to be considered as a UNESCO City of Design, visited Carlos's workshop. They saw the windmills and heard the story behind them and declared, "Oh, you are doing upcycling!" Carlos quickly seized on the term and saw this as new terrain over which he might extend his influence, with the windmill as the icon emblazoned on his standard.

Another element that defined the Detroit Windmill was the skill required to build it, and this was perhaps Carlos's most passionate commitment. He thought that if the imagination and talent of young people might be ignited by the example of the windmill, as his own spirit had been inspired by the swinging of the old monk's hammer and the bending of hot metal, it could unlock the potential buried in the neighborhoods of Detroit. He referred to this element simply as "skilled trades," but what he had in mind was a bit more refined than the hanging of sheetrock, the stringing of wires, or the welding of sheet metal. He had great respect for all of those who made a living with their hands, but his forte, as he often said, was the fusion of technical skill with artistic sensibility, something that might be more accurately called "creative industry." It was something that was understood and respected in Germany but had been degraded in the

American context, where everything was driven by market interests, and jobs often went to the lowest bidder.

These were the three legs of the stool that we came to call the Detroit Windmill Project: green energy, upcycling, and skilled trades or creative industry (Draus, 2020). In each case, the windmill represented the gritty DIY spirit of Detroit, the ability to "make a way out of no way," taking what had been left to you as a castoff and turning it into something useful, valuable, and inspirational. But the promise of the windmills also hinged on one central question: Did they actually work? In other words, did they produce power? If so, how much, and how consistently? I found myself asking this question every time I visited the studio and saw another colorful windmill spinning outside. Carlos was usually dismissive. "I've been watching and studying the wind for ten years here," he would say, "and my windmills turn in almost every level of wind, and after every big storm, when the grid crashes and the power is out, they are still out there spinning." Carlos, with

"Welcome to Green Energy Village! C.A.N. Art Handworks would like to announce the 'Green Energy Village Project.' . . . We are ready to take advantage of our surrounding unused space immediately and make a profit for the community." Illustration by Marco Evans, used with permission.

his friend and collaborator Marco Evans doing illustrations, had developed a vision for a Green Energy Village, utilizing his windmills as a central power source, showing a field of locally produced devices spinning in concert, freeing residents from the vicissitudes of the faulty grid.

With some of my colleagues at the University of Michigan–Dearborn, I developed a pilot research proposal premised on this idea. It assumed that the windmills were finished devices, installed by Carlos in Eastern Market with support from the Knight Arts grant. We would work with Carlos to measure their energy output and project their potential impact in terms of dollars saved to consumers and enhanced energy resilience when the power grid was interrupted, as had occurred during a major Midwest blackout in 2003 and many local blackouts since. This became the central question to be answered by the installation in the Eastern Market, in a public place where everyone would be able to see and touch the windmills and, most importantly, to charge their devices. Our goal was to explore the potential of the Green Energy Village in concrete terms, working with Carlos and other community partners to define key challenges and project long-term impacts for surrounding resource-stressed communities in terms of sustainable energy, environment, and jobs. That would be the proof in the pudding, as it were.

As a sociologist, with no training in or aptitude for engineering, I saw myself as a project coordinator, bringing Carlos's innovative spirit together with the research capacity of the university. My main interest was evaluating the repercussions of the windmill as a kind of community-building technology. I anticipated that the windmills would make a big splash, and I wanted to be there when it happened, to record and analyze the results. I saw the public installation of the windmills as something like a barn-raising event that would pull people in the community together. I could draw on colleagues and students in engineering fields to assist with the data collection and analysis that could help establish the viability of Carlos's invention.

In theory, a wind turbine is simple—kinetic energy, produced by wind current moving through blades, is converted to electricity by a generator; this energy is then stored in a battery and can be utilized to power various devices. Carlos sometimes dismissed the electrical work entirely, saying, "All I need is someone to twist the wires together!" Alas, it wasn't so simple.

Rather than simply testing a finished device in a real-world setting and exploring its impacts on the community, I walked into the maelstrom of a work very much in progress, with a multiplicity of moving pieces and a lot of relationships and personalities to manage. Because I wanted my own small research project to work out, I needed Carlos's project to be successful, and so I became a participant in the drama of the design and build. By the end of that long summer of 2018, I found myself sometimes in the role of a de-facto general contractor, while at other times I was more of a laborer—hauling parts here, shoveling cement there, and so on. In either case, I was certainly not the best person for the job, but I had one distinct advantage—my salary was already paid, and it was summer, so I had time available. Whatever I did to help Carlos, it didn't cost him anything out of his pocket.

This also offered me the opportunity to observe Carlos in action, up close. Like the windmills, Carlos moved incessantly, but he could produce nothing without a proper connection—some means of converting his kinetic energy into usable power. Jean Mallebay-Vacqueur, a retired Chrysler engineer and part-time French diplomat, who I met through Carlos, once told me that "he is like an electric wire, but he needs the right plug." With Detroit's induction into the UNESCO City of Design network in 2015, Carlos saw the promise of a new source of funding and cultural influence, something that could move the preservation of Detroit's heritage to the center stage—the perfect outlet for his combination of skills and interests. He had given a presentation at the Charles Wright Museum in October 2016 on the topic of "The Skilled Trades That Built Detroit, the Paris of North America," and he was seized by a sense of new possibility.

Carlos had many ideas for projects that could be shared with the city and the world, and the windmills seemed to hold a lot of promise precisely because they caught the eye and sparked the imagination. But they also raised a lot of questions when it came to their practical application. First of all, were windmills even feasible in a city like Detroit? Of course, wind power had a long-established utility. Carlos was fond of pointing to the millstone that he kept in his backyard, one edge buried in the earth. "Try to pick that up," he would say. "You can't do it, but the wind can turn that all day, no problem. It carried Columbus over the ocean without any motor." However, wind power's track record was a little mixed. Michigan had been home to at

least one ignominious episode of failed innovation, the so-called egg beater that never functioned properly and became a sort of an absurd eyesore in the little town of Ishpeming in the Upper Peninsula (Praslowicz, 2014).

Carlos detested any comparison between his windmills and other wind turbine devices. In his view, they served outside interests more than the communities where they were installed. He insisted that his windmills were different—they worked, they were reliable, and furthermore they were *relatable*. One day, Carlos was talking to an African American engineering student, whom I had brought to the shop to meet with him. The young man sat in a chair opposite Carlos on the first floor, adjacent to the cavernous work area, hung with chains, adorned with curlicues of iron, shelves of bars and beams, work benches, and welding machines. In explaining the purpose of his Detroit Windmill design, Carlos contrasted it with the impersonal towers now dominating parts of the rural landscape. "If you are a kid in the Upper Peninsula looking at these giant wind turbines," he said, "you stand in front of it speechless. There's no way you can relate to this. You are just confronted with the might."

Those giant windmills, the "big offshore boys," as Carlos called them, were in a sense his bête noire—they were one of the giants he was jousting against. The surrounding landscape was filled with such enemies, and like Don Quixote, he drew upon the skills of a past era to combat them. As he said to one visitor, "I'm going to be the last guy out here, and that's the way it's going to go. Everything that I do reaches back to the old guys, in the old days with the old ways." But also like Don Quixote, he often tried to go it alone and struggled to convince others of the merits of his campaign.

Carlos was absolutely confident in his ability to design and fabricate anything out of metal. But in building a working wind turbine, there were factors outside of Carlos's control. One of the issues with wind energy, I found out, was the lack of readily available components. Carlos had been buying alternator-generators from a guy in Norfolk, Virginia, who had a company called Hurricane Wind Power. Tom, one of the skilled tinkerers who helped Carlos configure the original electrical box for the windmill, using repurposed components, referred to the Hurricane Wind Power website as the work of a backwoods inventor, not so dissimilar from Carlos himself. There were no spec sheets, no technical details, just a lot of broad

and sweeping claims. One passage on the Hurricane Wind Power page read like an outright challenge:

> So while many of the people in the small wind community, social media, and sellers create mass hype hysteria and rely on mass inflated watt outputs to sell their wind generators Hurricane take a path less traveled in this industry. We have taken the "master your craft" approach and we simply focus on building and selling the most robust products available on the web. (2015)

At Carlos's urging, I called the company in April of 2019 and had a long conversation with Tony Jones, the owner and founder, about the dynamics of the small wind industry. "Carlos's wind turbine is a piece of artwork," he said, contrasting it with other devices on the market. "I'm talking about people who design wind turbines for power generation out of the get-go." He continued, "A lot of buyers are just curiosity buyers. Some people just like to watch things spin. It's all about finding your niche."

He had put his finger on one of the key issues with the Detroit Windmill—What was the niche that we were seeking to fill? Was it a work of kinetic art, or was it a piece of power-generating equipment? My position from the beginning was that it was a little bit of both, which was doubly compelling but also much more difficult to categorize and value. People looking to purchase a device that simply makes power might not be willing to spend the premium it would cost for one of Carlos's creations. After all, if you can get a solar panel that does the same thing, for less money and with no moving parts, why would you choose to buy a wind turbine? And if you just want to watch things spin, why bother with trying to produce power, especially given the inconsistencies of low-altitude urban wind?

In April 2018 I had a conversation with Carlos about the potential for producing wind turbine devices that would be compatible with readily available automotive industry components such as axles and hybrid engines. In his view, this would be a revolutionary innovation. He aimed to optimize his invention to the point that it would deliver double the energy for half the investment of a large scale wind turbine, and produce "something that will knock those high-altitude, mass-produced windmills out of the water." Though he wanted to slay the mega-windmills, he was not

opposed to capitalism, per se. In fact, he sought to rally some of these large corporate interests to his side. Being in the home of the US auto industry, it only made sense to take advantage of that technical expertise and those super-engineered products. However, to win in the marketplace, one needed the capacity to compete. "I want a million bucks," he said, "and all the access to all the Ford components to make that device."

In that same period of time, from the 2008 recession through the 2013 bankruptcy, Detroit was physically transformed—some might say abandoned for dead, others might say that it was actually cannibalized. Carlos often commented on the role of the scrappers, those who sold salvaged or stolen metal, stripped from Detroit's decaying physical infrastructure, to support themselves from day to day, and how they had played a part in turning the city into a so-called ruin. While some have considered scrapping in Detroit as a form of sustainable urban industry (Chohaney et al., 2016), Carlos saw it as the complete opposite. "That's Detroit dismembered," he said, "Detroit disassembled, right there. That's all murky, shadow economy stuff. But that's going to be over soon though. Those people are going to trail on, eating the scraps, sucking the bones. The rest is bare land, ready for redevelopment." Or as he described it on another occasion, "It's the dismantling and the pillaging of a beached whale. But you can't put the water back in the bucket, it's done, it's down the river."

A good part of the city had already been auctioned off, as emergency manager Kevyn Orr threatened to do with the collection owned by the Detroit Institute of Arts during the 2013 bankruptcy (Draus and Roddy, 2014). Upcycling for Carlos was the antidote to that approach—rather than picking the carcass of the whale, selling it off, or boiling it down, we would be preserving the city's legacy and conserving energy by reincorporating those bones and other parts into new higher-value applications, using ingenuity and sweat from the neighborhood.

In May 2018 our quest to locate more components to upcycle into the wind turbines led us to the scrapyard behind the massive old Mistersky Power Station, which had provided electrical service to half of the city before it was decommissioned in 2010. The six-story brick building was now vacant, like so many others in Detroit, a reminder of the city's faded might (Lindquist and Minton, 2019). We had open access to the yards at Mistersky for several days, aided by a Bureau of Lighting employee who was

Carlos cutting steel in the piles of scrap left behind at Mistersky power station following the city's bankruptcy. Drawing by Paul Draus.

riding out the last days until his retirement while the city transitioned into its new era of public–private governance. In that window of time, Carlos managed to cart away a couple of trailers of material that was otherwise destined for scrap. The main goal was to secure old light poles that could be used as the central shafts for the next crop of windmills. But while we were there, we saw light fixtures, transformers, pieces of old assembly lines, spools of wire, materials that Carlos immediately began to imagine as new assemblages of beauty and utility. Looking at the Mistersky yard with Carlos was a window into an evolving city: dismantled, scattered, reassembled in a herky-jerky fashion by multiple competing entities, feasting on the remains and guarding their piles. Back at the shop, Carlos would show me the latest

iterations in this windmill generator, how he had lined up a row of hubs and spokes, each one with a different belt or chain configuration to evaluate their comparative performance.

I was drawn to this makeshift world. It reminded me of my grandfather, a jack-of-all-trades, master of none, and my high school and college buddies, who had gone on to become engineers and artists, with whom I had shared my own dreams of welding things together to produce new works of art, and my childhood memories of crawling through broken windows and plundering junk piles for treasure. Carlos's creativity attracted people of like mind, and in the process of developing the windmills into fully functioning energy devices, he assembled a cadre of young open-source tinkerers, whom he simply called "the hackers." One day Carlos, in his late fifties, and one of the hackers, in his late twenties, each climbed the windmill pole that we had just raised at the shop, like kids at the jungle gym. First was Carlos, wearing a Haile Selassie T-shirt, swinging from the arm of the pole to show its strength. Then came the hacker's turn, and I was the last one up, standing on the pole, surveying the landscape like a sailor on the mast.

These moments of creative play and concrete accomplishment were part of the aura that Carlos cultivated at C.A.N. Art Handworks, but at times they actively competed with his business instinct. Carlos sometimes struggled to draw a line of separation between the friendships he developed through collaborations and his business interests, which were always bearing down on him. Carlos's language about the hackers was typically dramatic: "I love them for their creativity, but I hate them for their fuckups," he said.

There were other issues too. In a city that had been devastated by predatory scrapping, sanctioned access to surplus materials could be fleeting. One day a private contractor at Mistersky, employed by one of the consulting companies that was brought in to manage the downsizing of Detroit, asked who we were and what we were doing there. In July 2018 we got a call telling us that the yard was now off limits. There was too much liability, we were told. Our letter from a friendly city official, granting access to the yard for purposes of upcycling scrap into functional art, was revoked, and the gates were closed to us. After our access was cut, Carlos kept talking about getting back in there. For him it represented the tip of an enormous iceberg that constituted nothing less than the city's stolen legacy. All that material had been purchased with taxpayer dollars, yet the scrapping industry privatized

Sailor on the mast: Carlos sitting on the central pole for the windmill to be installed at Eastern Market, late 2018.
Drawing by Paul Draus.

the profit from what was left over or abandoned. Carlos took this as a personal affront, not just to himself but to the city.

As our deadline pulled closer, the pressure on Carlos, and by extension all those around him, intensified. The windmills needed to go in the ground by September 2018, and a lot of questions were still unanswered. His demands did not decrease as the time ran down—instead he added

more layers to the cake of his expectations. He would give me lists on a regular basis: professionally produced signs for the windmills; professional engineers; insurance; lectures on upcycling at the University of Michigan, Cranbrook, and Michigan State University; an audience with the mayor and the Bureau of Lighting; and lots of surprises for the final celebration or "whoop-de-whoop," including Mardi Gras dancers, Buffalo Soldiers on horseback, and a host of dignitaries. While some of these requests seemed fantastical, they were all based in discussions or connections that Carlos had previously had or made.

One of these discussions was with a man named Walter Bivens, whom Carlos had met at Historic Fort Wayne, where Walter led a contingent of Buffalo Soldiers reenactors. Walter was in the truck with Carlos when I came out to survey the just-installed windmill in advance of our final "whoop-de-whoop" ribbon-cutting event. Carlos beckoned for me to get in the back seat, and I listened in while they talked back and forth, occasionally engaging me also. Soon after that, Walter had to leave but not before agreeing (in principle) to bring a horse or two out for the unveiling. "This guy," he said, gesturing to Carlos, "is always in drive. He doesn't have no reverse gear."

I responded, "He can't even find neutral!" This made Walter laugh out loud. It was a tossed-off statement, but it got to a central fact about Carlos—he never wanted to back down, much less back up. His belief in his own ability, especially when in his native element of metal, was nearly boundless. The drive to get a job done emerged in a heroic fashion when all the pieces came together, and Carlos was the one with the skills and expertise needed to make it happen. Now all the pieces had to come together. There was a kind of collective rush to the process, which I saw up close as I helped to coordinate the final installation.

The third week of September had arrived, and it was time to put up the first public windmill in time for Eastern Market After Dark, a popular annual event, which would potentially shine a public spotlight on the new installation. At C.A.N. Handworks, the pieces were laid out like a large-scale Lego set—the central pole, one of those rescued from Mistersky yard, freshly painted grass green; the flower-like assemblage of blades in fire-engine red; the generator, the solar panels, and the electrical box—all the components of an off-grid energy production system, ready to move on

Carlos's trusty flatbed trailer. Carlos's former apprentice Eric Froh showed up to help at the last minute, along with a couple of the hackers, one of my former students, and me.

Tony Biundo, Carlos's long-time collaborator, had a plan for raising the windmill, using a system of straps, a pickup truck, and a scaffold, but Carlos was concerned that this would bring added risks of the windmill falling or someone getting hurt. Instead, he wanted to utilize a mobile lift from Eastern Market. He had seen some of them being used to prepare for the Murals at the Market Festival, which also figured prominently at Eastern Market After Dark. He asked me if I could temporarily procure one. I was willing to try, and so I got on the phone and started calling people at the market to figure out who owned those machines and how we could borrow one for about an hour. Somehow I managed to get hold of a machine operator, a low-key individual, who effectively shrugged and said, "Sure, why not?"

So it was that all those disparate pieces finally came together. Watching the green poles and spinning red blades rise against the fall sky was a shared thrill. Eric and Carlos perched on the arms extending horizontally off the central pole, while Carlos's daughter, Belinda, documented the moment with photographs. The windmill went up, the power was connected, and the ribbon was cut, with local artist and MC Bryce Detroit performing and some short speeches delivered through the windmill's robust speaker system. It was not quite the carnivalesque display Carlos had envisioned, but it was satisfying all the same. Later, in the cold of November, we put up a second Detroit Windmill, fulfilling the requirements of the Knight Arts grant and making a mark on the local landscape, outside of the confines of Carlos's shop.

In February 2019, as a follow-up to the installations, we conducted a community engagement session inside the Kid Rock Room at Eastern Market. Representatives of communities and organizations from across Detroit shared ideas for potential uses of the windmills in their own neighborhoods or institutions—for example, to power homes using old car batteries charged by the Detroit Windmill; to provide power for events, such as air compressors for bouncy houses, popcorn machines, and loudspeakers; and to provide power for localized security and wireless communications systems. They also

Chapter Four

Detroit Windmill installed in the Eastern Market Garden, November 2018. Drawing by Paul Draus.

discussed making the devices more inclusive and accessible by conducting windmill workshops throughout the city; creating cost-sharing options for communities; and developing a windmill-based skilled trades curriculum and certificate that could be transferred to other job opportunities.

As my partnership with C.A.N. Art Handworks continued, more advances were made in developing the Detroit Windmill Project as a platform for innovation and engagement of communities across the city. In 2021 a set of large-format informational displays were produced to communicate both the concept of upcycling and the process of generating electrical power by integrating energy inputs from both wind and sun. Temporary grant-funded installations were carried out in three community locations in Detroit in the summer and fall of 2021: at an urban farm on the city's east side, alongside an activated alleyway on the west side, and three units at a public park in the

Confronted with the Might

Carlos at newly installed Detroit Windmill at Feedom Freedom Growers, Detroit's lower Eastside, Summer 2021. Drawing by Paul Draus.

downtown area. Engagement sessions accompanied each installation, and locals suggested ideas for how the windmills might address local community needs while building a sense of identity and empowerment in relation to the generation of green energy and the challenges posed by climate change. An installation at Feedom Freedom Growers on the lower Eastside, for example, involved integration of a wind-and-solar microgrid in a unique community setting that brought together urban agriculture, placemaking, and civic education in response to community needs for improving food security,

educating about green energy opportunities, and enhancing environmental resilience especially in relation to chronic flooding.

Carlos was initially obsessed with protecting his intellectual property. One of the issues we confronted while preparing to do the installation in the Eastern Market was his fear that someone would be able to observe it up close and copy his idea. This would result in someone undeserving coming along and "scraping the butter off my bread," as he liked to say. Carlos was fond of referring to the Detroit Windmill as his attempt "to build a better mousetrap, so to say." He said it so often that I hardly thought about it, but after he received a US patent (US10844836B2) in November of 2020 for his distinctive windmill design, I looked into the origins of the phrase. It is often accepted as true on its face, but when I saw how many other windmill designs had patents and how similar they were in terms of what they could do, I started to wonder if it was so simple. In fact, there is one mousetrap design, the wire spring trap, patented in 1899, that still remains predominant, and all of the others (more than four thousand of them) have not shifted its position. There may be some designs that simply can't be improved upon, and any difference is too marginal to matter. This could, in fact, be the case for the Detroit Windmill—that it looked great and inspired people to create but only produced marginal levels of usable power.

Carlos did not accept this premise. He saw the patent as certification from the US government that his idea was unique and worthy. Soon he was developing more modifications—blades cut from easily available plywood that would catch even more wind and produce more torque. "That's more horses on your wagon," he would say. He had me stand in the middle of Wilkins Street on a windy day holding up one of the blades, and recorded on his phone as I was pushed steadily backwards. "Fuck those offshore boys," exclaimed Carlos, delighting in my plight.

However, the improving post-bankruptcy economy, while making an evident impact on the city's physical and social landscape, also tended to favor participation by those with more resources, connections, and capacity. Black-owned businesses like C.A.N. Art Handworks were especially attuned to the economic exclusion so often evident in development of the "New Detroit," and made even more stark by the COVID-19 pandemic that arrived in 2020 (Keppner and Mattoon, 2021). Nonprofit funders and foundations attempted to fill the gap by providing access to resources for capacity-building,

Carlos's vision of the Detroit Windmill as a one-stop microgrid power source, providing free green energy to meet a variety of local needs. Illustration by Marco Evans, used with permission.

but often these had their own costs in terms of money and effort. The trials and errors of research and development, especially for the electrical system and electronic components that the Detroit Windmill design demanded, contributed to time delays and additional costs in early phases of this project. Even after the initial installation of a Detroit Windmill, adjustments and modifications often needed to be made, and much of this cost was absorbed by Carlos himself, covered by earnings from commercial work. Apart from these internal challenges, the economic environment also presented obstacles. With new development projects launching on a regular basis and major companies entering the market from outside the city, local entrepreneurs began to feel as though the New Detroit was leaving them behind.

The Detroit Windmill microgrid, Carlos believed, could fit in that precise space, bridging the divide between the high-tech, big money world of downtown and the low-income, high-need environment of the neighborhoods—keeping parts out of landfills, providing jobs and skills, and transferring wealth all at once. In a 2021 video interview with Knox Cameron of DTE Energy's Renewable Solutions Team, conducted in front of windmills Carlos had recently installed at DTE's Beacon Park, Carlos articulated how his vision might fit within the institutional structure of power production. Cameron asked Carlos about the possibility of "looking at old DTE parts from either our electrical infrastructure or how we produced power in the past, to then inform, innovate, and introduce into our new fleet moving forward." To which Carlos responded, "Yes, [we would like to] have the opportunity to examine those parts, to study the process of recycling and then implicate a process of upcycling, which is re-engineering, like a Lego-stone principle, to repurpose those same beautiful engineered parts—they're working so long and so good—into something else like micro grids" (DTE Energy Corporation, 2021).

In those moments, Carlos was convinced, and convincing, concerning the possibility of achieving a win-win-win situation, where the community, the economy, and his own pocketbook would all benefit. But his moods shifted swiftly. One day, he would be riding high and ready to embrace everyone; the next, he would be down in the dumps, and the whole world was to blame. He installed a Detroit Windmill at Michigan State University's urban agricultural research center in the spring of 2020 but learned later that month that we had failed in our attempt to win the Department of Energy's Inclusive Innovation Energy Prize. His spirits, lifted to the clouds by one promising development, crashed to Earth just as quickly, and he wanted to know why the whole world was against him. The windmill's electrical system, though functional at first, proved fitful. This frustrated Carlos because this was not something he could control or fix by himself. His windmill was meant to change the world—why was the world not rushing to embrace it?

Meanwhile, his mind was constantly spinning off other potential projects—the Detroit Gallery of Metals, a showcase for both traditional and contemporary metalwork; the Detroit Historical Resource Recovery Authority, a city agency with jurisdiction over every building being remodeled or disassembled, empowered to keep valuable pieces of history from being

Carlos as heroic "Wind Man," bringing green energy to Detroit and the world.
Illustration by Marco Evans, used with permission.

sold for scrap or tossed in the trash; and the Handwerkskammer Detroit, an association of creative craftspeople that he envisioned setting the standards and providing the workforce for all work being done on historical properties in the city. However, as with Cervantes's protagonist, the phantoms lurking in Carlos's own mind were sometimes as much a challenge as the enemies arrayed outside.

Chapter 5

CRAZY AS HELL

In the summer of 2018, as we were frantically working to get the windmills installed in Eastern Market, two Sheriff's Department officers made an unannounced visit to Carlos's studio, looking to serve a warrant. Carlos's father Clarence, a former military policeman, dutifully opened the door, and the officers came inside, guns drawn, looking for Carlos. Carlos grabbed his own gun and retreated into one of the building's hidey-holes, afraid that they would drag him to jail or shoot him down on the spot.

I learned of the situation gradually, getting a first hint following a construction meeting at the Eastern Market offices with Kenneth the architect, Tony the cement guy, and one of the partners from Eastern Market Corporation in attendance. Carlos was conspicuously absent, and according to the others he had called in to let them know that he was stuck at home with the stomach flu. This was a little surprising to me, since I had been with him the previous day for about three hours, including a trip to the junkyard and the nearby Milano Bakery, and he didn't show any signs of illness then. In fact, I had never seen Carlos sick in all the years I had known him. At this time, he was approaching sixty years old, but he was usually as spry as a teenager. However, illness can happen to anyone, so at that moment I didn't think twice about it.

Walking to the parking lot, Tony and I struck up a conversation about brick patios and pizza ovens (building them was his passion) and his relationship with Carlos. He had been doing jobs with Carlos for decades, and he recalled going over to the building that housed Carlos's studio when Carlos first moved in. "There were hookers walking all around the block," he said, in typically blunt language. One of them got into Tony's truck, and

he had to give her some money and a sweater to get her to leave. "I don't have anything against hookers, but . . ."

This was the first time Tony and I met in person, but we would get to be quite close in the days and weeks that followed. When I said that Carlos was hoping to be included in all the new developments going on in the city, Tony simply replied, "He deserves it. He loves Detroit, and he is always promoting it, and I love him for that." He then summarized the mixture of qualities Carlos presented. "He's a madman," he said. "I love him, and he's very talented, but he's stubborn and he's crazy."

As I was getting ready to leave the market, I called Carlos to check in. He said he wasn't doing too well and asked if I could come over. Still thinking he had the stomach flu, I said yes, but only for five minutes, because I didn't want to catch whatever he had.

When I got to the shop, I learned the real story: Carlos was not ill, but he was in a state of distress. When I went upstairs to Carlos's inner sanctum, he looked me straight in the eyes with his blazing gray-green gaze and a shock of wild hair framing his gaunt face, "Do you think I'm legitimate? Do you believe that I know what I'm talking about?" he demanded.

This was something Carlos would often do—confront someone with a rhetorical question that had a strongly implied answer.

"Yes, of course," I said. "What's up?"

That's when he gave me the play-by-play, describing how the sheriff's officers came knocking on his door, saying that they had a warrant for his arrest. Clarence, who was then in his late eighties, had answered the door, and he let them in after telling them that Carlos was out of town due to a death in the family. They made Clarence take them all the way upstairs while Carlos tucked himself away in a hiding spot, somewhere in the fortress-like building, holding a gun, while his pit bull, Herman, barked ferociously from behind a flimsy barricade on the third floor. Carlos recalled worrying, "If my dog gets out, he's coming after them, and they are going to have no choice but to shoot my dog!"

Eventually the officers gave up and left the building, but Carlos remained stuck in that moment of terror. From there, we were left trying to unspool exactly what was going on. Why would sheriff's officers be knocking on the door of C.A.N. Art Handworks in the first place, with an arrest warrant, no less? Carlos initially speculated that the visit could trace back to an old bank

Carlos had a way of fixing you with his gray-green gaze. Drawing by Paul Draus.

debt from around 2012, which he said he had paid off, or most of it. When he had been in Germany the summer of 2018, his daughter, Belinda, had to wire money to keep one of his vehicles from being seized. However, the card left by the sheriff's officers said "Felony Warrant Enforcement," which made me think it might be something more serious—a criminal rather than a civil matter. But what had Carlos done or, more precisely, what could law enforcement possibly accuse him of doing?

This was not an easy question to answer. The border between everyday life and incarceration in urban communities of color is often porous. I had taught classes in Michigan prisons for years and helped organize numerous

workshops on criminal justice topics with men in prison. I knew how quickly a seemingly small incident or offense could lead to a complex entanglement with the criminal justice system—in addition to the more obvious and immediate risk of lethal force. As a result of my research and teaching, I knew some people who worked in this murky world every day. Making a few phone calls to clear up the uncertainty was the least I could do, so I reached out to some people—a street court lawyer, a social justice lawyer, and a judge—and got some informal advice as well as some assistance in clarifying what was going on.

The street lawyer was able to look up Carlos's name, and he found no criminal cases open against Carlos in Wayne, Oakland, or Macomb Counties—just the old bank claim in the amount of roughly $13,000. The judge I spoke to recommended that Carlos get an attorney right away and then approach the court with the attorney—not by himself. She said that would change the entire tone of the interaction. Otherwise they could hold him for forty-eight hours to arraign him, and you never know what might happen with that. One simple piece of advice was provided by both the street lawyer and the judge: don't call the cops. "Never talk to the police," the street lawyer said. "That's my first advice to anyone."

After talking to them, I called Carlos and reiterated the concern that this might be a criminal case, as suggested by the felony warrant identity on the sheriff's business card, and he got really upset about that: "I am not some *criminal*," he growled, pronouncing that word very deliberately, as though to emphasize how much he despised those who are.

Information dribbled in through text and email over the next few hours, and I gave Carlos several quick updates. I contacted one of the lawyers recommended by an associate and then called Carlos the next morning to follow up. That's when he stated his suspicion that the incident was not accidental. Something more nefarious was going on. Carlos mused, "Another n#$%@ down. A crazy old nappy headed n#$%@ down." His understandable fear of malicious intent and violent death was underscored by the all too common police killings of Black men recorded on cell-phone video, from Walter Scott to Philando Castile.

At this point Carlos started to make a connection between the sheriff's officers' visit and his water supply. The evidence was largely circumstantial. In the summer of 2018 Carlos found that his taps were running a

yellowish-brown color. He took me to his upstairs bathroom to demonstrate, filling the tub with a liquid roughly the color of rust and urine. "Would you bathe in that? Would you drink that? If you had water like that out in Dearborn, what would you do? My dad has to use that water to wash himself!" This was in the wake of the Flint Water Crisis, as well as the controversial water shutoffs in Detroit that became a locus of human-rights protests and generated a vigorous resistance movement in 2014, as the city endured austerity imposed by financial management and state-supervised bankruptcy (Montgomery and Dacin, 2020). Carlos was not personally a part of this movement, but he knew the issue and he saw a pattern. He started to conjecture that the powers that be were using every method possible to flush out the old residents of the greater Eastern Market area to make room for new development. In other words, to pave the way for gentrification. That's when he dropped his signature phrase: "Paul, this shit is crazy as hell."

The term "crazy" dates back to the late 1500s. It originated with the craft of pottery—to be crazy literally meant to be full of cracks, like an imperfectly

Carlos shows me the brownish water filling his bathtub during the summer of 2018. Drawing by Paul Draus.

fired pot. Later it came to be associated with unsoundness of mind, insanity, or mental illness, to use today's terminology. But threads still connect older meanings to contemporary usage—a situation can be described as crazy because it is chaotic and unpredictable, and something that is surprising and unexpected may be described as crazy in a very positive way.

"Crazy as hell" was one of Carlos's favorite expressions, and its meaning when he used it varied widely—sometimes it was the highest form of compliment, and sometimes it was a condemnation. His windmill, for example, when it was finally set up to ring like Big Ben at the turning of the hour, was going to be "crazy as hell." It could also be used to describe an idea that he found outrageous—for example, when some of his friends with the Boggs Center talked about "New Work and New Culture," or work that was based on meeting community needs or inherent satisfaction rather than financial compensation. Carlos's response to this idea was straightforward: "It's always about the money. How you gonna turn a student on to something that don't make no money? This is crazy as hell." Just as often, however, Carlos used the phrase to describe situations that were unfair, irrational, and counterproductive, especially when they undercut or impacted him in a negative way.

In the case of the sheriff's officers and the City of Detroit Water Department, I had to agree with Carlos. The situations he described were outlandish, but his speculations were all too believable in the context of a divided and unequal Detroit, institutional manifestations of what Partridge has called "hostility as technique" (2022). Big machines were in the street outside his building, and he saw the drilling of pavement and shaking of his foundation as another effort to make life in the area unbearable—especially because no notification had been given to the neighborhood. This was a stark reminder of the ways in which racism cleaves the world into different sets of experiences and expectations for different sets of people. In majority-White suburbs such as Dearborn, where I lived, there was an expectation that public agencies worked for citizens, particularly homeowners. I ended up calling the City of Detroit Water Department on Carlos's behalf, and they assured us that the problem was temporary and related to the repair work that was being done on aging underground pipes. In a few days, the problem subsided, but the impression it left on Carlos was clear. In the end, he never gave me a clear answer about the sheriff's officers' visit and why a warrant

was served at all, much less in such a violent way. He was eventually able to resolve the matter with the help of another attorney, who was referred by the social justice lawyer, but his underlying suspicion remained. The setbacks of the Great Recession had been traumatizing, and his perception of a hostile White power structure was only reinforced by these experiences.

Though exclusion from economic opportunity was often his primary focus, Carlos suffered serious losses in other areas besides his work. He had not only lost a father in boyhood, only to gain him back as a young man, but he had also lost a child—not to death but to the gaping maw of mass incarceration. Carlos didn't often talk about his only son, Keenan, but it was clear that his circumstances agonized him. One day, after having just watched the Netflix documentary series *Dope*, which included scenes of Keenan snorting crushed pills and then rapping while high, Carlos shared his thoughts with me. He was not pleased with what he saw. In his eyes, his son was acting like a "crackhead" or a drug addict, people for whom he normally had little sympathy. "He got to get what's coming to him," he said, "but there needs to be something on the rehabilitation side too."

I agreed with him, but I also knew that this was generally not how our system worked. All of the resources and authority are loaded at the front end, on the allocation of punishment. Rehabilitation, such as it is, only comes later, almost an afterthought, and is usually underfunded and often simply unavailable.

That same morning I spoke to Carlos's former apprentice, Eric. He now had his own shop, with attached living quarters, which he likened to "Carl's castle," except that it was located on the opposite side of the city. He had gotten to know Keenan after he was released from prison the first time, and he worked with him on a lot of projects. He tried to help him out as much as he could but eventually had to separate himself. "It was just too much," he said. "Too much." Keenan, he said, had a total lack of humility (maybe inherited from his dad) and came off as cocky in a way that didn't always work for potential clients. Eric watched, over and over again, how people came together to give Keenan opportunities, and Keenan, in his words, "pissed them all away."

On the other hand, nobody denied Keenan's ability. Carlos said, "Eric was all about the numbers, the business, but for Keenan he worked like he was playing; it was natural." Keenan's work still adorned the lot at C.A.N. Art

Chapter Five

Happier days: Carlos and Keenan at the Gateway to Freedom Memorial on the Detroit River. Drawing by Paul Draus, from a family photo.

Handworks and could also be seen in other parts of the city: giant origami birds made of steel, painted bright red; metal flowers as tall as small trees. Keenan and Eric had done some work with the Burning Man festival out west and had helped to host events at Historic Fort Wayne. Metalwork and sculpture were fields that Keenan had abundant access to, with both talent and connections beyond what most Detroit kids could even imagine.

But there was something about the old neighborhood that kept sucking Keenan back in. Carlos told me that if he had his way, he would have sent all of his kids to Europe to be raised there, but their mothers would not consider it. So Keenan grew up around a local crew on 7 Mile Road, and he went back and forth between there and his dad's house, between the block and the blacksmithing trade. His name on the street was "Dollar." Carlos said that Keenan had seen how racial preferences played out in the skilled

trades while working with Eric, and he simply said, "Fuck it, I'm not going to deal with it." As a White metalworker, Eric would get the majority of jobs, even though Eric and Keenan had worked side by side and Keenan's skills were equal or superior. So Keenan kept going back to the same old shit, his friends, the street, and his dream of being a rap star.

Here I saw a connection to that vast territory of socio-spatial trauma that touched almost every aspect of Detroit's daily existence, stemming from the ongoing and omnipresent pain of racism. As a scholar, I had tried to describe this terrain in a series of publications dating back to 2009, when I made my first attempt at writing about Detroit. That article, titled "Substance Abuse and Slow-Motion Disasters," concluded, "Patchwork labor markets, persistent poverty, and the drug economy achieved a stubborn symbiosis reflective of both continuing racial and ethnic segregation, and the entrepreneurial adaptation of those who have been historically excluded" (369).

Then, I had only been living and working around Detroit for a few years, and I drew heavily on the rich (and growing) body of literature about the city, as well as the parallels between Detroit and post–Hurricane Katrina in New Orleans. I read now-classic texts, such as Thomas Sugrue's *The Origins of the Urban Crisis* (1996) and Dan Georgakas and Marvin Surkin's *Detroit: I Do Mind Dying* (1998), and more journalistic and also more sensationalistic works, such as William M. Adler's *Land of Opportunity* (1995) and Z. Chafets's notorious *Devil's Night and Other True Tales of Detroit* (1990), as well as reams of academic articles. A renewed interest in Detroit following the financial crisis of 2007–2008 led to a surge in Detroit studies, which coincided with my own research trajectory. With co-author Juliette Roddy I published an article in the journal *Space and Culture* that specifically explored the role of monstrous imagery in furthering the marginalization of both residents and neighborhoods of the city (Draus and Roddy, 2015). In all of this research and writing, we grappled with the long-range impact of the repeated cycles of trauma that were inflicted on Black Detroiters.

Perhaps Keenan hadn't experienced the worst of racist segregation, at least not compared to someone like Clarence, who lived through Jim Crow. However, because of the environment he lived in, this was what he grew to know, and it shaped the choices he had, or that he thought he had. Trauma may stem from a single incident or a series of accumulating blows. If those blows are embedded in the very landscape that surrounds you every day, so

that it becomes a part of your *habitus*, then in effect you are living it out, and limited by it, because of how it continually interrupts your thoughts and short circuits your reactions.

I watched the *Dope* episode about Detroit years after I first learned about it from Carlos. I must say that I hated almost every moment of the program, with its all-too-familiar racialized tropes of dangerous urban streets, demon drugs, and heroic, well-meaning police, awash in an overbearing soundtrack that reinforced the contrived tension and drama. Perhaps as a result of my own research on substance abuse, I had developed an aversion to most Hollywood-style portrayals of addiction and the business that surrounds it, including the cop business. Nevertheless, I was pulled in by the sensationalized visual style and the melodramatic narrative. It told a real story—of young men trying to "get some of that White people money" in the best way they knew how—and provided a sense of the harsh environment that they were navigating, the abandoned buildings and neglected civic infrastructure that surrounded them. It did not do anything to interrogate that circumstance or explain how or why it came into being, but it did effectively convey the sense of meaning and purpose that people derived from their actions, especially as a response to the structural racism and poverty they experienced. "Chances make champions," says one of the young men involved in the production and trafficking of club drugs.

Of course, this also was part of the trap. People respond in a coordinated way to the stark limits that they confront, but in doing so they make themselves even more vulnerable to the punitive state. Tony Gaskew, in his 2014 book *Rethinking Prison Reentry*, describes this system as a pure predator: "Exactly like the great white shark, the criminal justice system is a machine, largely unchanged by the social evolutionary forces of due process, poverty, civil rights, war, demographics, or even politics . . . [I]t is designed to arrest, process and confine human beings, twenty-four hours a day, seven days a week" (93–94). In the Netflix show, a Border Patrol agent, patrolling the waters of the Detroit river to watch for drug smugglers going across on jet skis, articulates this all too clearly: "It's a classic shark in a school of fish," he says, talking about the drug traffickers riding WaveRunners. But another statement by a Border Patrol agent makes it clear who the real apex predator was: "He's moving right into my hunting grounds," he declares, before revving the engine of his patrol boat.

Eric lamented the irony: when everyone is poor and you do what you need to do to survive, when people pool their resources and rely on each other, and then law enforcement agencies take that pooling as prima facie evidence of collusion in an illegal enterprise. To my understanding, the video recordings that Keenan made with his 7 Mile buddies, including his aspirational rap videos, became a part of the criminal conspiracy case that the Feds built against him, resulting in his long-term incarceration, far from his home in Detroit and his infant son. To use law enforcement parlance, he was "stitched up"—tied to a network that implicated him simply through its proximity. The so-called gang to which he belonged, by virtue of life-long association, became a prize to display in the gallery of high-profile busts.

For Carlos, it all went back to the neighborhood and family environment and represented a fundamental reason why he chose to offer his own life and career as an alternative model—a way out of the dead-end life of the street. He described a recent experience with Keenan's son's mother, who was staying with Keenan's own mother, who now lived in a near suburb of Detroit, far away from 7 Mile. Nonetheless, in his view, she had brought all the baggage of the neighborhood with her. "All that shit is ghetto toxic, like you wouldn't want to believe," said Carlos. He continued at length:

> Keenan's mother is the only one in the whole family who has a steady job, so she have income. But socially she is, like, on the same level. It's not really a healthy situation, especially for, like, a two-year-old kid. I talked to Keenan cuz that's his girlfriend, his kid, and his mama. His mother is, like, always working, got money, everything. But there is disorder, dysfunction, hoarding, everything else you can imagine. It's not dangerous, or anything, but I wouldn't want to live like that, you wouldn't want to live like that. It's got to cause something to the kid, have, like, Vietnam shell-shock syndrome or something.

Carlos's experience growing up in postwar Germany, with old Nazis still around him, in every institution, informed his perspective on what was truly needed in the United States. "It's working with your past, just like if you're a rape victim or something, you need counseling. The Germans did something horrific, and how you going to deal with that? You don't even know how to resolve that. Analyzing the past, how it got to that point and

Chapter Five

making a strong effort to do it better. This never happened in America." Real work needed to be done, he seemed to be saying, on both the cultural and psychological side, for the oppressed and the oppressor.

In a long letter to me, written from federal prison, Keenan had transcribed words from a 1789 address authored by the Pennsylvania Society for Promoting the Abolition of Slavery that conveyed many of the same themes: "Today many of us sit in jail cells unhappy with hatred in our hearts.... The galling chains, that bind our bodies, do also fetter our intellectual faculties, and impair the social affections of our hearts. Accustomed to move like a mere machine, by the will of the oppressor, reflection is suspended; we have not the power of choice; due to the trauma of the captivity, poverty and oppression, reason and conscience have but little influence over our conduct, because we are chiefly governed by the passion of fear." Keenan ended up losing more than five years of his life to the criminal justice machinery, first while sitting in jail awaiting sentencing and then finishing his sentence. He was released in 2023 and sent to a halfway house in California. Eventually he hoped to return to Detroit and work with his father again.

"We spend so much time on this, that's not productive, at all," said Carlos. "Those stories are, like, socially dividing. I bet in every Black family there's a story like that. The stigma they associate with it; they paint you in a corner." Carlos was determined that his son and his grandson would not be stuck like so many others in a lifelong trap of trauma and exclusion. He refused to go to the prison or courtroom to see Keenan, because he considered himself a law-and-order supporter. But he wanted his son to come home; he wanted him to receive, as he put it, "due consideration." "Everybody know Keenan is in jail," he said. "I grow my hair long; when he gets out, I cut it off." It was a chain he always bore, heavy even when unseen by others, which he longed to break. Carlos's halo of hair, which he would comb straight back to make it look clean-cut for formal meetings, served as a kind of animated symbol of his Mr. Hyde side, as well as a sign of his commitment to his son.

I communicated with Keenan during his incarceration about his past and how it was impacting his potential future prospects. In this correspondence, he reflected on these circumstances and where they had led him: "You have to choose wisely who is in your front row of life and who is in the nosebleed sections. Me personally, I am at a stage in my life where I am

weighing the pros and cons of having certain individuals in the forefront of my life. Unfortunately, I have been involved with people who have had a negative influence on my life. And on the path to recovery, I am consciously deciding who is in the inner circle of my life and who I choose must remain at a distance in order to achieve the optimal outcome of success."

He also commented on the crushing impacts of the criminal justice system, which fueled his determination to overcome those circumstances: "From my observations and personal experiences, I have become aware that people are ashamed of being associated with so-called criminals. In American society, once labeled a criminal, people are ashamed to be associated with these labeled individuals. From my personal experience, I have observed that I have been hidden away from the public when it comes to C.A.N. Art Handworks. Since I have been incarcerated, there has been little to none in regards to promotion, sales, or advertisement of my artwork. Even my past projects have not been maintained or serviced. This is the motivation behind my desire to be one of the greatest artists ever. From my research, I have the potential. The only obstacle: my difficult journey and the opposition presented therein." He concluded by saying, "Any run-in with the American so-called justice system decimates Black families but we are strong and we will prevail. True love trumps all!"

Carlos, for his part, repeatedly found that passion was not enough. His expectations would shoot sky high, and when setbacks emerged (as they always did), his mood would plunge to abysmal lows. Those of us who spent a lot of time around him referred to this in a humorous way, remarking that today he was in "full Carlos mode." That was the no-first-gear, no reverse Carlos, a charismatic and chaotic force of nature that could immediately magnetize a room, but with varying valences. Sometimes Carlos attracted, sometimes he repelled; and though he often argued against what he called a "polarizing approach," at times he could not help himself. He sometimes burned bridges with a blazing torch.

What Carlos really needed was a project manager. Carlos himself often suggested this. The problem was, who could manage Carlos? At some level, he was essentially unmanageable, almost like the wind itself. A meeting that we held in December of 2020 was typical of the topsy-turvy direction these interactions could take. It was held on a virtual platform, as we were still in the midst of the COVID-19 pandemic, and the purpose of the meeting was

to discuss the implications of the US Design Patent Carlos had recently received for the Detroit Windmill. On the call were myself; one of my colleagues from the College of Engineering, who was just starting to work on some projects with Carlos and me; and Lorne Greenwood, a retired manufacturing engineer, who worked as a volunteer with the US Small Business Administration. Lorne had known Carlos for several years and was very familiar with the windmill project, but he was a no-nonsense realist when it came to the business side of things.

The meeting began with Carlos recounting the progress made on the windmills in the previous years: "After ten years of trial and implication, it was rewarded two days ago with a United States patent. I think it's done very beautiful, the object is already ten years in operation, so, from a mechanical standpoint, it is just as solid as a rock. What's left to explore is the electronic generation of the power that's got to be optimized, and the usage, how user-friendly is it, and how can it be integrated into the community." This was a very measured statement that accorded well with my own knowledge of the windmill, how far it had come, and what was still needed. From there, Carlos launched into a list of goals for the next phase of the windmill's development.

"Now that we have the patent, I'm so enthused to see where the next step is. How can we get this to the market? How we can implicate it to the community? How we can take advantage of some of the development that's taking place right now, with the people who are willing to implicate it, even if it's not generating power, just as a stepping stone toward generating power? I'm looking for a commitment of a hundred units before the year is over," he said with authoritative confidence. He was just getting warmed up.

"We have ten units on the docket right now. We have possibly anywhere from thirty-five to fifty in the Eastern Market development, that's promised, and maybe at the Fiat Chrysler plant if we have some more engagement there." This was starting to turn into an aspirational wish list rather than a realistic agenda. And he wasn't done. "It looks like we could probably get the letters of intent before the year is over to have one hundred units on the Eastside of Detroit, a regional distribution of it, and a regional implication that can be then calculated into other areas." For this last sentence, he raised both hands, as he often did to emphasize a point, and moved them

in a rotating motion, emphasizing the rolling out of this vision across the Detroit landscape.

His backdrop on the call was the metal eagle sculpture that hung on the wall behind his wooden desk, bearing a sword in one claw and an American flag in the other, flanked by an assortment Benin bronze busts and figures of various sizes—an impressive display that highlighted the range of his influences and interests. But the energy level in his voice trailed off just a little bit at the end, signaling perhaps that he had somewhat less confidence in these last few claims. I knew for a fact that Eastern Market Corporation had no firm commitment to purchase that many windmills. Carlos was seizing on the inclusion of his windmills in an artistic rendering done by planners. These images, produced as accompaniments to the community engagement process, painted a halcyon picture of what was possible that diverged starkly from what would eventually be done.

Lorne spoke next, concerning the implications of the patent and what it meant for the next stage of the windmill's development. His words were tactful but blunt. "Well," he said, "my understanding is it's a *design patent*. Because there's lots of windmills that generate electricity out there. So it's this particular design that is protected by the patent. Anybody can build a windmill. It's just that you can't build more that look just like Carl's." Lorne didn't know what the power production potential of Carlos's windmill was, but based on discussions with associates at a local technological university, as well our own pilot project, he proposed that it probably wouldn't generate much electricity. "If that's true, " he said, "then you've got a decoration. There's a thing that can generate a little electricity to power a cell phone or a loudspeaker, but it can't really provide power to a house or facility. So what's unique about this is that it looks different than the others; it is built with a combination of reused parts, antennas and wheel hubs, and so forth. How much market there is, I don't know."

Lorne had basically just described the Detroit Windmill as an oversized paperweight, a piece of yard art, or a mobile sculpture—but not an energy-producing device. This statement, delivered right at the outset, might have taken the wind out of anyone's sails. But Carlos pushed on, picking up momentum, asserting that his design was indeed viable if only he could have the technological support to move it to the next step. His belief was that

his wind turbine invention could produce enough consistent rotation, when hooked to the proper generator, to power whatever you needed to power. I pushed back a little bit, referring to Betz's law, which states that there is a maximum efficiency of 59.3 percent in wind-power generation—meaning that even the most efficient generator (which exists only in theory) could only harness about half the energy of the wind itself. My colleague, a mechanical engineering professor, affirmed that this was the case, while also noting that Carlos's concept of a high-torque, low-speed wind turbine was interesting and worth testing.

These back-and-forth deliberations tried Carlos's patience. He had a constant sense that time was running out, that this was a "race to the moon," and that testing urgently needed to be done. There was the consistent tension between the upcycling and creative industry aspects of the windmill project and the ambition he had to become a viable player in the sphere of green energy. Carlos wanted both simultaneously—to give his gift to the world and to maintain his intellectual property, to power a popular revolution and to generate wealth for himself and his family. "I need the support to sell the windmill as it is RIGHT NOW!" he demanded. "I don't look for twenty thousand dollars; I'm looking for two million dollars!" The meeting had clearly not gone as he intended. He had hoped that our university would be calling the news stations and arranging a press conference about his groundbreaking invention that was about to transform the universe. Instead, all he saw was "MORE WAFFLING!" His diatribe continued, "Let's bring the unit as it goes for ten years now on the market. Even if it don't generate electricity, let's promote it as a kinetic sculpture, and let's promote it as a stepping stone for creative industry, for upcycling, and bring it in front of school children. That's why it was originally designed, to be in front of kindergartens in schools for the next generation!"

In this conversation Carlos covered the whole heroic sweep of his quixotic quest, from competing with commercial industrial wind turbines to putting spinning sculptures in front of school children. This also illustrated the key problem—one goal was very different from the other. A few moments later, he calmed down again, and he managed to capture this tension, which some might call a contradiction. In his distinctive style, he summed it all up: "I'm interested in selling a product—I want to make a buck! But

we are creating not just a product, consumer type of situation, we are also having community benefit included into this and trying to figure out how this is all working together: green energy, Greta Thunberg, making a buck. There are major dynamics that are all playing a role, and if we can showcase that, there will be plenty of education and discoveries, and so on, for young minds to find, but also the way to industry, how to live the American way right here, how to go from zero to a product."

How to go from zero to make a product? This statement summarized Carlos's own mythologized story, as well as his version of the American Dream. In reality, these aspirations required material foundations. In the background of this conversation was the COVID-19 pandemic and the financial strain that it had brought to many small businesses, including C.A.N. Art Handworks. "I'm beyond my resources!" Carlos declared at one point. As I had learned, Carlos when he needed money was a whole different animal than Carlos when he was flush with funds. His business life, which also was his personal life, was a feast-or-famine, boom-or-bust cycle. Carlos was not on the street—in his self-made fortress on Wilkins Street, he was well above it—but nonetheless the street was all around him, and he was always one contract or payment away from it all falling down. It was a daily struggle, as he put it, "to keep all my marbles on the table."

Carlos would do anything to keep his business and his dream alive. That relentless drive and determination could be a source of innovation and inspiration, as it was with the creation of the Detroit Windmill and the vision it represented. Carlos had many impromptu and energetic discussions with guests in and around his workshop, some of which became heated, others filling him with hope and excitement. These discussions also sometimes inflamed Carlos's resentment concerning his missed opportunities. In those moments when things weren't going his way, enemies sprouted from behind every shrub on the horizon. Sometimes this seemed like a self-fulfilling prophecy; in perceiving people as potential enemies, he made them into actual ones. The COVID-19 pandemic intensified these cycles, cutting Carlos off from the day-to-day workplace and raising the stakes of survival. He always seemed to end up in a hopeful stance, like Don Quixote, getting back on the horse and remounting the lance, and I was sort of a Sancho Panza, providing a sounding board, and attempting to offer advice when he asked

Chapter Five

Meeting of minds: Carlos explains the necessity of his vision to a leader of a community block club in Detroit that had displayed one of the windmills at a public event. Drawing by Paul Draus.

for it. But I worried about the repercussions of his mood management issues for the long-term success of his projects.

As a sociologist, I was inclined to see Carlos's apparent "craziness" as largely contextual—reflecting the circumstances that produced it, as well as his modes of adaptation. Although he consistently projected absolute and unvarnished confidence in his abilities, this was accompanied by a tendency to shift blame onto others when things went sideways. However, Carlos was not devoid of introspection. One day, in February of 2019, he stated quite frankly: "I think I can really make a great contribution if I quit fucking around." He was thinking about the situation of Detroit, the great divide between Black and White, haves and have-nots, which he felt he had bridged, however tentatively. "I'm still astonished by the effect of this segregation. 'Free at last, free at last.' I thought that was all bygones, but this shit is still real. We're still wallowing in it."

On the other hand, it wasn't always easy to distinguish between the threats that Carlos suspected and the reality they reflected. It was hard to imagine a raid on his house happening totally out of the blue, without any plan or provocation. At the same time, it was difficult to see how a campaign of ethnic cleansing in the Eastern Market District would be coordinated. Like Sancho Panza, I knew that Don Carlos was neither insane nor a fool, but it was sometimes difficult for others to see the panorama he perceived. There was a stiff spine of belief in everything Carlos said, but his narratives could also be very self-serving. Like the metal that he loved to work, he could be both dynamic and unyielding. He knew how to bend, in order to adapt and survive, but he could also be stubborn and uncompromising, demanding to the point of conflict or breakdown, like a seized engine. Carlos's history of personal and business dealings was riddled with relationship wreckage—people that he was no longer speaking to, or who wouldn't deal with him again because of an argument or an agreement gone bad.

In August of 2021, more than a year into the pandemic, I met with Eric at his own studio workshop on the west side of Detroit. Eric had indeed taken Carlos's model and emulated it, creating a metal kingdom of his own behind a fence fashioned from shipping containers. However, he hadn't spoken to Carlos—who he still considered his "Detroit Dad"—in two years. I told him a little about the problem of project management that Carlos was facing. "Who could come in and manage a job, and also manage Carlos?" I asked.

"It's impossible," he said. "He does everything he can to ruin it."

"Why do you think that is?" I asked.

He shrugged. "I don't know. Childhood trauma. An appetite for destruction."

Eric recounted some of his own experiences. On one of his first jobs working as an apprentice on a metal fabrication job in Grosse Pointe, he ended up serving as the intermediary between Carlos and the client. "I was a twenty-four-year-old kid," he said.

Eric said he had learned a tremendous amount from Carlos—about what to do, and about what not to do. Eric had gotten more introspective due to the disruption of the pandemic. He had asked himself hard questions, such as, "Why do I have to be so good at everything? Why am I always right?" His workspace was adorned with artworks, those of others as well as his own, with inspirational aphorisms and books such as the poetry of

Dylan Thomas and *The Art of Happiness* by the Dalai Lama. When I asked him what he learned from Carlos that was positive, Eric was also very clear: "The absolute drive to get things right."

Carlos's vision for the future of Detroit, at its most expansive, involved enabling others to bridge that gap through bottom-up innovation and development of the human potential that was locked in the limiting confines of the neighborhoods—the same harsh environment that he had witnessed laying claim to his son. "The *Handwerkskammer* has got to be the ultimate goal," he said, referring to the German model of a craft union that negotiated solid living wages for those who worked with their hands. "You can make a pity party and list up all the bullshit that happened here, or you can try to make it in the system we have now and get a small business." Here he fell back on the myth of the American Dream, the belief in the better mousetrap. After all, it had worked for him.

As with most things, however, achieving this was more complex than it first appeared. Carlos couldn't just build a thing that worked; he had to bring others around to his perspective. Given how convinced he was of the quality of his creative output, he could not imagine that others would not recognize its value as well. That left only two options, both of which presumed malevolence in others: either they wanted to shut him out, or they wanted to steal his intellectual property. At those moments, he saw nothing but ill in the world. I and others around him worried about the repercussions of his mood swings for the long-term success of his projects. We tried to provide a sounding board for his anger and anxiety, offering advice when he asked for it. Keep your eye on the long-term vision, we would say. Don't get caught up in the weekly setbacks.

Carlos always seemed to end up in a hopeful stance, like Don Quixote getting back on the horse and remounting the lance. "I still got to see if I can make this happen, and not be out there and radical," he pronounced in one of these moments of optimistic commitment. He was speaking of the alternatives he saw before him: working within the system, getting a bigger piece of the capitalist pie, which he could distribute to more people, or storming the barricades with the revolutionaries to tear the system down. In effect, Carlos was confronting the question of Detroit itself: Could the past ever be transcended, if not repaired? Could the productive power and innovation of industrial capitalism exist in symbiosis with the craft

Empty pockets: Carlos was often struggling to make ends might while others in Detroit appeared to thrive.
Illustration by Marco Evans, used with permission.

consciousness of the artisan, the preservation of the natural environment, and the health and harmony of a diverse community? Could "true love," as Keenan put it, "trump all"? What would Detroit look like if remade in Carlos's vision? Given the forces arrayed against him, real and imagined, was it even possible to get his vision off the ground?

Chapter 6

FIGHTING (FOR) DETROIT'S FUTURE

Carlos's vision was expansive, and his ambitions were limitless, so it was not surprising that he was often disappointed in how things turned out. Beyond the innumerable, minute practical and logistical obstacles to be overcome in the pursuit of his various projects, there were also more malevolent forces at work. These ogres were poised to topple whatever castle he tried to erect. In particular, the specter of racism hung behind everything in Detroit, and it animated the landscape of threat that Carlos perceived. This perception went back to Carlos's earliest experiences in Detroit and, before that, to his run-ins with the closeted Nazis of postwar Germany. But the idea really began to crystallize while he was working at Detroit's Historic Fort Wayne in the late 2000s. It was there that he started laying the foundation for his dream of restoring Detroit as the Paris of the Midwest, as well as where he hit his first big barriers and glimpsed the monsters he confronted. That story needs to be told in order to understand how Carlos's vision for a prosperous future Detroit is simultaneously rooted in its past.

Historic Fort Wayne is situated on the banks of the Detroit River, south of the central business district and close to the edge of the city, a remnant of the city's dodgy, pre–Civil War days. The star-shaped fortress was built in 1851 as a frontier outpost, guarding against a potential invasion by British troops coming from the north through Canada, which was only a short boat ride away. That invasion never came, and Fort Wayne never experienced an actual battle, though it was used at various times as a detention center for Communists arrested during the Red Scare, as a supply center for World War II vehicles and spare parts, and as an induction station for newly enlisted troops. Like many other Black soldiers from Detroit, Carlos's

father, Clarence, had reported to Fort Wayne before shipping abroad for his military service in the 1950s. In 1967, during the Detroit rebellion against police brutality, the fort provided housing for families displaced by the widespread fires that reduced many of the city's commercial corridors to vacant shells. In the 1970s it was turned over to the City of Detroit, at the very time that the public purse was being massively drained by White flight and racist disinvestment.

By the early 2000s the fort's storied history had given way to prolonged institutional neglect, and the place became an untamed garden of competing interests. I had experience working there as a volunteer soccer coach from about 2005 to 2007. Chasing five-year-old kids on Saturday mornings across the tattered grass on the windswept fields along the river had made me fond of the place, another uniquely Detroit kind of treasure. Carlos first ventured onto the grounds of the fort in 2007, just before the Great Recession began to bite. There he found a feast of historical and craft treasures, the flotsam of Detroit's slow sinking, inexplicably moldering away, half-buried in dirt and weeds. The twelve-foot tall statues of the four virtues that formerly stood atop Detroit's Old City Hall were lying prostrate and in pieces. A box of human bones, likely looted from the nearby burial mound, was sitting unguarded in a dusty warehouse. To his eyes, educated in the value of artifacts, it was a travesty beyond belief. However, it also offered a redemptive path forward. "All we saw back then was the opportunity," he said later. "But then the city took a turn for the worse." Two different reports, one produced in 2016 and the other in 2020, describe the history of the fort and the city's relationship to it, as well as some of their visions for its future restoration, redevelopment, and public use (City of Detroit, 2016, 2020).

After establishing an agreement with the city in the late 2000s to early 2010s, Carlos occupied a guardhouse and began to restore it, as well as the historical theater, the bakery, and the blacksmith shop. He also sought to preserve some of the most significant metal artifacts stored at the fort, such as the bell from Detroit's Old City Hall, demolished in 1961, and the cannons intended for the city's defense. He began to see the possibility for an entire program of historic restoration and skilled trades education based at Fort Wayne, similar to what he had experienced at Johannesberg when he was a wild and troubled teenager. During this time, Keenan joined him at the site and used some of the space to build structures for the Burning

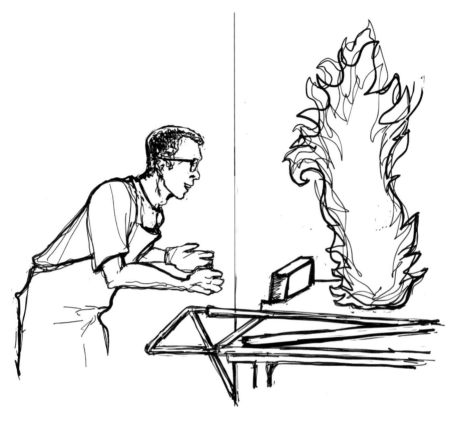

Carlos firing up the forge at Historic Fort Wayne's 1846 blacksmithing shop. Drawing by Paul Draus, based on a photo by Justin Rose for *Detroit Metro Times*.

Man festival in Nevada. This was more than ten years before Keenan's legal entanglements, and his career as an artist was in ascendance.

They weren't alone in trying to reinvigorate the fort. Others also laid claim to the legacy of the property, most prominently a group called the Historic Fort Wayne Coalition, who used the site to stage historical reenactments of Civil War battles—which never actually took place at Fort Wayn—and other events targeted to their non-Detroit-dwelling demographic. The long hours that Carlos and Keenan spent at the riverside ruins meant that they witnessed a lot of the other groups' activities up close, from Boy Scout jamborees to all-night bonfires. From this front row seat, it became clear to Carlos that their visions for the fort were starkly at odds.

Chapter Six

One of the most troubling encounters occurred in October 2010, when the Second SS Panzer Division Das Reich "Der Fuhrer" Regiment held a gathering at Historic Fort Wayne. According to the group's website, "no persons within this unit have political affiliations or beliefs that coincide with period or neo-Nazism.... Those supporting any racist, fascist, or extremist viewpoints should look elsewhere; we are involved in military historical interests only." However, as Carlos saw it, the supposed "reenactment" at Historic Fort Wayne appeared to perpetuate that very ideology through its idolization of the SS troops and displays of their paraphernalia. There were young boys that appeared to be about twelve years old, definitely not older than fourteen, in full uniform with guns. Men in Nazi uniforms were talking to groups of children, and there were no people of color represented anywhere. In his description, the atmosphere was one of a carefree day at the park.

Having grown up in a postwar Germany that was still reckoning with the traumatic aftermath of the Nazis' catastrophic reign of hate, Carlos was

Nazi SS Panzer Division reenactor at Historic Fort Wayne, October 2010.
Drawing by Paul Draus, based on photograph taken by Carlos Nielbock.

highly sensitized to the way this was being represented. He was shocked at the apparently celebratory display. The dressed-up tents, battlefields, and camps included no information that discussed the horrors of the Nazi regime. If the event was about historical education, Carlos reasoned, they would have provided information regarding the full scope of the war and Nazi atrocities, not just what seemed to be blatant glorification of the Nazi military. After talking with some of the Nazi impersonators, he brought his father Clarence, a US Army veteran, to see the event. Carlos took numerous photographs of Clarence amidst the Nazi flags and vehicles. Underneath the surface of his apparent geniality, he was outraged, thinking of the psychological effects the display might have, not only on his father but on the broader Detroit community—not to mention how offensive it was to those whose families suffered during World War II or whose relatives fought in the war against the Nazis.

At another reenactment, this time composed of ersatz Confederate soldiers, Carlos again observed that the atmosphere was more like that of a weekend carnival than a serious consideration of the true origins and traumatic impacts of the US Civil War. In his view, such events, absent any educational information demonstrating multiple aspects of the Civil War, including the sacrifice of Black and White Michiganders to defeat the Confederacy and end the abomination of slavery, only perpetuated ignorance and racism. As a Black soldier from Detroit, Clarence had experienced racist treatment throughout his lifetime. Ironically, this treatment was just as likely to take place on US soil as in postwar Germany where he was stationed. Nonetheless, he proudly served his country. To see events that apparently idolized the racist militarist regimes of the Nazis and the Confederacy taking place at Historic Fort Wayne, where he and many other Black soldiers were processed into the military, was potentially retraumatizing. The fact that there were no people of color present or represented at these events shielded them from any such criticism. They were effectively all-White bubbles of imagined history, staged inside the nation's largest majority-Black city.

Carlos's mind burned with questions for the powers-that-be. If these events were truly about military history, why were Black soldiers and Black army affiliations not highlighted to represent true history? Why were the victims of these murderous regimes, or the destructive, racist ideologies they embraced, not highlighted and exposed? Why were the actual battles that

occurred on the soil of, or near, Fort Wayne, not demonstrated? Why was there no proper Detroit War Memorial honoring Black as well as White soldiers at Historic Fort Wayne? The true racial and ethnic composition of Detroit, with its rich, diverse heritage was not reflected at Fort Wayne. In his mind, this represented not only a missed opportunity but also a form of cultural and historical malpractice.

His criticism was not reserved solely for those who continually whitewashed history and denied or suppressed the contributions of people of color. He was also disappointed with the ways in which African American cultural heritage was often depicted inside the Black community itself. "All they know about is the cotton field and the coal mine," he would often say. "How come they have not documented a cultural heritage predating slavery and servitude?" In the late 1980s Carlos had begun attending African World Festivals that took place annually at Detroit's Hart Plaza, and he started talking to the African people who were there, learning more about traditional metalwork. "I established a great relationship with all those African vendors," he said. He was struck by the apparent disconnect between that heritage and the African American people that he knew in Detroit, who did not see the value in this work or what it represented. "Everybody thought it was voodoo art," he said, "especially the Congo stuff with the nails in it." Carlos, however, immediately recognized the techniques of lost wax bronze casting and admired the skill evident in the pieces as well as their distinctive beauty. "I didn't know anything. I just knew that was great art, like what Ed Chesney was doing, and it looked Black." Chesney was a Polish American sculptor, born in Detroit, whose traditional, realist statues adorned institutions and memorials across the Midwest. Carlos had met him in the 1980s, when he kept a studio on the Eastside, near Clarence's place on Helen Street. Chesney had died in 2008, and Black Detroit, in Carlos's view, still had no comparable counterpart. Although upcoming sculptors such as Austen Brantley and Tiff Massey have begun to fill this void, Black experience remains largely unrepresented in prominent public art, in spite of Black people being the majority population in the city.

Carlos's search for an authentic Black heritage, not defined by oppression and victimization, was certainly not original to him, especially in the city of Detroit, where the Nation of Islam was founded. Black Nationalism has a long history, and many activists, scholars, teachers, and local and national

Fighting (for) Detroit's Future

leaders live and teach Afrocentric values. Carlos himself was friends with many of these figures and learned a great deal from them. He had even met Charles Wright, the founder of Detroit's Charles Wright Museum of African American History, at the African World Festivals, where he began his own collection of artifacts. What he offered, relative to others in the city, was the distinctive insight of someone trained in the craft of traditional metalworking. By the time Carlos came to Fort Wayne, he had a large and growing collection of West African metal art, and in his usual

Carlos's exhibit of African art went on display at Historic Fort Wayne in August 2010, with this mounted figure and heading. Drawing by Paul Draus based on a poster printed by C.A.N. Art Handworks.

voracious autodidactic style, he had learned a great deal about the pieces and their historical and cultural significance. He decided to establish an exhibition of African Metal Art at the Fort, and his ambitions were typically lofty: "I merely wanted to present five hundred years of craftsmanship." He created a small poster that depicted a mounted figure from Benin, bearing a lance. It could be read as a stand-in for Carlos's quixotic jousting with the majority-White groups who laid claim to the fort and who did not react well to the exhibition. "All them rumped their nose," he said, using a colloquial German expression indicating a gesture of disdain. "From 2007 to 2010, I was the German, and after that I was the Black guy."

In the midst of the financial woes of the late 2000s, Carlos was also actively working on his windmill designs, and his vision again expanded. He began to see the fort as the focal point for several initiatives: green energy research and development, skilled trades workshops and training programs, and ongoing historic restoration. He imagined something along the lines of a European model, with established crafts professionals and academics working alongside students drawn from the local community, training a new generation in manual skills while faithfully restoring the legacy of Detroit's past. He worked with a prominent local architect to develop a plan for rehabilitating the historic buildings and occupying them with workshops or cultural interpretation, creating a kind of craft ecosystem along the Detroit River that would both support a tourist economy and generate useful products and skills. He established alliances with some of the less prominent groups represented at the park, such as the proprietors of the Tuskegee Airmen Museum, the Woodland Indian Museum, and the African American men who portrayed the legendary Buffalo Soldiers and the 102nd Colored Infantry, complete with horses and rifles. These groups held Juneteenth celebrations at the fort long before it became recognized as a national holiday, and Carlos began working with them on a plan to restore the stables at Fort Wayne. Like many other plans made during this tumultuous time, it did not come to pass.

I was not yet working with Carlos during this time period, but my colleague Juliette went to the Fort with him to see what he was up to. She was enthusiastic about the potential for his projects to get broader support, and we began thinking of ways that our university might partner on some of them. Together we developed our first proposal with him, entitled

"Integrating the Manual Arts into Detroit's New Economic Development," which we submitted to a university grant program dedicated to fostering social innovation in Detroit. The proposal had two major components. The first was developing Carlos's workspace at Historic Fort Wayne into an active commercial workshop, educational center, and potential tourist destination, similar to what can be found in places such as Dearborn's Greenfield Village or Colonial Williamsburg in Virginia, where authentic work could be produced and craft processes observed and learned directly from Carlos, his craft colleagues, and their apprentices. Large-scale restoration projects could be a potential source of employment in the short term while enhancing economic growth and quality of life for the city in the long term. Secondly, we proposed that Carlos's old-world techniques could be integrated into the design of products that could connect to potential growth markets, especially

Carlos's vision of locally made wind turbines installed at Historic Fort Wayne.
Illustration by Marco Evans, used with permission.

in the areas of consumer goods, such as custom hardware or decorative or functional art.

Even as these visions were developing, however, the city's financial fortunes further declined, and Carlos's relationships with the Historic Fort Wayne Coalition deteriorated. In Carlos's account, the repeated orchestration of de-contextualized, White-centered activities derailed his plans to restore several buildings and activate them with positive educational programming that would benefit the people, and especially youth of color, in the city of Detroit. He believed that the coalition's continuing activities would degrade the value of the fort as a cultural and historical resource, reducing it to a playground or stage for "re-enactments" that idolized White supremacy and militarism. His visions of windmills installed at the fort, converting some of its unused territory into a test field of locally designed and constructed green energy, also went nowhere.

In a recorded sit-down conversation in 2020, Walter Bivens, one of the Buffalo Soldiers reenactors, shared his recollections of this period. With a bald head and full, graying beard, seated in one of the ornate African chairs of handmade bronze at C.A.N. Art Handworks, Walter looked like a warrior, scholar, or king, in a black Nike T-shirt. He recalled Carlos's vision for the fort, as well as the obstructions he encountered: "When you were in the embryo stages of starting the restoration of the entire fort, it appeared as if they could not stand to see one man that was ready to grab a project, knowing it was a mammoth project, and start putting it together. So they found a way to sneak, steal, and deprive you out of the fort altogether. They had members of the Aryan Nation coming in at night, and they had rituals going on, when you would never think that something like that would ever exist. They were doing this right up under our noses."

Carlos chimed in, "Promises was not met, and we was bamboozled and burned our own money on all of the events. We didn't even know what was a grant or how to apply for it. They took so much advantage of our ignorance, and that has scattered all hopes for the older people; they believed us, that we getting something going there finally, we getting some kind of recognition for our cultural heritage. They came up with a three-hundred-man volunteer army, cut the grass, booted us out of there, made us look ignorant, like we couldn't do nothing, but all of those people come from the suburbs or the militias right there. They have farms and farm

equipment, and applied themselves at the fort and took the whole thing over and booted us out of there."

Walter nodded and said, "That's exactly what took place."

Carlos continued, "It took an emotional toll. Like the young man that was promised a career or future there was lied to and went different ways. And the volunteers, they was promised to unfold their museums and their historical wherewithals there and make them accessible to a greater public. That was all undermined, and everybody's existence was threatened there by those Nazis and the Ku Klux Klan."

"I was surprised to see that they would allow Confederate soldiers to come in," said Walter.

"And rub it in our faces!" exclaimed Carlos. "We could fill up museums; we could fill up a whole barracks with Black history stuff we had. In fact, we did with telling-our-story events."

Walter summed up the situation in very stark terms: "Fort Wayne has been raped, pillaged beyond our wildest imagination. You could do a world of good there, because number one, you are quite the historian: You are very knowledgeable about how Fort Wayne was established. You have seen all of the artifacts that Fort Wayne has had in its possession at one time. You've seen the thievery of the artifacts that we had—we even found tomahawks in the ground at one time. They acted as if it was more their fort than it was the City of Detroit's fort."

While it might be easy to dismiss Walter and Carlos's accusations about the "Fort Wayne Nazis" as paranoia or hyperbole, the events of January 6, 2021, highlighted the persistence of White nationalist sentiments emanating from every area of the country. On that day, White insurrectionists carried Confederate flags into the US Capitol rotunda, a desecration that did not occur even in the Civil War. Detroit had once been a stronghold of the KKK, and there was every reason to believe that the White flight of the post-1960s period had relocated rather than reformed these elements. The perceived lawlessness of Detroit during the Great Recession opened a space for people to come into the city and do what they wanted, leading some to describe it as a kind of "new frontier" (Safransky, 2014; Kinney, 2016). In some quarters, this was celebrated, as Detroit was seen as a form of DIY utopia, drawing artists and hipsters in search of challenge and adventure, including the "Johnny Appletrees" as Carlos called them, who began planting farms in

his Eastside neighborhood (Kinder, 2016). But on the shadowy side, there were the scrappers, the pillagers and plunderers, and the rank opportunists, looking to take advantage of the loose anything-goes environment. At a contested place, such as the fort, the echoes of settler colonialism could not be avoided.

Carlos eventually retreated, having sunk considerable time, effort, and expense into his projects at the fort. For the time being, he had to concede that "the Nazis" had won. Though he never gave up on his vision, he also carried with him a suspicion that the same forces were lying in wait elsewhere. With the master plan for the fort forestalled, Carlos began casting his eyes around for other opportunities to transform the city he had grown to love. He began building his own castle in the grassy fields that opened up around him as a result of Mayor Dave Bing's alliance with something called the Detroit Blight Authority.

In February 2013, Detroit's then-mayor, former NBA basketball star and corporate CEO, Dave Bing, stood alongside real estate magnate Bill Pulte and announced that this chimeric public-private partnership had found an appropriate area to flex its muscle and knock down some degraded buildings, presumably to make room for new development. The site was just east of the Eastern Market District, including ten full blocks around St. Aubin and Wilkins Streets. This happened to be right in Carlos's backyard, effectively making his neighborhood ground zero for home demolition. At the press conference, Mayor Bing stated:

> For many years, children from this neighborhood have had to walk by blocks of boarded-up homes and piles of brush and dangerous debris to get to Detroit Edison Public School Academy. Today, thanks to Bill Pulte, the Detroit Blight Authority and our committed partners, this area is much safer for our children and the land has become an asset for this community and the entire city (Williams, 2013).

This was a double-edged blade for Carlos. It could mean that new opportunities were opening up, for him and his business, right next door in the neighborhood—or else he might be next on the demolition list. Two rays of possible hope came from the Detroit Future City (DFC) framework released in 2012, and Detroit's UNESCO City of Design application in

2015. The DFC document, like the Blight Authority's bulldozers, sent a set of mixed signals to Detroiters. Its alluring depictions of Detroit landscapes cleansed of crime and pollution, populated by cardboard cutout people on bicycles and rollerblades shopping at artisanal businesses carved out of renovated warehouses and long-abandoned storefronts, was once described by a colleague as "granola urbanism." This offhand comment was made at a local urban studies conference held at Wayne State, but it reflected a deep-seated suspicion of these plans and who they served that I heard from fellow academics as well as community residents.

One set of images in particular caught Carlos's eye: the proposed "daylighting" of a buried creek that ran through his neighborhood, and a rendering that depicted a landscape of canals and lagoons in what had been, until fairly recently, a densely inhabited cluster of working-class homes. The creek had been the site of an eighteenth-century battle between British colonial forces and Odawa warriors led by Chief Pontiac. Then known as Parent's Creek, it was renamed Bloody River Run to memorialize the loss of British life that day. In the late nineteenth century, the creek was entombed and incorporated into the underground sewer system of the burgeoning industrial metropolis. Now that the city was moving in the opposite direction population-wise, the idea of opening the water to the sky seemed appealing, at least to those in the world of urban planning. The project designer was University of Detroit architect Steven Vogel, and even though it was only a vision on paper (or a digital screen), it was described by journalists, such as John Gallagher, as an exciting project that was already in the works. In his 2013 book *Revolution Detroit*, Gallagher stated, "Based on demand, the Bloody Run watershed could become a center for recreation, wind and solar farms, and urban agriculture, as well as more traditional economic development" (147).

Though not directly connected to the DFC framework, the spirit of transformational redesign was similar, and it was in the press at the same time, making it easy to confuse them, along with some of the other visionary projects being proposed as potential solutions to Detroit's conjoined crises of population decline and economic collapse. Carlos was able to pull the renderings up on his computer screen and then look out the window of his building and see the exact landscape upon which this ecotopia was being envisioned, and he sought to adapt, to make himself a player in the

Chapter Six

developing game. Surely, he imagined, when all these projects began, they would need someone to build and manage the windmills and other associated green energy infrastructure, and he saw himself as the logical choice.

Carlos had done his own mapping of the historical course of the buried body of water, and he determined that a segment of it ran right below his property. He began to dream of hosting an epic reenactment of his own and selling tickets to tourists from around the world. As a youth in Germany, Carlos had consumed the films based on the Western novels of Karl May, and like many of his countrymen he rooted for Winnetou, the Apache hero, in his struggles against the White colonizers. Why not create a historical monument and cultural festival to honor the great Chief Pontiac? If Fort Wayne could not be the site of diverse and truthful representation of Detroit's history, he could make it happen on his own street.

Carlos's fondness for the stories of Karl May was not surprising; this was common among German men in the postwar period, and it had its own problematic overtones (Galchen, 2012). My colleague Juliette, who is Native American (Ojibway), tried to disabuse Carlos of some of his ideas about incorporating Indigenous people into his schemes without talking to any of them first. He listened to these arguments, but he didn't surrender the idea, and in fact he populated his property with Keenan's metal stick figures, painted red and sporting bows and arrows, meant to represent Pontiac's warriors defending their land.

By this time, Carlos's workshop was a regular stop on tours intended to demonstrate that the Motor City was a burgeoning hub of creativity. Nothing seemed to tell that story better than the man who built windmills out of old parts. As later recounted by Karl Stocker, a design professor from Graz, Austria, who served on the UNESCO Creative Cities selection committee in 2015, the visit to C.A.N. Art Handworks was among the more memorable experiences he had in Detroit. In a personal interview conducted remotely in 2021, Karl recalled this moment:

> We came there, and for me it was really astonishing because this all looked like a fort, and he came out and first he showed us the first floor, and you could see all this incredible metal stuff that he took from the street, the lamps and the lightnings and everything. I thought we are now in a room of the British Museum in London. It's incredible, this stuff, and then he

showed us the windmill. And I thought, this guy is really crazy, and this guy is a quite interesting person, and I like this guy, because he is powerful and didn't move from Detroit. He is kind of those people who take resistance, and they do their thing. I like him very much, because I thought this is the direction that creative industry should go.

As Stocker wrote in his book *The Power of Design* (2013), the intention of the network was to expand the reach of the individual member cities and bring them additional resources and exposure: "The partner cities should exchange their experiences, ideas and best practice examples, mutually promote one another, 'live' the most varied forms of collaborations and projects, organize competitions, and invite the public to presentations and exhibitions" (9).

As a native of Germany, Carlos welcomed the connection to this global system of cultural exchange. He saw Detroit's membership in the UNESCO Creative Cities Network as a potential link to allies and funders from outside of the city, who would understand the intrinsic value of the programs he was proposing, specifically in relation to the importance of the skilled trades and restoration of historic objects to the public domain. As with the DFC plan, Carlos sought inclusion in this promise of opportunity. Every year his hopes were raised as to what Detroit's UNESCO membership would bring to artisans such as himself and how his work would be lifted up and promoted, but the real implications were unclear. In an unpublished paper about the City of Design and its ideology, art historian Irfan Hošić (n.d.) wrote: "When talking about design in Detroit, the main question that comes up as an urgent topic is: Does Detroit design strategy attempt to restore exclusive frames of neoliberal capitalism and self-interests of [the] favored class—putting profit at the first row, and roughly neglecting injustice to which the citizens [have] been exposed for more than a half of century; or is Detroit's design strategy oriented toward practices of human dignity, ecological sustainability, moral and ethical responsibility?" This question spoke directly to Carlos's hopes as well as his fears.

In 2018 Marsha Philpot, a.k.a. Marsha Music, and I helped Carlos draft a proposal to the Knight Arts Challenge to fund a project called the Detroit Gallery of Metals. It was a $200,000 proposal, but because it was a challenge grant, he had to raise $100,000 of that money himself. He had done this

Chapter Six

successfully with the Detroit Windmill Project, but for half as much money and with a lot of help from some of the other project partners. To my surprise and his great satisfaction, he won the award for a second time and launched a new trajectory into the world of art exhibitions. The Gallery of Metals was more of an umbrella project than the stand-alone windmill—it included the windmills, as part of a larger green-energy program, but also the African art collection and various other metal artifacts and creations that populated Carlos's world. The idea of "metal connecting worlds" was expressed by Nii Quarcoopome, curator of African art from the Detroit Institute of Arts, who visited C.A.N. Art Handworks to view Carlos's collection in November of 2018. He was accompanied by Jean-Claude Quenum, a professor of sociology and African American studies at Wayne State University, and Marsha. As was often the case at these impromptu gatherings, the topic of Carlos's and other artists' roles in Detroit's rebirth was front and center.

"He is an expression of this creative lava that bubbles up in this city," said Marsha. "The people that were here to vet Detroit for UNESCO, when they were here, they were taken on the dog-and-pony show. These people met us, and they wanted to hang with us, enough with all of these other people. Here we were, we were dealing with the city as a life force."

Carlos responded, "The people from UNESCO were interested in the Black culture here—they were asking, where the Black people at? Where's the jazz? Me, I wanted to know where the money was, what is the economy there? It seems like it's the last opportunity to be a part of it in a major way."

Jean-Claude chimed in, "When I came here, Detroit looked like a war zone; coming from Paris, I was shocked, believe me. But I got to know that Detroit was one of the most beautiful cities, and we got to know the African artists here, so Detroit had a spirit that was known around the world."

There was no doubt among this circle that Carlos was a treasure who ought to be celebrated. However, as Carlos knew, the challenge of converting creativity into cash was first and foremost. He had watched his friend David Philpot, Marsha's late husband, produce a house full of intricate carved, wooden staffs that never sold, even while he was paraded out for events celebrating his iconic status as an elder statesman of African American art in Detroit. Though the Knight Challenge victory was a shot in the arm, coming as it did on the heels of the award for the windmill project, fundraising for the Gallery of Metals proved to be much more of a hardship.

The nonprofit world of donations and grants was befuddling compared to the straightforward exchange of work for commission Carlos he understood very well. Throughout 2019 Carlos struggled to find matching funds. Then the COVID-19 pandemic hit, and all activity ground to a standstill. Like everyone else in the world of small business, Carlos went into a tailspin in the year 2020. The murder of George Floyd and the protests that filled the streets of Detroit throughout the summer only added to his sense of apocalyptic urgency.

In January of 2021 I sat down to do an interview session with Carlos, to "rent and vent" as he called it. I only had to ask one opening question: "What happened in 2020?" It uncorked a wave of reflection upon all that he had gone through, all the ups and downs, the highs and lows of the pandemic year. Once again, Historic Fort Wayne emerged as a key indicator for him: "We entered a new decade. I'm ready to put a rest to a lot of things and move forward," he stated. "Every ten years, I like to assess what I'm doing. I tried to assert myself in being a good son to my dad. Every time I got comfortable with things and established some sustainability, things got swooped up and turned around. This entrenched trajectory, this separatism was bringing about, like Soweto in South Africa. It all goes back to Historic Fort Wayne. May 1, 2007, that's when I found the bell; I started this work with those agreements that I had with the park and recreation department, all kinds of people involved down there. I just needed written confirmation that I could do it and stay out of my way. And that's when the whole drive to get rid of Nielbock happened. The whole idea was to use Fort Wayne as a test field. You design a better mousetrap, and that's the great American experience, right there. So I studied the American windmill. Low-level wind, that is the way to go."

Around the same time, Design Core Detroit, the organization that coordinated all of the city's UNESCO activities, announced something called the City of Design Challenge. The focus of the challenge was the development of "community tech hubs," and assistance was offered for small, locally based organizations to realize their ideas. Carlos and I teamed up with Rukiya Colvin of the Eastside Solutionaries Collective, a group affiliated with the James and Grace Lee Boggs Center, to propose a project that brought the Detroit Windmill Project together with Feedom Freedom Growers, an urban farm on the city's Eastside founded by grassroots activists Myrtle

Thompson and Wayne Curtis. This whole process culminated in a final showcase at the end of the annual Detroit Month of Design in September 2021, and we worked throughout the summer installing a prototype at the farm, engaging with visitors at public events, and connecting the windmill project to the endemic flooding that occurred on the lower Eastside, envisioning a little Netherlands in Detroit's swamped canal district, where Feedom Freedom was located.

Michigan weather that September was characteristically temperamental, and the days alternated between torrential downpours, blasting hot afternoons, and balmy watercolor evenings. Carlos had several projects featured on the thirty-day calendar of events for the Month of Design, with a driving goal, as always, of getting his work and the city of Detroit onto the global stage that they deserved. In the end, however, of the six finalists, only three were awarded funds for the showcase, and our project was not among them. I talked to Carlos the next day, and he said that he knew there was a problem as soon as he saw the food they put out at the reception. "They didn't even have a buffet," he said, "they had chips from the gas station." Due to rain, the event had been switched at the last minute from an outdoor community site in the Boston Edison neighborhood to the eleventh-floor auditorium in the Taubman Building at the College for Creative Studies, and a table was set up with Better Made potato chips. I imagine this was intended as an authentic Detroit touch, as this is an iconic local brand, but Carlos simply read it as *cheap*.

While the pandemic had been punishing, and UNESCO had not yet panned out as he hoped, other things were looking up for Carlos at the end of 2021, with progress taking place on several fronts. He was commissioned to do historic restoration contracts focused on the Beverly Gate and the Edsel Ford House in Grosse Pointe and the restoration of the Gateway to Freedom Monument in Detroit's Hart Plaza. The Charles Wright Museum of African American History was planning an exhibition featuring eighty pieces from his *Bronze People of Detroit* collection for February of 2022, and Carlos sold a Detroit Windmill to Michigan State University for use in their urban agriculture research center on the city's west side. In 2021 we also made contact with an expatriate engineer and inventor based in Malaysia who offered a slew of suggestions for optimizing the energy production of

the wind turbine. Finally, the release of pandemic stimulus funds held some promise for the funding of microgrid research.

In October 2021, the winners of the inaugural Detroit Arts, Culture and Entrepreneurship Honors Award were announced by Mayor Mike Duggan, and Carlos was among them—alongside local luminaries, such as the late Charles McGee, Dudley Randall, and Tyree Guyton. The award was meant to recognize artists who had given at least twenty-five years of creative service to the city of Detroit. The announcement summarized Carlos's achievements as follows:

> CARLOS NIELBOCK: Master architectural ornamental metal and design artist, engineer and craftsman, with work featured in the Fox Theatre restoration; inventor of the Detroit Windmill, the first and only fully upcycled, low level wind turbine; UNESCO Detroit City of Design Ambassador and Honorary Member of the American Institute of Architects; founder of C.A.N. Art Handworks, an ornamental architectural metals handcrafting studio on Detroit's east side.

Carlos was unsure of what it meant. "I got this stupid award, and I'm so suspicious; it's just a backflash to the lights cut out, the foreclosure notices, the tax foreclosures. I don't want to be used as a spinning thing in their promotional video for how creative Detroit is. I don't want nothing off that, and don't want to be in the mix of that, in the pot of that. It's a plastic award on top of that. They don't even take my bronze *Spirit of Detroit* sculpture to make their Spirit of Detroit award. Everything in my fiber says 'no'!"

Clearly Carlos was interested in more than just symbolic recognition. The fact that the actual award consisted of an insubstantial medallion, rather than one of the perfect replicas of Marshall Fredericks's iconic *Spirit of Detroit* statue that he produced out of his own shop, was indicative of its superficiality. He wanted real inclusion in the economy of Detroit, which meant access to city contracts at the very least. His most ambitious vision included the founding of a city department with a multimillion dollar budget and resources at his disposal to enact his program for reinstatement of Detroit's cultural heritage into the public domain. He would call it the Detroit Historical Resource Recovery Authority, and its purpose would be

Chapter Six

Carlos with the massive iron bell from Detroit's Old City Hall, which he had found in a warehouse at Historic Fort Wayne in 2007. He fashioned this metal frame to hold, and it stayed there on display until 2021.
Drawing by Paul Draus

to reclaim, renovate, and restore Detroit's lost or forgotten architectural and ornamental treasure. In Europe, seemingly every town and city has distinctive features that residents are proud of and that tourists come to see. In Carlo's hometown of Celle, there is the castle, or *schloss*, in the center of town, and the historic chateau-style buildings that give the place its character. When I went to visit the city of Poznan, Poland, in 2021, I told Carlos about the city hall and the legendary chimes, which feature two mechanical goats that emerge once a day at noon and butt heads with musical accompaniment, often in front of a large crowd gathered in the square. "You have to go see that," he said. "These towns used to compete, to see who had the better attraction. It was a very big deal. We need to have more of that here."

The prototype for everything his proposed Recovery Authority would do was contained within something that Carlos called the Clock Tower Project, which centered on the restoration of core elements of Detroit's

Carlos working on the bell, and then standing proudly before the refurbished and re-christened Detroit Unity Bell in his workshop. Drawings by Paul Draus.

Old City Hall (Sharp, 2016; Draus, 2022). When the hall first opened to the public in 1871, it was located at the center of the city. The clock tower struck on the hour, and the people of Detroit would use it to set their watches to standardized time. Each and every New Year's Eve, Detroiters would gather at the tower to "kiss in the new year" at the stroke of midnight to the hopeful sound of the clock-tower bell. In 1961 the Old City Hall was demolished, and much of its elaborate decor was destroyed. The artifacts that were salvaged ended up at Historic Fort Wayne. As Carlos explained: "More than ten years ago, I discovered the old clock-tower bell and dug it out of the ground before it could fall into the river. It was an amazing discovery! My desire has always been to rescue these historical artifacts from their current situation, so they can be restored and reinstated back to the public domain." With the support of the Eastern Market Corporation, Carlos eventually managed to secure the bell from Historic Fort Wayne in 2021, where it had been hanging in a sagging metal frame he fashioned after wrestling it out of the dirt in 2007. He brought it to the shop on Wilkins Street for restoration; the goal was for the bell to ring in the Saturday market, beginning with the New Year of 2022. With assistance from a historic metal expert at Lansing Community College, Carlos designed a riveted frame to house the bell, enshrining it in a manner that fit its illustrious lineage. Detroit deserved its own version of the Liberty Bell, Carlos surmised—and this would be even better.

Carlos often expanded on this vision when people came to visit his workshop, and he shared his poster displays demonstrating the research he had done on the Old City Hall as well as his renderings of its restored clock tower. "It is time to move forward," he would say, "and bring back the 'Paris of the Midwest,' so the people of the city may share in the economy and prosperity. We are not only looking to reinstate the artifacts, but also the skilled trades that created those artifacts. It is essential and opens up a new market, to create new economies, which serve our great historic districts. Historic Fort Wayne is central to this vision. There is a whole creative craft economy waiting to take shape." In a world where entities such as the Detroit Blight Authority could spring up seemingly overnight and disappear down the memory hole a few years later, and the Detroit Office of Sustainability could be launched with the help of Bloomberg Associates and half a million dollars in philanthropic support, this wasn't such a crazy idea. Whether or not Carlos would be chosen to lead such an effort was another question.

Carlos had an almost limitless belief in his own ability, perhaps surpassed only by his faith in the American Dream. The crop of windmills on his land stood spinning through every storm, and still Detroit kept changing around him. This was the question that remained as we moved deeper into the twenty-first century: who would be included, and who would benefit from the latest wave of changes washing over Detroit? Carlos had a compelling vision for Detroit's recovery, and like Don Quixote he pursued his quest, no matter how many times fate knocked him down. One had to wonder if his ideas had a chance in the context of the "New Detroit," in a country that had never shown an interest in funding either skilled crafts or historic restoration projects out of the public purse, at least not in the manner that occurred in countries like Germany, which formed Carlos's main basis of comparison. At the same time, Carlos's vision of communal prosperity sometimes seemed at odds with his own individualistic pursuit of profitable business opportunities.

In a sense, this contradiction was encapsulated in the name of his family firm: C.A.N. Art Handworks, with the *C.A.N.* representing himself (Carlos Antonios Nielbock), while the *Handworks* summoned a larger idea, that of the *Handwerkskammer,* or association of crafts practitioners that could wield power in the marketplace proportional to that of the government or private industry. Building a Handwerkskammer Detroit would necessitate coordination among many different people and organizations, the kind of work that is often done behind the scenes over many years. While Carlos had allies among the fort's other users, he still tended to see himself as someone on a singular quest rather than as a member of a movement. Carlos knew how to create and innovate and knew how to fight for what was his, but whether he could weave together a diverse coalition was another question. He had been a lone voice, calling from inside his castle, for so long that one could reasonably question his ability to work in productive collaboration with others. In this respect, he reminded me again of Thorstein Veblen, whose name remains obscure today precisely because he refused to cultivate a scholarly following.

While Carlos was often identified with the functional sculpture that came to be known as the Detroit Windmill, the vision he formulated at Fort Wayne was much broader than just one device: it encompassed cultural heritage, skilled trades traditions, and economic justice. "Resisting that

gentrification is my main task in life here," he once said to a visitor, and for him that meant building up local economies that were properly financed and equipped to resist, without reliance on do-gooder foundations and their grant dollars. For Carlos, the Clock Tower Project and Unity Bell were essential, but they were only the beginning. The whole city was waiting to be reborn from the ground up, using the same people and materials and ingenuity that had survived the hard times. All it took was the ability to see the potential that was all around you. Following Carlos's line of sight, the future city of Detroit rivaled any European capital built for feudal lords and aristocrats. It was a place where the ingenuity of Black people would

Carlos at the base of his ever-growing Sky Garden. *Drawing by Paul Draus.*

be uplifted and celebrated, recognized for their vital contributions to the American craft tradition, and everything that made the city beautiful. It would be a place where you could flourish and support your family with the work of your hands, your innate creativity would be nurtured, and you would be given a full piece of the bountiful American pie.

If you looked across the horizon from the top of Carlos's Sky Garden, suspended three stories above the earth, in the fading light, you could imagine the twenty-first-century Paris of the Midwest emerging around you, rippling forth in waves from Carlos's Afro-futurist fortress. There was the Bloody River Run, open to the sky; the red blades of Detroit-made windmills flashing in the fields; arrays of microgrids powering the future; the city's rich and diverse heritage on public display; and people working with their hands and minds, dreaming the city into being. In a reflective moment, Carlos acknowledged that he might not reach the pinnacle of his vision in the time he had left.

Even in the darkness of his doubts, he remained undeterred. "It is imminent," said Carlos. "It may happen with people that I don't even know."

CONCLUSION

In July 2023 Carlos introduced me to a new word: *Gesamtkunstwerk*. "Look it up," he said. Here is what I found: "The German term *Gesamtkunstwerk*, roughly translates as a "total work of art" and describes an artwork, design, or creative process where different art forms are combined to create a single cohesive whole" (TheArtStory.org). It was a term broad enough to encompass all the branches of Carlos's growing tree of ideas under its expansive canopy. C.A.N. Art Handworks, the little seed of a company Carlos started in Celle, then carried with him over the sea, where it took root in the soil of his adopted city of Detroit, now had offshoots extending in all directions—in his mind, on paper, and to some extent on the ground around his workshop. Carlos had recently installed a metal sign marking Milwaukee Junction in Detroit's North End, and he had some other jobs lined up. Keenan had been released from prison earlier in the year and was living in a halfway house in California. Carlos had erected a wooden privacy fence around the section of his property that contained the still-buried section of the Bloody River Run.

Carlos described what he was then working on in these terms. "I have three stories of stuff that's ready to go," he said, "whenever the projects take off." He seemed to have arrived at a place of relative peace, where he would work on jobs that made money in order to be able to pursue the more visionary and imaginative projects. "Art and industry," he explained, "it's always been like that; you only have creative people when you have money, and usually that's from industry." Then he gestured to a large blackboard on the wall that showed all the different endeavors that he had embarked on through the past decade and a half: Detroit Gallery of Metals, Detroit

Conclusion

Carlos installing the metal sign marking the entrance to Milwaukee Junction, in Detroit's North End community, summer of 2023. Drawing by Paul Draus.

Historical Recovery Authority, Fort Wayne, Handwerkskammer Detroit, *Bronze People of Detroit*, and the poster describing the Detroit Windmill. "This whole wall of shame here is a reminder not to get crazy with the crazies."

This is where he slipped from thoughtful reflection into grievance mode: "I was led to believe that I should develop a local economy, not going out to Bloomfield Hills and being subjected to all this racism. Every job I got from Detroit, it wouldn't even pay a light bill, much less hire one person or ten or twenty. It's *Scheisse*, eh? Just ask me about any engagement, if anything happened with anything. I'm kind of mad because I allowed myself to be snookered into all this." Carlos went from seeing the symphony of interests, the "non-polarizing approach," as he often called it, to unmasking a conspiracy. "All these ways they described me, all the terms they used:

unreasonable, temperamental. It was all for a good reason because if I had been anything else I would have been gentrified. My reactions and mis-readings and cautions turned out to be the truth."

Here was the lightning alchemy of Carlos's thinking: all those characteristics that others saw as flaws were suddenly transmuted into virtues, like metal rendered to liquid and molded to another form. The stubbornness, the irascibility, the refusal to pipe down that were essential to his character, to his being, things that had been true of Carlos since his youth, when the German military labeled him *renitent*. They were the key to his survival, even if they also limited his opportunities. He could always smell a rat, and he would always call it out.

"Now the third phase is happening," he declared, "ostracizing and ignoring."

I asked Carlos to expand on what he meant about the third phase; if this was the third phase, what were the first two? He had clearly thought this through carefully, so I diligently copied down his words.

"Phase 1: Infiltrating with promises and trivial gifts and inclusion to give you a warm and fuzzy feeling that someone will evoke a change.

"Phase 2: Engagement in this trivial shit and a calculated measuring of your financial stability and false promise that you don't understand the duration of the problem; if you don't have any money, like Willie living with the squirrels under his porch, then you will take what they are offering just to relieve the pain. That entire duration, it don't pay your light bills *right now*, it don't get the rodents out from under your porch *right now*. Meanwhile there's a rollout of benefits to every new motherfucker coming in here, and I invited them in here for all these phony bullshit events that I had to do, and not get even one dime."

Bitterness nearly dripped from these sentences. Willie had been his neighbor down the street, who had lived on the block for decades. Clarence often talked to Willie as he made his routine trips around the block on his electric golf cart. As the community emptied, and the buildings around him were demolished, Willie's domicile began to resemble the little house on the prairie, but in a downward slide. His roof was failing, and a colony of squirrels had moved in; Willie couldn't afford to fix the place as it fell down around him. Eventually, he took a deal from the Eastern Market Development Corporation (EMDC) to sell his home. While Carlos had

Conclusion

helped facilitate Willie's conversation with EMDC because he worried about his neighbor's health and wellbeing, he also saw this buyout as part of a long-term strategy to depopulate and then repopulate the neighborhood. In other words, Willie was another victim of gentrification, a representative in Carlos's mind of the hard, slow fate of displacement and erasure. When Carlos's thinking ran in this direction, all the perceived slights and exclusions he had experienced pooled and ran together with the bigger picture of Detroit's recapture by hostile White capitalists and colonizers. So much for being non-polarizing, I thought.

Then came the optimistic turn, the molten iron cooling into solidity, the opportunity to build a legacy and be right there in the mix with the corporate interests, with industry, the kings and dukes of our own era: "I'm applying

Carlos on the front stoop, enjoying the sun and continuing the conversation. Drawing by Paul Draus

for this Kresge Grant, which will merge all this shit together. It's almost right up my alley," Carlos said, referring to a recent request for proposals that seemed to fit with his projects. Maybe this could be the opportunity to realize the *Gesamtkunstwerk,* the whole work of art. Our conversation continued as we headed back out of the building to Wilkins Street, where Carlos sat on the front stoop and took in some of the summer sun.

This conversation raised the question of what it was all about—what was the essence of the *Gesamtkunstwerk*? Why did Carlos pursue this work, these visionary projects, when he could instead simply focus on making money in the first (and last) place? Why did he stick it out in Detroit, rather than taking himself out to the suburbs, or returning to Germany for that matter? What was his struggle really *for*?

Friedrich Schiller's classic Romantic poem, "*Das Lied von der Glocke,*" or "Song of the Bell," summons a spirit of contemplation, asking readers to consider what they have accomplished in their life's work. Translated into English by Margarete Münsterberg (1916), one section reads:

> Now let us earnestly be spying
> What our weak powers can create;
> I scorn the man who is not trying
> On his own work to meditate.
> This is the fairest of man's graces:
> The power to think and understand—
> For in his inmost heart he traces
> What he has fashioned with his hand.

Carlos described this as "a most beautiful poem, paying homage to one craftsman's ability." He elaborated, "If you're a religious person, you adhere to religion; if you're a scholar, you adhere to some scholarly philosophy, but this here speaks to a creating person who manifests things with their hands, to a certain standard." Schiller's work, he said, was once popular all over the world. There is even a statue of him on Belle Isle in Detroit, bearing the inscription "Erected by Citizens of German Descent, Detroit, Mich., 1907." Carlos had taken some students there, during a summer internship program that he supervised. They did not know who Schiller was, of course. For Carlos, this was indicative of a city that does not know its own history and

heritage, partly because a dead European like Schiller has no relation to the majority-Black population of contemporary Detroit, but also because these monuments to the past are not cherished or recognized in their own right. American cities move relentlessly forward, erasing communities and their history in search of the next round of profitable investment. Nearly forty years after Carlos departed Germany and arrived in Detroit he considered this situation once again. "The most amazing conclusion," he stated, "is the institutionalized exploitation that still continues to this day. It's fucked up. I thought it was maybe more advanced. I believed that those ceilings and barriers was eliminated, but they're not. It's a continuation, and maybe in fifty years it's a different situation where we have economic equality, but this shit here is *Scheisse* times three."

Carlos paused, and continued: "It don't matter. I see the light, and I'm going to do what I need to do. The amount of involvement we had to understand how deep it is with my collection right here and the attention that this type of work is getting on an international level shine the light and give the proof on how fucked up this really is right here, that there's no consideration of cultural enlightenment, there's no curriculum or real undertaking. The people that have it on their business cards, in the name of their institutions, they're responsible for cultural enlightenment and education, need to get to the point that people that live here also can have property in the Eastern Market or Brush Park or have a development, not that make-believe kind of Black entrepreneur bullshit right there. Out of all the Black businesses there in the Eastern Market, how many own the property that they are in? Only me."

It was true Carlos had come a long way from Celle to the city of Detroit, and he had made a mark on the landscape and culture around him. "So the realization is that I already accomplished a lot; I already overcame all types of obstacles and difficulties and racism and all this shit. So if it'll all be over tomorrow, it's still good, it's already good, more than average."

This didn't mean he was content to sit on his laurels. "I still got gas in the tank, man. I'm, like, refined to the point that I need a big project. Not the penny-ante shit, give me a fucking opportunity so I can make some money and present all my skills and talents in one project for the betterment, for the community, or a developer, or a development, a financial whatever group. So I must also include an exit strategy, a strong one, and that include

what I do with my art right here." Carlos knocked on the wooden table, as if sending a signal to his silent companions, the sculptures gathered around the floor in complex configurations.

"My connection to the few people of color in Celle, they was Caribbean, I found a kinship with them and the food and the sounds they produce, and at the same time I developed an affection for blues, music from America; major performers were invited to Germany to participate in music shows, as a way of increasing awareness after that Nazi shit, and when I came here I also found a kinship with this art that was powerful and supernatural. The final thing is the *i.Detroit* project, which provided the scientific proof of the connection between the Yoruba people, who covered this vast territory where those slaves came from, who had those skills, the metalworking skills. So there you have it, the bronze people of Detroit are the descendants of the Yoruba people, that end up in this unique constellation here in Detroit and I'm just a little piece of it."

Carlos was referring to photographer Marcus Lyons's *i.Detroit* project, in which he had participated, standing for a portrait that was printed alongside a representation of his genetic ancestry, split almost evenly between western Europe and the west coast of Africa. I asked him to elaborate on the role that DNA, or genetic heritage, played in his own personal evolution and disposition. "All of those things in my DNA point toward those Yoruba people, from the British Jamaican soldiers that I liked, from the music that I liked, from the kinship that I felt coming over here, from the cultural reality that I engaged here, despite all those obstacles. Still I found it easier to maintain here than in Bloomfield or in Grosse Pointe, although I connected with that. It's all within my genes too, to be prosperous there and have something to offer and be productive and so on; the same thing is right here. Those things that were unknown to me, but yet I picked them up, and I liked them, and I kept them around—like the Yoruba culture, that is, among other cultures, in my genes. You can't deny it. It's in the DNA test right there."

Carlos indicated a bronze figure of a man, sitting cross-legged, holding a snake. "This metalwork depict scientists that make venom from snakes and produce medicine and darts for your arrows. It's a written fact; it's a fact that you can visualize. The writing about that don't exist. Black people, in the White people culture right here, are too stupid to put one thing on top

of the other; their only existence is labor, that they was [caught] in Africa in some kind of stupid way or handed over by some stupid king to serve, to build the plantations. Those Yoruba people was the first industry in [the] United States; they was the very first industry. They couldn't use the Indians; they didn't give a fuck, they didn't want to be slaves or anything. You had to do that trick with the boats and the transatlantic slave trade and all that kind of shit, and you got to exploit the praxis that's already existing in Africa, because they raided villages and had prisoners that they had enslaved, and all this kind of shit for centuries, to the point that you bring four hundred million over here."

"This guy right here is the main culprit. Come on, make a picture of him." He was pointing to a bronze statue of a male figure holding a musket, with a small rectangle containing eight balls, representing ammunition, resting between his bare, square-toed feet. On his head was a three-cornered hat. Carlos explained that this was a depiction of a Portuguese slave trader. "All the kingdom's army, their soldiers, with their weapons in their hands, that don't do shit, if you have a gun. They had spears and knives, and once you come with one of those, all you got to do is go to the king, and say, 'show me your enemy.' You shoot him dead, and that's it. And soon he upholding the kingdom."

"It's all in this one here," he said, picking up a hardbound copy of the 2020 book *The Brutish Museums: The Benin Bronzes, Colonial Violence and Cultural Restitution*, by Dan Hicks, professor of contemporary archaeology at the University of Oxford, which was resting on top of one of his museum-quality display cases. Hicks writes that "the Kingdom [of Benin] grew in power and scope during its involvement in European and transatlantic trade from the 16th century, first with Portuguese traders and later British and French—central among which was the slave trade" (39). This neglected/ignored history of African cultural achievement, and its subsequent assault by European colonial violence, was written in metal in Carlos's collected art, and also in his mind. To some extent this conflict resided within him and was central to every story he told. One could see why he worried about the legacy being lost, if his collection was never shared, or the stories behind it never told, if the Gallery of Metals and its virtual museum, the Historical Recovery Authority, the *Handwerskammer*, and the *Gesamtkunstwerk* never came to be.

Conclusion

Carlos pointed out this Benin bronze figure of a sixteenth-century Portuguese slave trader to illustrate the history of White colonial brutality.
Drawing by Paul Draus.

In his 2021 essay, "What Would It Mean to Decolonize Detroit?" Damani Partridge writes:

> I turn to Detroit, because I see possibility in the impossible: inasmuch as decoloniality will not come through capitalism, and inasmuch as the assertion of Blackness is the response to the failure of the original universalized liberal claims of freedom and democracy, Detroit is both deeply familiar

with inclusion's repeated failure as well as the impossibility for the majority of its (nearly 80 percent Black) subjects to become White (299).

Carlos's cultural commitment to Blackness, while also seeking true inclusion in the dominant economy of Detroit, seemed to mirror Partridge's "impossible possibility." In other words, it was a truly quixotic quest. Alternatively, he could cash in his chips and say: "Fuck you all, I'm going to back to my mother in Germany, and sit there in the backyard. And when she gone, I'll take care of her garden right there. What more do you want?"

I had seen Marianne's backyard garden in Celle. Her house was small, but the garden was large, intricate, and lush, with statuary and flowers of all kinds. It was certainly a place where one could imagine living out a quiet retirement, at peace with the world. Somehow, I had a hard time picturing Carlos ever not wanting more.

But Carlos had another backup plan. He showed me photos, on his phone, of the monumental sarcophagi at historic Elmwood Cemetery, located just down the street from his workshop, where the last remnant of Bloody River Run still ran open to the sky. "All I need is a slab, and then you can visit me right there. I'll be laying in my box and have nice pictures on the outside."

I then asked, "Will you have Martha Jean on your sarcophagus?" He had developed a full vision of a public memorial to Martha Jean the Queen that could one day stand resplendent on Belle Isle.

"Whaaaat?" he replied, laughing. "I'll have a homeboy, rolling a blunt, sitting on it." I could picture that too, a classical sculpture of a young man from the neighborhood, enjoying some now-legal weed.

"That could be on the other side. Martha Jean on one side, and homeboy on the other," I responded back. It would be like the Zum Teufel devil head, opposite the Queen's cross of carved wood, balancing each other out, like the angels and demons in his own demeanor. The thought of having her holy personage watching over his tomb clearly made him a little uneasy. He laughed out loud. "I can have anything I want."

"If it haven't found any other arrangements, upon my death, all this stuff supposed to be melted into ingots. Actually put the smelter down into my shop down there, and bring everything down there, and smelt it into ingots, and then use them ingots to make this sarcophagus. I might make

Drawing of Carlos's proposed memorial statue of Martha Jean "The Queen" Steinberg, which he believed should be installed at Belle Isle. Illustration by Marco Evans, used with permission.

the molds already and everything. You like that?" I had to acknowledge that the sarcophagus idea kind of made sense. They say you can't take it with you, but generations of kings, queens, pharaohs, and emperors had certainly tried, with the aid of craftspeople like Carlos, to achieve some kind of immortality. Maybe that could be his last trick, his way to finally get over to the side of the gods, with his divided and indefatigable soul intact.

"I'm a shit starter like you wouldn't believe," he said, as we talked about the way to close out this book. "But I want it to end with the possibility of redemption." Then he told me to include two Golden Rules, sayings from

Germany that guided how he had lived. "You wouldn't understand them," he said, "but any German would understand." The first is "*Handwerk hat goldenen Boden*," which translates to "A trade in hand finds gold in every land." The second is "*Eig'ner Herd ist Goldes wert*," which roughly translates to "There's no place like home."

To make sure I had the meanings right, I consulted with an old friend of mine, a Czech man who grew up partly in West Germany and partly in Prague. He responded, "Yes, both sayings reflect German thinking, an affinity to (1) learn a skilled trade that can feed you and your family anywhere and anytime (like becoming a saddler in old days, or a car mechanic later or a bricklayer/mason/electrician, etc.), and (2) save money and build your own home, so as not to be dependent on others for sustenance and a roof over your head. It also reflects the experience of hardship; when social order collapses, you can always rely on your own house as a safe haven."

Inside his castle of metal and dreams, it appeared that Carlos had already achieved these things: he had persisted through the whirlwinds of change sweeping the city, finding a way to forge something lasting for himself. He had come to the city to find his father, and he stayed to build a business as well as a stronghold for his family. He had earned enough by his hand to own his land and to populate it with works of imagination designed to inspire. Whether his larger visions of transformation would be realized remained an open question, but there was no doubt that Carlos would keep trying to joust with the giants. This son of Detroit still believed in the city and its possibilities in spite of all his frustrations.

Carlos's path had never been a straight one. Standing under his newly installed front awning, adorned with curves and loops of black iron, he commented on the ornate design, the distinct signature of his work. "Just don't think in straight lines, there's complexity to everything. Those curls are beautiful to me."

AFTERWORD

Carlos Antonios Nielbock

Moving from the economic collapse of 2008 to Detroit's bankruptcy in 2013, and through all the years that followed, my guiding principles were the same: I wanted to preserve Detroit's historical legacy, to provide employment opportunities in the skilled trades, and to develop a sustainable economy for the city's future. I built the Detroit Windmill for green energy, and I started the Gallery of Metals to reinstate all that good stuff back into the public domain. When everyone was talking about urban farming, at C.A.N. Art Handworks we said *we don't do no potatoes and tomatoes* in the city of Detroit. Instead we focused on realizing creativity in a physical form. That's why we wanted to be a part of creative industries and the UNESCO City of Design network, which Detroit joined in 2015.

The development of the 2025 Greater Eastern Market Neighborhood Framework plan felt inclusive. I attended all the meetings. I was highly interested in the community development aspect, looking for economic engagement, either cash to sell my property and business or to be economically included by staying and providing educational and cultural improvements to meet the standards of the UNESCO City of Design goals. Through my participation, I was able to develop a $21 million master plan for C.A.N. Art Handworks to facilitate the infusion of cultural heritage, green energy, and rust-belt art into the Eastern Market. This, in turn, would create workforce development, moving toward the vision of a Detroit Handwerkskammer, an association to support those working in skilled crafts. The fulfillment of the master plan would serve the city by reinstating valuable property back to the public domain, creating equity on an annual basis; increasing insurable value; reinstating master crafts and trades that originally built Detroit; and restoring Detroit's historic churches and other architectural

Afterword

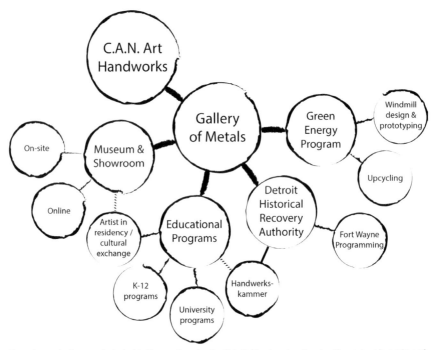

The schematic diagram included in the master plan for C.A.N. Handworks, showing the various branches of ongoing and proposed activities. Used with permission of C.A.N. Art Handworks.

treasures, while providing education, including the most modern advanced restoration technologies.

Throughout this process, we realized there was public discourse and unrest concerning the fate of the city of Detroit. Who was driving development, and who would benefit? As a part of the creative industries, we were concentrating on addressing positive aspects of it. A careful plan was developed with help of Eastern Market Development Corporation for us to fit into the emerging neighborhood framework. A scalable measure would be the number of employees on payroll. We targeted adding twenty to twenty-five employees by 2025. Based on the assurance that C.A.N. Art Handworks would be a cornerstone of the neighborhood redevelopment, I invested significantly in my property.

The reality today is that the hope of economic inclusion has been repeatedly let down. This causes a workforce erosion. The level of disrepair and

broken promises eroded my entire business, because the loss of a qualified workforce resulted in not being able to deliver what is promised on potential contracts. The prolonging of fulfillment of the 2025 framework led to a loss of trust and hope, topped by the inability to get access to any professional service, including legal service, business development service, energy and building improvement, and so on. As a result, we were not able to get qualified in providing any service that Eastern Market can use. We haven't had that opportunity. We have been ostracized from development. When the COVID-19 pandemic hit, many of our efforts were delayed or derailed. After the pandemic, we were in a position where we needed to tally it up like an abacus, to decide what we would keep and what we would cut. Based on our experience with city planning, the Detroit Future City framework in 2012, and the Greater Eastern Market Neighborhood Framework in 2019, we decided it is time to either GROW OR GO.

After all these years, I continue to be increasingly committed to my work. The Detroit Unity Bell and proposed Clock Tower Project represent all the possibilities contained within the C.A.N. Art Handworks master plan. The Unity Bell was originally housed in the clock tower atop Detroit's former city hall, in what is now Campus Martius Park. First dedicated in 1871, the bell weighs over 7,500 pounds and was part of the largest clock tower in the United States at the time it was built. Every New Year's Eve, the ringing of the bell brought Detroiters together with a shared sense of hope. In 1961 Detroit's Old City Hall was demolished to make way for newer buildings. Many artifacts, including the bell, were relegated to obscurity at Historic Fort Wayne. In 2007, through extensive forensic research, I was able to locate many of these forgotten relics and campaign for their recovery. In 2022, with support from Sun Communities, Eastern Market Partnership, and the Detroit Historical Society, we have now fully restored the Detroit Unity Bell and installed it, once again, in the public domain. The Unity Bell project is an effort to recognize the accomplishments of the city's past while educating future generations. The Clock Tower Project will build on this foundation. If funded, it will reinstate the remaining treasures of Old City Hall to the heart of Detroit and its people.

The entire purpose of the Gallery of Metals is to create a cultural heritage and sense of ability for the people of Detroit and a direct link to their ancestral heritage. This is also my attempt to provide a meaningful,

Afterword

The Clock Tower Project, a reconstruction of the pinnacle of the Old Detroit City Hall, which Carlos envisions occupying a central place downtown, creating a landmark and meeting point to rival European town squares. Illustration by Marco Evans, used with permission.

cultural understanding for the people of color in Detroit. We noticed within our research that all the experts, scholars, and scientists regarding this matter are of European descent and, with an Indiana Jones–like enthusiasm, pursuing every aspect of this scarcely researched subject. It is my opinion, living in Detroit for over thirty years, that for many residents the priority of life overrides the acquisition of a cultural experience that is only present in museums and elite institutions.

My collection of African bronzes began and continues to be a personal, cultural, and ethnic journey of self-discovery. I cannot speak for all people,

Afterword

but I am presenting another viewpoint regarding multiculturalism. I feel I can assert the best attributes of each culture within my DNA and apply it to my personal life. This is critical in understanding the exhibit that I have called the *Bronze People of Detroit*. Many people of color residing in Detroit have ancestral heritage from the west coast of Africa, the very same areas in which this highly skilled bronze art has originated. My quest to understand my father's cultural heritage and my personal multicultural identity began with my arrival to Detroit in 1984. A very pivotal experience for me was visiting the African World Festival developed by Charles Wright (founded in 1983, one year prior to my arrival in Detroit) on an annual basis. The African World Festival was inspired by the international Festival of African Culture, which took place, originally, in Nigeria. The African World Festival represents the cultures of numerous countries throughout the African continent. I have patronized every African World Festival since 1984. I have been able to establish a great network and forged a strong connection with the African art dealers.

 I was immediately drawn to the metalwork at the African World Festivals. I found the beauty and intensity radiating from these objects extremely captivating and mysteriously powerful. I quickly identified the old-world craftsmanship and a continuation of metalworking skills passed from generation to generation. I saw objects that were executed in various forms of excellence and refinement. The shapes and themes were different, but the technique and amount of skill was reminiscent of what I saw in Europe, and at one time mainly associated with European craftsmanship. I later discovered this was a skill perfected by Africans prior to colonialism. Once I discovered the broad span of metal art that originated in Africa, my admiration of it led to the beginning of my collection. There is an absolute need to understand this cultural heritage that is not based on servitude, not based on slavery. Other such quintessential art is often reduced to coping methods like gospel, blues, and jazz. I'm looking for a cultural heritage that precedes that. Hence, I desired to fully understand and promote the intended purpose of the metal art. These objects were created in lieu of writing to relay messages and religious and cultural information. This is pertinent in understanding one's heritage.

 It has become apparent to me that only a virtual museum will be able to deliver the diversity of C.A.N. Art Handworks and the Gallery of

Afterword

Carlos imagined the exterior of C.A.N. Handworks and Detroit Gallery of Metals redone in a traditional African architectural style, bringing cultural heritage relevant to Detroiters to life in his Eastside neighborhood. Illustration by Marco Evans, used with permission.

Metals Program. This is a multicultural practice producing different forms, variations, and purposes with the same techniques, including bronze casting, iron forging, and crafting copper, silver, and gold. From mining to smelting, to producing products, such as jewelry, medical devices, or weapons, metalworking is governed by creativity, which the virtual museum will help visitors to explore on a global level. It is a very fortunate circumstance that Detroit is in the center of the global metal Industrial Revolution, which brought forth architecture and artwork representative of culture and civilization in the form of sculptures and monuments. This story, along with opportunities lying in this field of architectural, ornamental metal, demands world-class standards. I refuse to accept that all the years of hard work, input, and endurance will remain unfulfilled.

EPILOGUE

Marsha Music

As much a son of Detroit as a product of Deutschland, Carlos Nielbock was born to his beautiful German mother into the post-Nazi landscape of Celle, Germany, a beige child in an uber-White land. Young Carlos, growing up without his father, who was African American, was inexorably drawn to Blackness, ever searching for a facsimile of his father, for the quality that caused Germans to mark Carlos as "Other." Although the war had ended, Nazism wasn't exactly over, but Carlos had the good fortune to have a (White) stepfather, his mother's husband, who loved and protected him from some of the worst instances of racial animus. Yet, he sought a connection to Black people—to the heroic father figure of his imagination, exemplar of the liberating American forces, who had catapulted Germans from their suffering.

Carlos was attracted not so much to stories of enslavement and oppression as to the heroism and majesty of the Black experience. As a teen he was drawn to the Jamaicans who had settled in an area nearby. Many were Rastafarian, a cultural stamp that has remained with Carlos to this day. From the Rastas, he learned of Ethiopia, with its royal, biblical legacy and its unconquered lineage. Carlos speaks of Haile Selassie's 1954 visit to Detroit in almost hallowed tones, an extraordinary historical event. To this day he is flummoxed that it is not commemorated as anything less than a local holiday—and even more stunned that few Detroiters even know about it.

Arriving in Detroit in 1984 with a giant Afro—gleaned from magazines and television—Carlos had just missed the intensity of the sixties and seventies emergent Black Power movement, but he stepped into a city that was Black political power manifest. Coleman Young was mayor—to the chagrin of many Whites who had moved to the suburbs or who remained on the city's outskirts, for some of whom Young was the devil himself.

Although the 1967 Detroit Rebellion caused catastrophic devastation to many main commercial areas and collateral damage to housing stock in the uprising's epicenter, the devastation to the built environment—the destruction for which Detroit later became infamous—had not yet begun, despite tropes and pronouncements to the contrary. That would take the foreclosure crisis, which began four decades later. So Carlos arrived in a city that was, although mangled by rioting in some areas, in the main, an example of beautiful communities—with some of the most significant architecture in the Western world—inhabited by increasingly prosperous Black people, as Whites continued leaving for the suburbs, a process that had begun decades before WWII (not post Rebellion). Although Motown Records had moved to Los Angeles in 1972, the radio was full of Black music and internationally renowned artists, such as Tina Turner and Lionel Richie—a crossover into pop after the heavy Motown and soul rotations of the sixties. Carlos had reached his promised land.

In this atmosphere infused with Black music, Black walk, and Black talk—on two Black radio stations and even a Black TV station, WGPR—the dame of Detroit radio, Martha Jean the Queen, held forth each day, her honeyed southern voice dispensing spiritualisms, wisdom, and womanisms. Her noonday show, *Inspiration Time*, and her daily veneration of the working class in Detroit—known as her *Blue Collar Hour*—was an unprecedented paean to the proletarian roots of the city. Daily she called out those who had requested a mid-day shout-out: "to the garbage men, the nurses, the car-wash men; the day laborers (maids and servants of the wealthy Whites), the street cleaners and workers on the assembly lines." One could drive down the street with the radio on and look out the window to see the very folks she mentioned each day.

Her veneration of the working class stood in marked contrast to the post-1967 rise in the professional and civic leaders, of which she was clearly a part. Her growing role in ministry inspired her to lead baptisms in the river off Detroit's singular island park, Belle Isle, a rite that many elder Black Pentecostals and Baptists remember fondly. It was a marked turn away from the formalized worship that characterized many churches of the time. Carlos befriended a daughter of Martha Jean, and Detroit's radio matriarch became Carlos's mentor. He could not have been in better hands. For she too contended with the enigmas of race, as a woman light enough to

"pass for White" yet unapologetically Black. Doubtless his view of Detroit's humanity was colored by her influence as well as that of his working-class father and their Eastside relatives.

Detroit's architectural gems, its mansions and mini-castles, were becoming occupied by the city's Black upper class, which included its still relatively prosperous—and even affluent—working and professional class. Carlos's first major "public" project was the renovation of the legendary Fox Theatre, something that drew the sharp attention of other tradesmen and metalsmith circles. Carl was a conundrum to many; his European/Germanic persona raised xenophobic hackles, yet he was Black enough to stir the impulse of exclusion. Here too, in the United States—twice over, no less—Carlos was cast as "Other."

Some of the most significant things about Carlos's presence in the city, in his compound on the eastside of the city near Eastern Market, are his remarkable presentations on the magnificence of Detroit. He can—and will—talk for hours in his atelier and living space above his work studio about Detroit's architectural history—and even more particularly, its metal history. Surrounded by stunning artifacts, sculptural busts, and the arcana of his creative process, his walls are covered in expanded photos of Detroit architectural elements, commendations, blueprints, and plans for future projects.

In the years before Detroit was "cool"—that is, before land and property had been devalued to the point where investors could return for potential profitability—photographers created art from ruins, which made the destruction in Detroit visibly ubiquitous. Haters of the city and its Black population made trenchant videos highlighting the city's areas of destruction—yet here was Carlos, seeing Detroit's similarities to European grandeur and lecturing on the city's stunning architecture, so ubiquitous that it is not even seen by many Detroiters, so accustomed we are to dwelling in this environment. Such magnificence was often unknown or only dimly remembered by many suburbanites, whose experience of the city consisted only of tales of its accelerating decline.

Yet Carlos, in his home and studio, pressed down on stories of the history of metal; of the role of massive railway ties and iron T-bars, a cornerstone of America's development; of the astonishing role of Detroit and its firsts in American history; of cornices and clocktowers, mansions and masonry. At a time when many could only see Detroit's decline, Carlos was

obsessed with the city's enduring greatness. He could clearly see its direct lineage from the European works that he studied in the German monastery.

In Detroit, he had found his father, and after a time he began to ponder the fact that the blood of Detroit that ran through his veins had an even earlier West African source, which he would connect with a particular kind of metalwork—Benin Bronzes. He felt an affinity for the lost-wax method, a seminal metalwork in Africa that predated much European smithery. He began to connect this art with the largely Black population in Detroit, many of whom also traced their roots to West Africa. I was honored to partner with him in the development of plans to display his significant collection.

I had first read about Carlos Nielbock in 2017, in a feature piece in the *Detroit Metro Times*. He was already legendary in certain creative circles. The writer Michael Jackman waxed so eloquently about him that, by the time I met Carlos at a cultural event a few years later, I was so astonished to see him in real life I spontaneously bowed! My husband, artist David Philpot, followed suit. It was a beginning of our friendship, and something of a partnership between the two men—both outsiders. The fact that David, a prodigiously gifted wood-carver and assemblage artist, was a Vietnam-era veteran, who had served in Germany and could still speak a smattering of the language, endeared him to Carlos even more. They were beloved friends until David's death in 2018.

As much as Carlos wanted to be Black, he is also German, and he reverberates with the characteristic—even stereotypical—quality of German *order*. The meticulousness of his work, his pristine surroundings—in a metal workshop, no less—and the demand for order in his milieu are deeply ingrained in his personality. It was a shock to him to arrive in Detroit and, after a time, become all too keenly aware of the sometimes paralyzing lack of order and ambition in some of the young folks he encountered. He was incredulous at the evidence of hesitance and defeat that permeated so many in the community—a kind of PTSD after centuries of repression and discrimination in innumerable forms. It took him many years to come to understand it—after having experienced being passed over himself.

A mural in the second-story studio of his workshop is a visual reference to another aspect of Carl's life—his love of Native American culture. Little did I know, until meeting him and visiting his atelier, that a kind of ersatz Native American lore, based on potboiler stories by nineteenth-century German

author Karl May, were—and are—a common cultural leitmotif in Germany. Children learn these pulp-fiction stories of Native American bravery and nobility starting in kindergarten. Carlos's stories include many of these tales, a fascinating—if rather incongruous—aspect of his emotional and spiritual connection to America. The fact that Bloody River Run cuts through his property in Detroit is a source of delightful, historical happenstance.

His dream project is the restoration of the Old City Hall clock tower, and it is also the source of much frustration. For years the seeming lack of interest in this project underscored an apparent lack of reverence for the grandeur of the city and its remaining markers. Subsequently, Carlos has carved out a not-insubstantial, if sporadic, living doing his bread-and-butter work—barrier construction, i.e., gates, iron fencing, and security structures, albeit, often spectacular, in some of the wealthiest homesteads in the area. It has taken him a while to be on the radar of the design powers that be, as he is now. Perhaps one day soon the Clock Tower Project will be a reality. Carlos also began to shift his attention to green energy—not merely as an ecological issue but to satisfy his ceaseless desire to train and hire youth in the city—and his eternally twirling windmills on his workshop grounds have now been patented. Likewise, there are important projects pending.

Carlo's father, far from abandoning him those years ago in Germany, was actually barred from contact with his mother, like many Black soldiers of the time and circumstance. His father wrote to his mother for some time after his return to America before life redirected them both. Carlos's hunger for his father drove him, with virtually no money, no English, and knowing nothing about being Black, to the Blackest city in the United States. Today, Carlos and his father, a nonagenarian, live together. Carlos can be seen tooling round their Eastern Market neighborhood on a golf cart. I had the chance to meet his mother and sister when they visited America before the pandemic, gracious, handsome women. Germans, Native Americans, Rastas, Black Detroiters are all reflected in his life and the music he loves—German lederhosen-clad, beer-hall singers, old-time Gospel artists, and Reggae bands—an amalgam of humanity and sounds, distilled in the new old-world of Carlos Nielbock—who is a gift to Detroit and America.

FAREWELL TO CLARENCE

Clarence Cheeks passed away peacefully on the day after Thanksgiving 2023 at the age of ninety-three. I was able to visit him, with Carlos and Belinda both present, a few days earlier. He was in hospice care at that point, resting peacefully but uncommunicative due to heavy medication. I was able to touch his hand, his fingers still ropy and strong, and to say a quiet thank you—for his service to his country, for taking care of his family and community, and for the time he had spent with me.

Clarence was the reason why Carlos came to Detroit, and they shared a home for almost four decades—almost twice as long as Carlos's time in Germany. Clarence was also an adopted Detroiter, having migrated from West Virginia in the late 1940s, but he became firmly rooted in the city, returning to it following his forays abroad in the armed forces. It was his gift with gardening that granted that same feeling to Carlos, the sense of what it means to have a home. In their years living together in the building on Wilkins Street, Clarence tended to the flowers, cut the grass, and answered the door—a military man of duty to the very end.

At the funeral service, held on east Grand Boulevard, there was a small crowd gathered, mainly consisting of family and old friends. In the casket, Clarence was decked out in his finest style, a gray pinstripe suit, with a black shirt and black tie, his gray hair combed back and his Van Dyke beard neatly trimmed, a look that recalled his dance hall days. There were only three White people present, Carlos later pointed out—Dan Carmody from Eastern Market Corporation, Rich Feldman from the Boggs Center, and me. Keenan had flown in from California, where he was staying in a halfway house since his release from federal prison earlier that year. The minister gave a short eulogy for Clarence and then invited guests to come

Farewell to Clarence

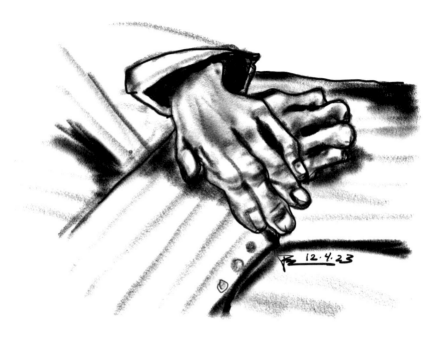

Clarence's hands, folded on his pinstripe suit, weathered by decades of work. Drawing by Paul Draus.

and speak a few words of remembrance. I had some of my writing about Clarence's life story ready, but three other people quickly got up, so I stayed in my seat and listened.

Keenan was the last one to stand behind the lectern, and the crowd fell silent as he gathered his words. Carlos sat directly in front of him, recording the whole thing on his phone. Keenan began to speak. "This is not easy. This is not easy. I got hit hard, you know what I mean? That shit was easy compared to this one here."

The folks in the room knew exactly what he was talking about. Too many people in the community had spent time in a cell, or had seen their own family members end up there. He was giving voice to one generation, those who grew up in the shadow of mass incarceration, looking for wisdom in the experience of those who had come before.

"My grandfather was something, a person like no other person, like, the discipline, the everyday push. I don't know where he got that. In my life, I'm

glad that he had that, because he kind of made me his little soldier. And a lot of people might think that I'm rough around the edges, but that's where I get that. Like, at any time, if you would of came to this man, and two plus two wasn't four, you know what I mean? If it didn't make sense, it's over. And that's something I kind of want to take, and move forward on, with my life, if I could take anything from him, you know what I mean? That's the most thing I'm going to take from you, Grandpa. He wasn't going to be played with; you weren't pulling nothing over, nothing. You know what I mean?"

"All right," said someone in the audience, acknowledging the accuracy of Keenan's characterization and encouraging him to continue.

"I done seen him at the gate, watching people. They don't know he watching. He, at the gate, at the crack." Now there was low laughter as Keenan leaned over, imitating the way Clarence would set up inside the building on Wilkins Street, a stalwart sentinel keeping an eye on the street. "He gonna watch you until you get in your car and leave. You on your phone talking to somebody else, he watch it, and that's something that can help you live to [ninety-three] years old. That's gonna get you there."

"All right, sir!" called an audience member.

"In my life, that's what showed me the code to survive, as good as I been surviving. I pretty much been in every situation around this country that you can be in, from the top to the bottom, and the tools that I use to thrive in all these situations is pretty much what I got from my grandfather. Just be quiet and let people tell you the truth. So if you ain't going to learn nothing from him, that right there: be careful. This guy was careful, *real* careful.

"And I wish I had more of the opportunity—like, I would always try to get around my grandpa, and, like, talk to him, and learn stuff, but he wouldn't say nothing when we got together. Like, I would always try to get around him and learn about his past, because it's so extensive, going to so many places around the world, and doing this and that, and when I tried to get around him, he only wanted to live in the moment with me. Like, trying to talk about the past, he ain't going for that. We right here.

"So that's what I'm going to take from my granddaddy for the future. Ain't nobody in this room had a good past. But tomorrow, we can get up at five in the morning and keep pushing. The next day, and the next day, and the next day."

"Amen" came the response from the family gathered around.

"So, I thank you all for showing up, and shit, in this room is pretty much the only people in the world that love me, so I appreciate you all."

He stepped down and was greeted with gentle applause.

The group gathered outside, and some of us followed Clarence the rest of the way to the Trinity Cemetery on Mount Elliott Street. It was a wet, cold day, and we stood within sight of the crumbling Packard plant, another monument to Detroit's storied past that was slowly eroding. As an automobile factory, it had once employed more than forty thousand people. The factory closed in 1958, and since then the massive site had hosted graffiti art, raves, photo shoots, informal housing, and a few remaining businesses that hung on in the periphery. Carlos's entire life had taken place in the span of time since the plant had closed, and Clarence had lived through it all.

In his black leather jacket and suit, Keenan cut a sharp figure, with a swagger, an air of physical confidence that seemed to defy the odds stacked against him. Carlos pointed out to me how many of Keenan's buddies from the neighborhood had come along, an indication of their abiding respect for the no-nonsense elder, who had made it this far, from the era of segregation and the golden age of Motown, through the long years of Detroit's depopulation, into the twenty-first-century version of rebirth.

Under this cloud of uncertainty, the quest would continue.

Months later, sitting in the ground-floor room that had been Clarence's, now converted to a C.A.N. Art Handworks meeting space, Carlos handed me a sheet of paper with some words printed in all capital letters. It had clearly been photocopied many times. Clarence always kept this posted in his room, Carlos told me. He then asked me to read it out loud, so I did:

I've smoked dope,
danced, French-kissed,
fucked, farted, fought.
Shot the moon, drove
big trucks, I've been to
Maine, Spain, Spokane,
and Fort Wayne, seen
three world's fairs
been around the world
twice, looked danger

in the face, but I ain't
seen no shit like the
shit that goes on
around this place

Was he thinking about the city of Detroit, the household, the workplace, or all three? In any case, it seemed like an appropriate way to go out: with a sharp observation, informed by worldly wisdom, seasoned with vulgarity, and defiant until the end.

REFERENCES

Adler, William M. 1995. *Land of opportunity: One family's quest for the American dream in the age of crack.* New York: Atlantic Monthly Press.

Art Story Foundation, The. 2020. Gesamtkunstwerk, Jan 21. The art story. https://www.theartstory.org/amp/definition/gesamtkunstwerk/.

Bailey, Ronald W. 2013. American revolutionary: The evolution of Grace Lee Boggs—A review. *Fire!!!, 2*(1), 60–85. https://doi.org/10.5323/fire.2.1.0060.

BBC Witness History. 2020. I just wanted to be white: Growing up as a black child in post-war Germany. BBC. November 3. https://www.bbc.co.uk/sounds/play/w3cszmq9.

Bjärgvide, K. 2021. Black history: Radio pioneer Martha Jean the queen (feat Diane Steinberg Lewis), interview, November 29 [YouTube video]. https://www.youtube.com/watch?v=5kjmWlvZM9s.

Boggs, G. L. 2012. Reimagine everything. *Reimagine!, 19*(2). https://www.reimaginerpe.org/19-2/boggs.

Bourdieu, P. 1999. *The weight of the world.* Stanford, CA: Stanford University Press.

Chafets, Z. 1990. *Devil's night and other true tales of Detroit.* New York: Random House.

Chohaney, M. L., Yeager, C., Gatrell, J. D., and Nemeth, D. J. 2016. Poverty, sustainability, & metal recycling: Geovisualizing the case of scrapping as a sustainable urban industry in Detroit. In J. D. Gatrell, R. R. Jensen, M. W. Patterson, and N. Hoalst-Pullen (Eds.), *Urban sustainability: Policy and praxis.* London: Springer. https://link.springer.com/chapter/10.1007/978-3-319-26218-5_8.

City of Detroit. 2016. Proposed Fort Wayne Historic District. https://detroitmi.gov/sites/detroitmi.localhost/files/2018-08/Fort%20Wayne%20HD%20Final%20Report.pdf.

City of Detroit. 2020. Revitalizing Historic Fort Wayne. https://detroitmi.gov/sites/detroitmi.localhost/files/2020-02/Historic%20Fort%20Wayne%20RFI%202-10-20.pdf.

Crawford, M. 2009. *Shop class as soulcraft*. New York: Penguin.
Detroit Future City. 2017. *139 square miles*. https://detroitfuturecity.com/wp-content/uploads/2017/08/DFC-139-Square-Miles-Report-FINAL.pdf.
Detroit Works Project Long-Term Planning Steering Committee. 2012. *Detroit future city: Detroit strategic framework plan, December 2012*. Detroit: n.p.
Donskis, L. 2008. *Power and imagination: Studies in politics and literature*. New York: Peter Lang.
Dooling, D. M. 1985. *A way of working: The spiritual dimension of craft*. Lincolndale, NY: Parabola Books.
Draus, P. 2009. Substance abuse and slow-motion disasters: The case of Detroit. *Sociological Quarterly*, *50*, 360–382.
Draus, P. 2020. Inclusive design in contemporary Detroit. In K. Stocker and S. Bürstmayr (Eds.), *Designing sustainable: Manageable approaches to make urban spaces better* (pp. 24–41). Basel, Switzerland: Birkhäuser.
Draus, P. 2022. As Detroit's RoboCop statue slowly comes together, another local craftsman has a different vision for public art: RoboCop vs. the Clock Tower. *Detroit Metro Times*, December 30. https://www.metrotimes.com/arts/as-detroits-robocop-statue-slowly-comes-together-another-local-artist-has-a-different-vision-for-public-art-31985080.
Draus, P., and Roddy, J. 2014. Paintings, pensions and pain. *Contexts*, *13*(2), 58–60.
Draus, P., and Roddy, J. 2015. Ghosts, devils and the undead city: Detroit and the narrative of monstrosity. *Space and Culture*, *19*(1), 67–79.
Draus, P., and Roddy, J. 2022. Dodging bricks and baseball bats: On tourism, territoriality and responsibility. In Andrea Mubi Brighenti and Mattias Kärrholm (Eds.), *Territories, Environments, Politics: Explorations in Territoriology* (pp. 206–225). London: Routledge.
Draus, P., Roddy, J., and McDuffie, A. 2013. We don't have no neighborhood: Advanced marginality and urban agriculture in Detroit. *Urban Studies*, *51*(12), 2523–2538.
Draus, P., Roddy, J., and McDuffie, A. 2018. "It's like half and half": Austerity, possibility and daily life inside a depopulated Detroit neighborhood. *City, Culture, and Society*, *14*, 37–46. https://doi.org/10.1016/j.ccs.2018.01.001.
DTE Energy Corporation. 2021. Knox Cameron and Carlos Nielbock talk recycled parts and renewables at Beacon Park, August 18 [YouTube video]. https://www.youtube.com/watch?v=F8MXIkhuYsk.
Du Bois, W. E. B. 1903. *The souls of black folk*. Chicago: A. C. McClurg.
Du Bois, W. E. B. 1990. "My Evolving Program for Negro Freedom." *Clinical Sociology*

Review, *8*(1), http://digitalcommons.wayne.edu/csr/vol8/iss1/5.

Environment America. 2017. President Obama's renewable energy legacy. *Environment America*, January 10. https://environmentamerica.org/blogs/environment-america-blog/ame/president-obama%E2%80%99s-renewable-energy-legacy.

Eschner, K. 2016. In 1913, Henry Ford introduced the assembly line: His workers hated it. *Smithsonian Magazine* (December). https://www.smithsonianmag.com/smart-news/one-hundred-and-three-years-ago-today-henry-ford-introduced-assembly-line-his-workers-hated-it-180961267/.

Gaiman, N. 2017. *Norse mythology*. New York: W. W. Norton.

Galchen, R. 2012. Wild west Germany: Why do cowboys and Indians so captivate the country? *New Yorker*. https://www.newyorker.com/magazine/2012/04/09/wild-west-germany.

Gallagher, J. 2013. *Revolution Detroit: Strategies of urban reinvention*. Detroit: Wayne State University Press.

Gaskew, T. 2014. *Rethinking prison reentry*. Lanham, MD: Lexington Books.

Georgakas, Dan, and Marvin Surkin. 1998. *Detroit: I do mind dying*. Cambridge, MA: South End Press.

Hansen, H. 2009. Rethinking the role of artisans in modern German development. *Central European History*, *42*, 33–64.

Hicks, D. 2020. *The brutish museums: The Benin Bronzes, colonial violence and cultural restitution*. London: Pluto Press.

Hošić, I. 2020. Detroit: The city of design and its ideological backgrounds [unpublished manuscript]. https://www.academia.edu/42983711/Detroit_The_City_of_Design_and_its_ideological_backgrounds.

Hügel-Marshall, I. 2008. *Invisible woman: Growing up Black in Germany*. New York: Peter Lang.

Hurricane Wind Power. 2015. Wind turbines for the beginner: How to part one [YouTube video]. https://youtu.be/zuhYfGd24g0.

James and Grace Lee Boggs Center. http://boggscenter.org/.

Keppner, E., and Mattoon, R. 2021. What would Detroit's business ownership look like with racial parity? [Web blog post]. Federal Reserve Bank of Chicago, Michigan Economy blog, August 2. https://www.chicagofed.org/publications/blogs/michigan-economy/2021/detroit-business-ownership-racial-parity.

Kinder, K. 2016. *DIY Detroit: Making do in a city without services*. Minneapolis: University of Minnesota Press.

Kinney, R. J. 2016. *Beautiful wasteland: The rise of Detroit as America's postindustrial frontier.*

Minneapolis: University of Minnesota Press.

LeDuff, C. 2013. *Detroit: An American autopsy*. New York: Penguin.

Lenz-Gleißner, Jana Pareigis, and Adama Ulrich. 2017. *Afro.Germany* [Documentary]. https://www.youtube.com/watch?v=pcfPVj5qR1E.

Library of Congress. 2014. *The Civil Rights Act of 1964: A Long Struggle for Freedom*. https://www.loc.gov/exhibits/civil-rights-act/index.html.

Lindquist, S., and Minton, E. 2019. Power plant power. *Scenario*, 7. https://scenariojournal.com/article/power-plant-power/.

Lyon, M. 2020. *i.Detroit: A human atlas of an American City*. London: Glassworks.

McGraw, B. (Ed). 2005. *The quotations of Mayor Coleman A. Young*. Detroit: Wayne State University Press.

Montgomery, A. W., and Dacin, M. T. 2020. Water wars in Detroit: Custodianship and the work of institutional renewal. *Academy of Management Journal*, 63(5). https://journals.aom.org/doi/10.5465/amj.2017.1098.

Newman, A., and Safransky, S. 2014. Remapping the motor city and the politics of austerity. *Anthropology Now*, 6(3), 17–28.

Nielbock, Carlos. 2020. U.S. Patent No. 10,844,836 B2. Washington, DC: U.S. Patent and Trademark Office. https://patentimages.storage.googleapis.com/93/4f/c5/2b0d0e398b7c71/US10844836.pdf.

Partridge, D. J. 2022. Hostility as technique: Making white space in a Black city. *Anthropological Quarterly*, 95(2), 363–386. https://doi.org/10.1353/anq.2022.0019.

Partridge, D. J. 2021. What would it mean to decolonize Detroit? How does anthropology figure? *HAU: Journal of Ethnographic Theory*, 11(1), 299–308.

Praslowicz, K. 2014. Wind turbine, Ishpeming, Michigan, March 2014 [Web blog post]. K. Praslowicz blog. https://www.kpraslowicz.com/project/watershed/wind-turbine.

Randall, D. "Booker T. and W.E.B." 1969. Poetry Foundation. https://www.poetryfoundation.org/poems/47690/booker-t-and-web.

Roediger, D. 2005. *Working toward whiteness: How America's immigrants became white*. New York: Basic Books.

Safransky, S. 2014. Greening the urban frontier: Race, property, and resettlement in Detroit. *Geoforum*, 56, 237–248.

Saram, P. A. 1998. Reflections on the reception of Veblen and Weber in American Sociology. *International Journal of Politics, Culture, and Society*, 11(4), 579–605.

Scheltema, D. 2013. Meet Detroit maker Carlos Neilbock [*sic*]. *Make:*, August 8. https://makezine.com/article/craft/meet-detroit-maker-carlos-neilbock2-2/.

Schiller, Friedrich von. 1916. "The Song of the Bell." In M. Münsterberg (Ed. and tran.), *A

Harvest of German Verse. New York: D. Appleton and Co. Bartleby.com, 2010.

Schnurr, R. 2018. The iconic windmills that made the American west. *Atlas Obscura*, January 15. https://www.atlasobscura.com/articles/windmills-water-pumping-museum-indiana.

Schroer, T. L. 2007. *Recasting race after World War II: Germans and African Americans in American-occupied Germany*. Boulder: University Press of Colorado.

Sennett, R. 2009. *The craftsman*. New Haven: Yale University Press.

Sharp, S. R. 2016. Restoring memories and forging futures with Carl Nielbock of CAN Art Handworks. *Model D Media*, September 5. .https://www.modeldmedia.com/features/can-art-handworks-050916.aspx.

Sinclair, U. 1908. *The flivver king: A story of America*. Chicago: Charles H. Kerr.

Soyinka, W. 1976. *Myth, literature and the African world*. Cambridge: Cambridge University Press.

Spröer, S. 2016. Why so many Germans fell in love with Winnetou. December 22. Deutsche Welle, https://www.dw.com/en/winnetou-why-so-many-germans-fell-in-love-with-the-unrealistic-indian/a-36861258.

Steele, C. M., and Aronson, J. 1995. Stereotype threat and the intellectual test performance of African Americans. *Journal of Personality and Social Psychology*, *69*(5), 797–811.

Stocker, K. 2013. *The power of design: A journey through the 11 UNESCO cities of design*. Berlin: Springer-Verlag.

Sugrue, T. 1996. *The origins of the urban crisis: Race and inequality in postwar Detroit*. Princeton, NJ: Princeton University Press.

Sugrue, T. 2015. Postscript: Grace Lee Boggs. *New Yorker*, October 8. https://www.newyorker.com/news/news-desk/postscript-grace-lee-boggs.

Thomas, M. 2017. The day Harold Washington died. *Chicago Magazine*. https://www.chicagomag.com/Chicago-Magazine/December-2017/The-Day-Harold-Washington-Died/.

Thompson, H. A. 1999. Rethinking the politics of white flight in the postwar city: Detroit, 1945–1980. *Journal of Urban History*, *25*(2), 163–198.

Van Gelder, S. 1994. New work, new culture: An interview with Frithjof Bergmann. *In Context*, *37*, 54. https://www.context.org/iclib/ic37/.

Veblen, T. 1899. *The theory of the leisure class*. New York: Macmillan.

Veblen, T. 1969. *The vested interests and the common man*. New York: Capricorn Books.

Weingarten, C. A. 2013. Detroit: *The renaissance of America*. [Documentary]. Explore Films, https://explore.org/livecams/documentary-films/detroit.

Williams, A. J. 2013. Mayor Bing and Bill Pulte unveil site for Detroit Blight Authority. *Michigan Chronicle*, February 22. https://michiganchronicle.com/2013/02/22/mayor-bing-and-bill-pulte-unveil-site-for-detroit-blight-authority/.

Wojdyla, B. 2011. 5 coolest DIY projects from Detroit Maker Faire 2011. *Popular Mechanics*, August 2. https://www.popularmechanics.com/technology/g589/10-coolest-diy-projects-detroit-maker-faire-2011/?slide=5.

World War II and post war (1940–1949). 2014–2016. In James H. Billington et al. (Eds.), The Civil Rights Act of 1964: A long struggle for freedom. Exhibition presented at the Library of Congress, Washington, DC. https://www.loc.gov/exhibits/civil-rights-act/index.html.